Situational Diagram

Situational Diagram

Karin Schneider
Begum Yasar

Dominique Lévy

Contents

Preface and Acknowledgements

In today's world of ever-rising inequality, of ceaseless conflict and injustice, it is more difficult than ever to justify being an artist or having a career in the art world. It is our conviction that for any of us to be able to reconcile what we are doing, we must strive to reinvent the ways our subjectivities are formed, by developing new practices of resistance.

This book is not the culmination of a process, but one step among many. It engages issues that have occupied our thoughts, independently and together, for several years. It stands as a critical companion to the body of work on view at Dominique Lévy, New York, September–October 2016. Yet it does not claim to be a complete record of this exhibition, and should not be treated as a document endowed with archival finality.

The concepts that are central to this book are coextensive with the materiality of the work. The object and the idea are equally important. A reinvention of our subjectivities—our forms of connection with the world and with each other—implies encounters with both objects and ideas. We are adamant that the exhibition be experienced, and this publication be read, together. Renegotiating our relationship to abstraction and to images in the wider sense is a political act. Art doesn't operate at the same speed as the stock market or as social media. Art demands a slow and intimate relationship, increasingly antithetical to the velocities of our time.

Institutions are not monoliths; they are groups of thinking and acting people. We need the gallery system to confront existing dogmas dictating how art must be seen, understood, and acquired. There is no operative art without the social—the "socius," as Félix Guattari called it. There is no "outside," but there *are* people inside who can challenge prevailing forms and functions, clearing the way for the emergence of new ones and introducing multiple coexisting points of view. To say "yes" in this sense is not a simple affirmation, but a site of communication with an accompanying "if."

Thus, this project would not have been possible anywhere other than this gallery. It takes a radically open mind and a passionate commitment to art—in both its present and its future. For this, we salute Dominique Lévy.

Sabu Kohso, Jaleh Mansoor, Jean-Luc Nancy, Simon O'Sullivan, Anne Querrien, Abrahão de Oliveira Santos, Valentin Schaepelynck, Aliza Shvarts, and Tirdad Zolghadr, your enthusiasm, generosity, and rigor in contributing your thoughts and experiences to this publication will continue to inspire us as we go on to think of the next step and the ones after.

Our heartfelt gratitude goes out to the entire staff at Dominique Lévy. Among them, a few merit special acknowledgement. Sylvia Gorelick, Andrew Kachel, and Valerie Werder, your unwavering dedication to both the concepts and the objects, and your tireless efforts to find ways to communicate and materialize them have been exemplary. The series of readings and gatherings, which are part and parcel of this project, would not have been possible without your terrific ideas. Clara Touboul and Liz Nelson, your respective contributions to realizing this difficult installation have been indispensable.

A special thank you to Tomaz Azevedo Capobianco, an extraordinary architect who has collaborated with the artist since 2013 and produced the renderings in this book. Franklin Vandiver, in designing this book, your readiness to immerse yourself in what is at stake, with principles and precision, made a remarkable difference.

We are grateful to Mary Ceruti, Nicolás Guagnini, Anthony Huberman, and Reinaldo Laddaga for being sounding boards for many of our ideas and hypotheses; Abraham Adams and Sam Frank for their diligent copy editing; John Cussans for providing the

diagrams to accompany Simon O'Sullivan's text; Renato Rezende for translating Abrahão de Oliveira Santos's text; Germana Agnetti at Archivio Vincenzo Agnetti, Tarsilinha do Amaral and Luciana Rangel, William Cerbone at Fordham University Press, Angeles Devoto at MALBA, Stephen Faught and Ivan Gaytan at Miguel Abreu, Martha Fleming-Ives at Greene Naftali, Julio Grinblatt, John Knight, Rosalia Pasqualino di Marineo at the Fondazione Piero Manzoni, Grady O'Connor at David Zwirner, the Estate of Ad Reinhardt, and Eva Sørensen for their assistance in obtaining rights and images for this book.

Thank you to all those who contributed to materially realizing the exhibition. We would especially like to acknowledge Maria Antelman, Miah Artola, Pilita Garcia, Bill Jacobs, Ted Lawson, Francesco Mo, Richard Stump, Ian Szydlowski, Niagara Custom Lab, and the team at Pranayama for their ingenuity and hard work in the fabrication of the many elements in this complex installation.

Karin Schneider and Begum Yasar
New York, July 2016

On the Diagram (and a Practice of Diagrammatics)

Simon O'Sullivan

The following definitions of the diagram—which double as protocols for a possible practice (of diagrammatics)—are taken from different philosophical and psychoanalytic sources, but also from outside of these registers. Generally speaking, I leave aside those uses of the diagram as solely functional tool, as for example in wiring diagrams, or, indeed, for pedagogical purposes, as for example to simplify or instruct (although both of these functions can and do tangentially come into my definitions). The intention of this experimental approach and format (which, at times, moves at speed so as to cover ground) is to think specifically about the diagram in a contemporary art context—or, again, of diagrammatics as a form of expanded aesthetic practice—as well as, more generally (following Félix Guattari), about the role of diagrams in the more ethico-aesthetic practice of the production of subjectivity. What follows might also itself be understood diagrammatically insofar as it performs a certain abstraction (from its various sources), suggests connections and compatibilities (across different terrains), and ultimately offers a certain kind of perspective (a meta-modelization) that might be considered a speculative fiction.

1. Formal (Matheme)

This is the diagram in what we might call its mathematical sense (when the latter is broadly construed). In terms of the softer sciences

it is the diagram as deployed in structuralism, paradigmatically in Lacanian psychoanalysis (which itself looks back to Freud's use of diagrams), as for example in the matheme of the Four Discourses (of the Master, of the University, of the Hysteric, of the Analyst). Claude Lévi-Strauss—with his "science of myth"—would also be a key exponent here (as would structuralist anthropology more generally). It is also the diagram as used in a particular type of contemporary Continental philosophy (following both mathematics and Lacan): Alain Badiou, for example, with his mathemes of the subject, but also, more generally, his use of mathematical set and sheaf theory. In relation to Lacan, we might also note here the importance of diagrams for cybernetic understandings of life more generally (see also 10., below).

The diagram here is an abstraction (from the body and/or the world). It tends to take on an objective status (it is usually technically drawn, for example by computer). The account of the subject it concerns is also abstract and formal, tending to foreground language and the symbolic (as a kind of parasite) or an "Idea" that, in each case, constitutes the subject "up and above" any brute existence as (human) animal.

2. Communication Without Meaning

A crucial aspect of this formal understanding of the diagram—to return to Lacan—is its ability (or at least claim) to communicate without meaning. Indeed, this is very much the diagram's pragmatic character (it moves things on). In relation to this we might note that a text can operate diagrammatically, as in Lacan's suggestion that his *Écrits* was not written so that it might be understood (the writings, rather, "must be placed in water, like Japanese flowers, in order to unfold"). Jean-François Lyotard also suggests that the sign might operate as a tensor in this sense—demarcating a "region in flames"—not necessarily to be interpreted, but rather, again, to set things in motion.

In relation to art practice more generally we might simply claim that the diagram can short-circuit the discursive (and, as such, demand ever more interpretations) whilst also calling for other

Jacques Lacan's matheme of the Four Discourses

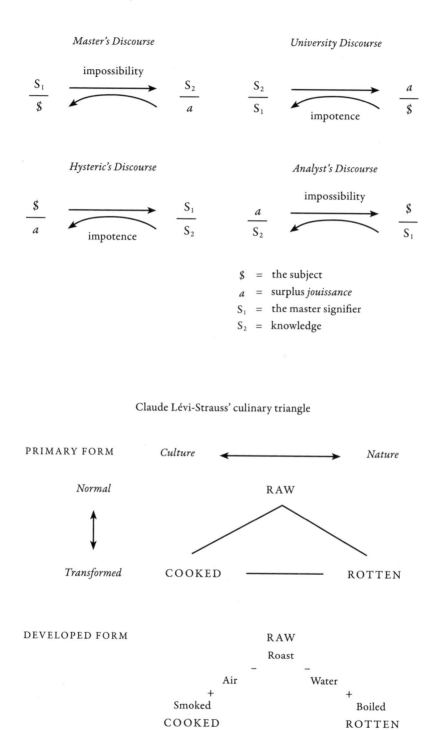

Master's Discourse

$$\frac{S_1}{\$} \quad \xrightarrow{\text{impossibility}} \quad \frac{S_2}{a}$$

University Discourse

$$\frac{S_2}{S_1} \quad \xrightarrow{} \quad \frac{a}{\$}$$
impotence

Hysteric's Discourse

$$\frac{\$}{a} \quad \xrightarrow{} \quad \frac{S_1}{S_2}$$
impotence

Analyst's Discourse

$$\frac{a}{S_2} \quad \xrightarrow{\text{impossibility}} \quad \frac{\$}{S_1}$$

$\$$ = the subject
a = surplus *jouissance*
S_1 = the master signifier
S_2 = knowledge

Claude Lévi-Strauss' culinary triangle

PRIMARY FORM *Culture* ⟷ *Nature*

Normal RAW

Transformed COOKED ——— ROTTEN

DEVELOPED FORM RAW
Roast

− −
Air Water
+ +
Smoked Boiled
COOKED ROTTEN

forms of interaction to be enacted. This is especially the case with abstract art, and, more particularly, the non-figurative and mute. Indeed, what is the appropriate response to a diagram in this form? And what about a similar kind of abstract diagram that moves away from a two-dimensional surface into a three-dimensional space (and, as such, introduces the dimension of time)?

3. Animal (Patheme)

Animal here refers to a more creaturely—or affective—understanding of the diagram (and, as such, stands in contradistinction [with respect] to the formal). This is the diagram in its more processual (and experimental) use. Or, put more simply, the diagram as drawing. In terms of contemporary Continental philosophy (and psycho/schizoanalysis), it is Gilles Deleuze and Félix Guattari, especially in *A Thousand Plateaus*, that exemplify this kind of diagrammatic work (as, for example, in the plateaus on "Faciality" and "On Several Regimes of Signs"). In terms of the subject, or here, the production of subjectivity, this kind of diagram foregrounds the potentialities of the body and world. It provides an ethology and cartography of lived life (the speeds and slownesses that make up an "individual"; the various capacities to affect and be affected).

This diagram is still an abstraction, but of a different kind (a working out of the conditions of possible experience). The hand-drawn nature of this kind of diagram is important (in *A Thousand Plateaus* the diagrams are reproduced as drawings), not least insofar as this necessarily involves a certain affect that accompanies any strictly conceptual work. Indeed, might we even say that drawing (when this is not figurative [does not delineate a recognizable form] but follows the "abstract line") is opposed to the diagram in its more formal, fixed, and apparently objective sense?

4. Forces and Experimentation

Following this animal understanding, we might turn from Deleuze and Guattari to Deleuze, for whom the diagram can be a "picturing" of forces—as, for example, in the account (and accompanying

diagram) that Deleuze gives of Michel Foucault and his account of subjectivation as the "folding in" of the forces of the outside. In relation to art practice we might also note Deleuze's take on Francis Bacon's paintings, wherein the diagram announces the enactment of random marks and splashes—a whole asignifying economy—that disrupts a given signifying order (in this case figuration), allowing a "new" world to emerge. We might also reference here the way in which a "minor literature," with its stuttering and stammering of language—and foregrounding of the affective—offers up a diagram that disrupts common sense (and, as such, contains the germ of new forms of sense, calling forth a people adequate to the latter).

The diagram here is a strategy of experimentation that scrambles narrative, figuration—the givens—and allows something else, at last, to step forward. This is the production of the unknown from within the known, the unseen from within the seen. The diagram, we might say, is a strategy for sidestepping intention from within intention; it involves the production of something that then "speaks back" to its progenitor.

5. Conjunction and Synthesis

A practice of diagrammatics (in terms of both art practice and the production of subjectivity more generally) might also involve the bringing of the above understandings of the diagram together. This is the "drawing" of matheme/patheme diagrams that incorporates both the formal and the creaturely (and, as such, offers a more accurate image of a lived life). In fact, with a thinker like Spinoza do we not already have a diagramming of the matheme/patheme insofar as in The Ethics the rational (formal) and affective (animal) are inextricably entwined and co-determinant? (But also, we might note, how one reads Spinoza [and which parts one reads closely] can determine one's take on both analysis [psycho or schizo?] and philosophy [rational or affective?].)

More generally, diagramming concepts might allow for the forcing of encounters and conjunctions and the production of surprising compatibilities (as, for example, when diagrams from different milieus are superimposed on one another). A practice of

Deleuze and Guattari's Terrestrial Signifying Despotic Face
from "Year Zero: Faciality"

Simple Machine

With multiple
bordering effects

Four-Eye Machine

Proliferation of Eyes By Multiplication of Border

Deleuze and Guattari's Maritime Subjective Authoritarian Face
(after Tristan and Isolde) from "Year Zero: Faciality"

Celebratory Machine

Coupled Machine

Complex Machine

1. Musicality Line
2. Picturality Line
3. Landscapity Line
4. Faciality Line
5. Consiousness Line
6. Passion Line
 etc.

Lacan's completed graph of desire

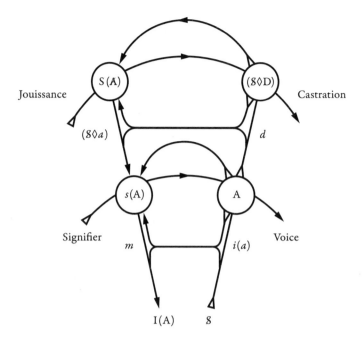

Deleuze and Guattari's diagram from "On Several Regimes of Signs"

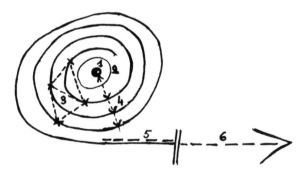

1. The Center of the Signifier; the faciality of the god or despot.
2. The Temple or Palace, with priests and bureaucrats.
3. The organization in circles and the sign referring to other signs on the same circle or on different circles.
4. The interpretive development of signifier into signified, which then reimparts signifier.
5. The expiatory animal; the blocking of the line of flight.
6. The scapegoat, or the negative sign of the line of flight.

diagrammatics might in this sense involve the production of composite diagrams. (In relation to this, it is also worth noting the way in which new digital-imaging technology allows ever more complex modeling and, especially, the animation of diagrams.)

6. Meta-modeling

One name for this kind of synthetic project, following Guattari, is meta-modelization. This is the bringing together of different models, even the placing of one model "inside" another (as, for example, in Guattari's situating Lacan's signifying schema within a broader schema of signifying and asignifying semiotics). Here the diagram is a way of re-positioning existing frameworks, and of working out possible relations as well as divergences. Crucially, meta-modelization refuses a partisan attitude (as in, "This is the way things are"). and opens up thought to other perspectives and points of view (see also 8., below).

Indeed, meta-modelization involves a less objective take on diagrams. They are understood as less universal (and timeless), but rather tied to particular kinds of subjectivity and drawn for particular kinds of purposes (not a tracing—reliant on a predetermined given—but a map that is always open to revision). Which is to say they are strategic and pragmatic (as in, "What diagram do I need here to get me out of this impasse?"). As such, again, they relate to both art practice and life, especially when the latter is itself understood aesthetically (as in Foucault's thesis on subjectivation and "life as a work of art").

7. Speculation and Speed

On the one hand a diagram can offer a kind of "view from elsewhere." Indeed, in terms of Philosophy (as a discourse of the Master), the diagram offers a birds-eye perspective, precisely "from above" (on a world that, in fact, it co-constitutes—but also on the other disciplines that it surveys from its throne). On the other hand, however, we are always already "on the ground" and in the thick of it, and, as such, this perspective can only be a kind of fiction. Indeed,

the diagram, although it can be an index of Philosophy's arrogant and autocratic functioning, also operates to dethrone the king and open thought up to other adventures. The diagram, in this sense, might be thought of as a speculative fiction (see also 8., below).

A diagram, especially as drawing, often leads ahead of conceptual thought. It operates as a probe prior to any consistency (this, we might say, is the diagram as sketch). The diagram can also move at a different speed from, for example, writing, and as such can achieve an escape velocity from the purely textual (this, we might say, is the diagram as automatic writing). The speed of the hand (or intelligence of the body) can outrun the cogito (or, more simply, the diagram is of the unconscious, however the latter is figured).

8. Fictions and Models

The diagram can be thought of as a model (in the mathematical rather than Platonic sense), which is to say, following François Laruelle, it names those philosophical materials that have been untethered from their properly "Philosophical" function (the claim to be able to give a sufficient account of the real). These "philofictions" can then be laid alongside other models of thought (art, science, the animal, and so forth) in a general democratization of all thought.

Diagrammatics might also refer to the recontextualization and manipulation of concepts (if they can still be called as such) once the philosophical overview has been "dropped down" from its position of transcendence. Such a practice—manipulating concepts as if on a tabletop—might, again, allow for hitherto "illegal" connections and syntheses to be made. One strategy to allow for this change in vision is to draw concepts (as diagrams) and then, perhaps, to allow the drawing itself to suggest further avenues of exploration. In relation to art practice, we might note here the invention of fictional diagrams (for example in Asger Jorn's account and diagrams of Lettrism and the "System of Isou") that are given a certain currency or "authority" (after all, all diagrams [whatever their claims] are from [and equal before] the Real).

Isidore Isou's
systems of perspective

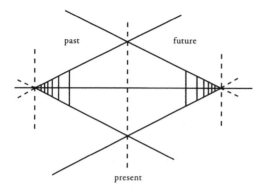

DUAL PERSPECTIVE
OF CLASSICAL EUROPE

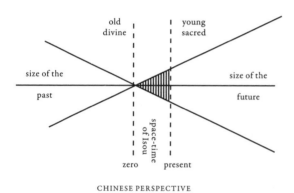

CHINESE PERSPECTIVE

The sigil of the gateway or
Necronomicon gate

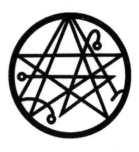

A sigil from Austin Osman
Spare's *The Book of Pleasure
(Self-Love): The Psychology
of Ecstasy*

This my wish

To obtain

The strength of a Tiger

Combined as one sigil

9. Magic(k)

In terms of fictions or simply diagrams of different modes of existence in contrast to the dominant, we might note magical diagrams and schema. Here, again, the diagram is an abstraction—and, in the case of a sigil, a condensing and concentration of information intended to generate focus and transformation (the use of signifying form to produce asignifying effects). Magical diagrams announce the willed transformation of the self and a different kind of sympathetic causality (of macro- and microcosm, where like affects like).

But *magic* also names a radically different mode of existence from the techno-scientific: a pre-modern understanding that also gestures towards a future aesthetic mode yet-to-come. Indeed, following Gilbert Simondon, the magical mode of existence itself involves a diagrammatic structuring of the landscape in terms of lines, tracks, and privileged points. This grid in space is doubled by a similar reticulation in time (the foregrounding of certain moments when it is auspicious to act). In our own moribund and increasingly restricted neoliberal present (with its domination of nature) this kind of diagrammatics becomes politically charged. A practice of diagrammatics might also be understood as more sorcerous, when it involves—to return to Deleuze and Guattari (and their plateau on "Becoming")—the following of the abstract line from animal to plant to ever stranger and imperceptible becomings.

10. World Building

Finally, might *diagrammatics* also name a kind of second-order art practice (is there any other today?) that uses previous art in its own particular diagrams, perhaps alongside other representational material: for example, the photograph, once it has itself been untethered from its more typical, representational function. Here diagrammatics announces a kind of nesting of fictions within fictions to produce a certain density, even an opacity. Indeed, an art practice in this sense builds its own worlds and suggests the terms by which they could be approached.

Might this diagrammatics also involve a different take on relations among the past, present, and future? This is the "drawing" of lines between different times, the building of circuits and the following of feedback loops; it is to understand time as specific to any given system (or practice) and not as neutral background. This might involve diagramming the way a different kind of future can work back on the present (and determine how we act or make in the here and now). Or, indeed, diagramming how the present itself can involve a re-engineering of the past (understood as resource and living archive) that will then allow a different kind of future to emerge.

John Cussans, *Carrefour Hyperface 1*, 2016

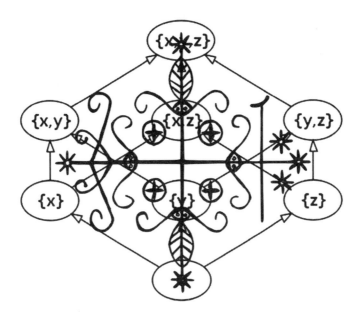

John Cussans, *Samedi Schema (Elementary Cell)*, 2016

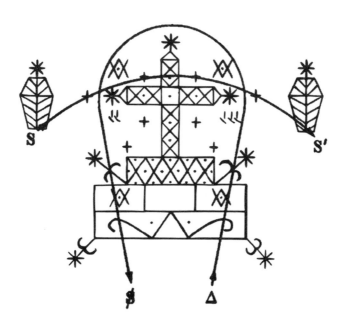

Far from Equilibrium

Begum Yasar

> How are sounds and forms going to be arranged so that the subjectivity adjacent to them remains in movement, and really alive?[1]
>
> —Félix Guattari

Today the territorializing and homogenizing force of capital manifests itself at an unprecedented degree of abstraction and general equivalence, propagated by the intertwined global assemblages (*agencements*) of finance, cybernetics, and techno-scientific industries. Neoliberal governance and consensus politics of the post-political liberal-democratic conjuncture have not only stood by but have also catalyzed new forms of colonization through the accelerated extraction of surplus value out of fractioned and atomized labor and energy in regionalized locales thousands of miles away. Exponentially rising inequities of income, wealth, and access to education and healthcare across the globe have gone hand in hand with the ascendance of right-wing propaganda, xenophobic and populist ideologies, and abuse of legislative and judicial power in the service of the enhanced efficiency of the alignment of capital and government apparatuses, the rapid proliferation of surveillance technologies, censorship and suppression of resistance, activism, and

1. Félix Guattari, *Chaosmosis: An Ethico-Aesthetic Paradigm*, trans. Paul Bains and Julian Pefanis (Sydney: Power Publications, 1995), 133.

dissent. Political and economic forms of domination, divisionism, and conflict have exacerbated, while the threat of nuclear catastrophe—coupled with the dissemination of new kinds of chemical, biological, and computerized weapons—has become increasingly real and ominous. All the while we have been experiencing more frequent and devastating acts of terrorism, human rights violations, traditional military conflict, and protracted civil war, causing, among other things, the forced migration of millions of civilians across national borders under dire circumstances.

If we were to zoom out for a moment, to take stock of our own individual coordinates, the nature and extent of our involvement in this multitude of interlocking assemblages (*agencements*), that is to say, institutional organizations, interpersonal networks, and social entities, and found ourselves in the so-called art world[2] doing what we do every day, what would the picture that emerges from this exercise look like? Could we develop and problematize the possibility of a workable ethico-aesthetics through the application, to contemporary art, of the methodology of a realist ontology of institutions and practices?[3]

There has been much critical writing, conversation, and activity recently stating the need for (and exploring the possible forms of) escape or exit from contemporary art, in other words, the art

2. The category *art world* itself must be problematized. See the excellent account by Anton Vidokle and Brian Kuan Wood of the way "the expansionary impulse of contemporary art has already injected art into daily life, just as it has enclosed art practitioners within a particular life-world known as the art world," in their article "Breaking the Contract," *e-flux* 37 (September 2012).

3. Throughout this essay I rely on Gilles Deleuze and Félix Guattari's theory of assemblage (*agencement*), as well as "neo-assemblage theory" developed by Manuel DeLanda. In the introduction to *A New Philosophy of Society: Assemblage Theory and Social Complexity* ([London: Continuum, 2009], 3), DeLanda explains: "A theory of assemblages, and of the processes that create and stabilize their historical identity, was created by the philosopher Gilles Deleuze in the last decades of the twentieth century. This theory was meant to apply to a wide variety of wholes constructed from heterogeneous parts. Entities ranging from atoms and molecules to biological organisms, species and ecosystems may be usefully treated as assemblages and therefore as entities that are products of historical processes. This implies, of course, that one uses the term 'historical' to include cosmological and evolutionary history, not only human history. Assemblage theory may also be applied to social entities, but the very fact that it cuts across the nature-culture divide is evidence of its realist credentials."

world or the art institution, as we know it.[4] The problem is two-fold, as Anton Vidokle and Brian Kuan Wood suggest.[5] The first has to do with the fact that artists and art institutions are inextricably bound together by "the supra-institution of Contemporary Art," which self-perpetuates by incentivizing the ever-increasing professionalization of artists, curators, and other practitioners in the field. Because of this, artistic freedom has become an illusion: "While as an artist you may think you are free to do as you please, in order for your work to be economically sustainable, critically acknowledged, or even simply brought into contact with the art public, it needs to conform to certain network protocols that dictate the forms of art production that circulate."[6] As stated, this observation isn't novel; after all, this has been the case, to varying degrees in different contexts, since the advent of patronage and specialization in the art market in seventeenth-century Netherlands. Today's call for "a form of agency that does not lean entirely on the professional superstructure of art in order to come into being as art,"[7] although long built into the Duchampian gesture, is further complicated by the fact that:

> Over the past decade, contemporary art has merged increasingly with the sensibilities of actual, concrete political structures, which have discovered in contemporary art and culture a means of exhibiting liberal, enlightened, globally conscious moral values. ... The artistic field is happy to serve in this diplomatic capacity, because expanding its rule allows it to bury its own ontological crisis. ... There is a lot of money in this game, for it is in many cases financed by municipalities, monarchs, and oligarchs who have discovered in

4. See, for example, Suhail Malik's book *On the Necessity of Art's Exit from Contemporary Art* (Falmouth: Urbanomic, 2016); the related series of talks held in May–June 2013 at Artists Space, New York; and e-flux conversations such as "Can Financialization Offer an Exit from Contemporary Art?" (April 2015).

5. Vidokle and Kuan Wood, "Breaking the Contract."

6. Ibid.

7. Ibid.

the cultural field a new, advanced form of social capital. ...
As if rescuing art from the industry of contemporary art
were not difficult enough, moving one level higher, even
contemporary art itself becomes harder to disentangle
from cultural diplomacy and municipal and state mar-
keting. But it is also here that contemporary art becomes
almost hysterical in its structural instability. ... Could it
be, then, that if we are to take the lessons of institutional
critique to heart, that a Duchampian break today would
necessarily have to take into consideration not only the
aesthetic field and its logics of museological enclosure,
but would also have to identify the weak points and sys-
temic inconsistencies of the meta-museum of global lib-
eral democratic capitalism that has absorbed it?[8]

The answer to this question could demonstrate the extent of
the perversity of the present conjuncture. In the face of the osten-
sible failure of post–Cold War politics, or post-politics—politics
of consensus, administration, managerialism, technocracy, and
policing, as opposed to a politics of debate and antagonism—to
embody the values set forth by the constitutions that emerged from
Enlightenment ideas, the very foundations of liberal democracies,
there is a demand on art to be critical of the existing system by rep-
resenting all possible difference, and to give voice to that which is
oppressed. Accordingly, the supra-structure of neoliberalism, the
very alliance of advanced capital with the nation-state in the form
of an institutional public-private system, rewards and promotes the
art that pinpoints the failures of that system. The catch here is that
most of this pinpointing is illustrative and as such does not have the
power to really give voice to that which is oppressed or excluded.
Here, Jacques Rancière's distinction between the notion of *le poli-
tique* (politics proper, as dissensus), and what he terms *la police* (the
police or police order) is instructive. The fundamental divergence
between politics proper and the police, says Rancière, is their respec-
tive representations of the common. The former not only recognizes,

8. Ibid.

but also calls forth the contested nature of the common. Meanwhile, the police "symbolizes the community as an ensemble of well-defined parts, places and functions, and of the properties and capabilities linked to them, all of which presupposes a fixed distribution of things into common and private—a distinction which itself depends on an ordered distribution of the visible and the invisible, noise and speech, etc. ... This way of counting [parts, places, and functions] simultaneously defines the ways of being, doing, and saying appropriate to these places."[9] Most art that is critical of the system (while being fully institutionalized and sponsored by the system) operates precisely on the logic of recounting the parts. Rancière emphasizes that *les sans-part* (the unaccounted for) is not so much a social class or group excluded and thus awaiting incorporation and representation. That would imply not only a procedural account of equality but also the existence of the emergent political subject—as an identity pre-given in the police order—prior to the political moment, neither worthy of the name *politics* according to Rancière.[10] Subjects are "not reducible to social groups or identities but are, rather, collectives of enunciation and demonstration *surplus* to the count of social groups."[11] *Les sans-part* (the unaccounted for) should be thought of as a supernumerary category, existing "at once nowhere and everywhere."[12] Art can accordingly be truly political if it can "*call into question* the counting of the community's parts and the relations of inclusion and exclusion which define that count."[13] Art that is illustrative of social identities and groups inadvertently yields to and replicates the police logic of the proper, which is radically negated by the very existence of *les sans-parts* as excess.

Andrea Fraser has posed a similar question of the possibility of art's dissociation from the machinery of neoliberal capitalism. After elaborating in great statistical detail the direct correlation between

9. Jacques Rancière, "Introducing Disagreement," *Angelaki: Journal of the Theoretical Humanities* 9, no. 3 (2004): 6.

10. Ibid.

11. Ibid.

12. Mustafa Dikec, "Space, Politics, and the Political," *Environment and Planning D: Society and Space* 23 (2005): 176.

13. Rancière, "Introducing Disagreement," 7 (emphasis added).

the economic activities of the top 0.1 percent of the US population and the art market, Fraser asks how we can possibly continue to rationalize our participation in this particular economy.[14] "The only 'alternative' today," Fraser writes, "is to recognize our participation in that economy and confront it in a direct and immediate way in all of our institutions, including museums, and galleries, and publications. ... At the very least, we must begin to evaluate whether artworks fulfill, or fail to fulfill, political or critical claims on the level of their social and economic conditions."[15] Fraser goes on to conclude that the only way out of this conundrum is a split between the territories that are stratified by commercial interests and those that aren't. The latter category leaves only state-funded European museums, which she identifies as singularly having the potential to become the kinds of spaces in which critical discourse and social justice could flourish. My question is whether we can keep thinking in terms of binary oppositions—such as that between spheres stratified by commercial interests and those that aren't—considering the complex forms of abstraction in which capital exists and circulates. The delineation of the truly critical from everything else that is subsumed and commodified by the institutions of neoliberal capitalism could well be a chimera in the face of the all-too-familiar legitimation crisis that befalls institutions regardless of which side of the public-private dichotomy they formally fall under. Indeed, the dichotomy itself is practically nonexistent today as more and more not-for-profit organizations are becoming hybrid entities in order to survive, by attempting to keep up with more heavily privatized entities in their programming, development, and marketing efforts. Many have cautiously embraced their need for the market and adopted the machinery that comes with this affiliation in order to grow and reach (and remain at) a point of equilibrium. It also works the other way around. Regardless of whether an exhibition is staged at a privately funded museum in the US or a state-funded museum in Europe,[16] the positive feedback vectors en route from

14. Andrea Fraser, "L'1%, C'est Moi," *Texte Zur Kunst* 83 (2011): 122.

15. Ibid., 124.

16. The very assumption that state-funded European institutions could offer a less

the not-for-profit territory toward the for-profit territory will nec-
essarily be at work. A solo exhibition at a state-funded Kunsthalle
in Europe, not to mention the presentation of an artist's work in a
predominantly state-funded European biennial, which in most cases
also relies on private sponsors, by all means correlates with the pres-
ence—and enhances the sales potential and future value—of the
same artist's work being offered for sale by several commercial art
galleries in an art fair. This process works just as efficiently in both
directions: art with high levels of support and visibility in the pri-
vate sphere will most likely make its way into the public sphere by
the sheer virtue of the assemblage (*agencement*) that is the art world,
which I will discuss in more detail below.

The classic threefold distinction—as described by Adrian Piper
in an interview by Maria Eichhorn regarding Piper's use of an altered
version of Seth Siegelaub's "The Artist's Reserved Rights Transfer
And Sale Agreement"—is one between the work's art market value,
its aesthetic value, and its meaning.[17] Often there is a direct correla-
tion between the first two types of value. In the context of the finan-
cialized contemporary art world, rife with speculation and collusion,
it has become increasingly difficult for professionals and non-profes-
sionals alike to discern the work's aesthetic value independent of its
market value, let alone its meaning (if any). This is, needless to say,
due to the forces of abstraction and general equivalence that govern
all goods, services, and assets in the economy—the reign of exchange

contaminated realm for the emergence and flourishing of free art and truly
critical discourse due to their cultural heritage and the European tradition of
state patronage of the arts in a way chooses to forget colonialism as a quintes-
sentially European activity practiced for centuries, which has financed to a great
extent the endowments dedicated to supporting the arts with value extracted
from elsewhere. European policies of immigration since the 1960s have followed
a parallel course with the persistent extraction of surplus value from immigrant
labor, which today has come to an impasse due to the rise of nationalist ideolo-
gies, which culminated not only with the British withdrawal from the European
Union in June 2016, but also with the ostensible inadaptability of the European
infrastructure in effectively dealing with the greatest migrant and refugee crisis
since the Second World War.

17. Adrian Piper, interview by Maria Eichhorn in *The Artist's Contract: Interviews
 with Carl Andre, Daniel Buren, Paula Cooper, Hans Haacke, Jenny Holzer, Adrian
 Piper, Robert Projansky, Robert Ryman, Seth Siegelaub, John Weber, Lawrence
 Weiner, Jackie Winsor*, ed. Gerti Fietzek (Cologne: Walther König, 2009), 203.

value as opposed to use value. In this context, Fraser's dictate is that "we must insist that what artworks *are* economically centrally determines what they *mean* socially and also artistically."[18] This requirement, which Fraser does not further expand upon in this article, is a tall order, and would be difficult to enforce in the majority of cases simply because questions of ethics have to be contended with before one can wholesale dismiss an artwork that has legitimate aesthetic value and meaning, on the basis of its life on the market and the ex post facto financial value it accrues. How much responsibility can be imputed to a particular artwork at the time of its production and exhibition and at a later point in time, respectively—or to its maker, for that matter, especially if the artist is no longer alive?

Perhaps another set of criteria can be articulated through a slightly different question: "Whether art should, or even can, be held responsible for its ex post facto consequences."[19] This question is posed by David Joselit in an article about institutional responsibility in which he focuses on the operations of the artist-run commercial art gallery Orchard.[20] Joselit continues: "The question implies an anticipatory consideration on the part of the artwork for the effects of its future economic, philosophical, and spatial circulation. One could say that in order to take seriously this responsibility, the nature of aesthetics must shift toward an ethics of emplacement, whereby the artwork's 'meaning' derives from its movements in time and space— or, in [Bruno] Latour's terms, the *associations* it establishes—rather than its 'content' per se."[21] The question I would like to raise is how we can further the strategies and tactics of this "anticipatory consideration" beyond the trajectories of institutional critique and relational aesthetics, which were effective to varying degrees in responding to certain circumstances that characterized the art institution from the

18. Fraser, "L'1%, C'est Moi," 124.

19. David Joselit, "Institutional Responsibility: The Short Life of Orchard," *Grey Room* 35 (2009): 110.

20. Orchard was an experimental Lower East Side New York gallery that operated from 2005–2008, cofounded by Rhea Anastas, Moyra Davey, Andrea Fraser, Nicolás Guagnini, Gareth James, Christian Phillip Müller, Jeff Preiss, R. H. Quaytman, Karin Schneider, Jason Simon, John Yancy Jr., and an anonymous member.

21. Joselit, "Institutional Responsibility," 110.

late 1970s to the mid 1990s. If institutional critique and relational aesthetics, however, were variously didactic and prone to being easily subsumed back into the institution,[22] then the need for a new ethico-aesthetic and semio-economic paradigm has been pressing for quite some time.

If we assume that the artwork's meaning can and should, to an extent, derive from its future movements in space and time, then its meaning cannot be dissociated from its content—which now has to actively generate itself as form and adapt to its own time. If the artwork is to effectively carry out a critique of economic abstraction, then it has to propose a *futurity* of meaning. In what follows, I will argue, using the work of Karin Schneider as a case study, that a *diagrammatic* practice has presented itself as an effective way for the artwork to incorporate a future into its present. "A process of diagrammatization," Schneider writes in her essay in this book, "already exists in many modes of artistic production, in an embryonic form, producing movements in our ways of perceiving and/ or creating situations. A process of diagrammatization detaches signs from language in relation to systems and processes of social interconnections."[23] As I hope will become clear both through this publication and the exhibition that the publication accompanies, SD (@DL/NY, 2016),[24] diagrammatic practice is a way of moving artistic programs away from the fixities of language and relocating them as both practice and discourse. Drawing on the model of

22. As has been famously pointed out by Fraser in her 2005 article "From the Critique of Institutions to an Institution of Critique," *Artforum* 44, no. 1 (2005): 278–86. At this point, it is important to remember that institutional critique has two parallel histories. In the 1970s, Michael Asher engaged in a radical form of exploration of the very activity of "critique." Asher's work tackled the phenomenological apparatus of art with an eye to incorporating actively transforming subjectivities into a dynamic program, implementing the tactics of negation proposed by his gestures. For him, the work was never merely an analysis or a proposition of facts but an ongoing conversation with the institutional staff who also wanted to rethink the nature of their work and positions. As recounted by Karin Schneider, Asher was able to maintain an exemplary degree of coherence across his work, career, and ethics; he is a major influence on Schneider's practice.

23. Karin Schneider, "Situational Diagram," in this book, p. 233.

24. SD (@DL/NY, 2016) refers throughout this publication to Situational Diagram in its iteration as exhibition at Dominique Lévy, September 7–October 20, 2016.

micropolitics proposed by Deleuze and Guattari, diagrammatic practice carries out a form of thought production that entangles artistic programs with the socio-political context of their time in the service of redistributing affect, concept, and value *into the future.*

*

In *A Thousand Plateaus*, Deleuze and Guattari speak of the world as consisting of ever-evolving *segmentarities* that are overlapping and entangled in binary, circular, and linear configurations. They can be rigid or supple; but they are always the result of an *abstract machine* and abstract machines operate both in the rigid and the supple.[25]

> Every abstract machine is linked to other abstract machines, not only because they are inseparably political, economic, scientific, artistic, ecological, cosmic—perceptive, affective, active, thinking, physical, and semiotic—but because their various types are as intertwined as their operations are convergent. Mechanosphere.[26]

When we think of our world as a mechanosphere of a multitude of abstract machines operating simultaneously and in an interrelated fashion, the possibility of a practical ethico-aesthetics presents itself. An object (or action) comes into being, is received, consumed, coded, circulated, and used as discourse in the mechanosphere. This way of situating the artwork and ourselves is the prerequisite for an effective micropolitics and aesthetic activism. It would entail the occurrence of *encounters* that could transform subjectivities by setting into motion novel processes of creating the meaning and value of that artwork. It consists in a mode of producing and disseminating art that not only exposes but also engages with and transforms the mechanosphere in which it is located (that is, institutional apparatuses themselves and the criteria by which those apparatuses are

25. Gilles Deleuze and Félix Guattari, *A Thousand Plateaus*, trans. Brian Massumi (Minneapolis: University of Minnesota Press, 1987), 212.

26. Deleuze and Guattari, *A Thousand Plateaus*, 514.

defined and delineated), reshuffling the roles and functions associated with its participants.

Two salient points are of note here. "The diagrammatic or abstract machine does not function to represent, even something real, but rather constructs a real that is yet to come, a new type of reality."[27] The diagrammatic approach is therefore different from the mimetic approach, which consists in the reproduction of the workings of society and/or art as institution. This has been the case with institutional critique, which aimed to expose the institutional apparatuses of art, the *dispositifs* of its production and circulation: the museum and its architectural enclosures; its devices and criteria for categorization, display, archive, and conservation; its bureaucratic and managerial strata; its board of trustees and their political and economic activities and alliances; the demographic statistics of the museum visitors; the commercial art gallery and its relationship to the market; the inside versus the outside, where the consideration of the outside incorporates the effects of art as institution on the urban landscape, the real estate market and gentrification. Maurizio Lazzarato argues, in an essay focusing on Duchamp's readymade as the originary moment of institutional critique, that it was the ur-act of economic and political self-reflexivity in the history of art, whereby the artist and artwork were able to "problematise and experiment at the same time with the modes of constitution of the work of art (and the artist) and with the commodity (and the laborer) by examining the forces, principles, and *dispositifs* which institute and consolidate them as values."[28] This has in fact been the driving force of institutional critique at its most effective. Although it "functioned firmly within the confines of the contemporary art system," institutional critique "was absolutely crucial for recognizing the integration of contemporary art within a global system of power—and this constitutes the core challenge facing any Duchampian break today in a way that did not concern Duchamp in his own time."[29] In

27. Ibid., 142.

28. Maurizio Lazzarato, "The Practice and Anti-Dialectical Thought of an 'Anartist'," in *Deleuze and Contemporary Art*, ed. Simon O'Sullivan and Stephen Zepke (Edinburgh: Edinburgh University Press, 2011), 104.

29. Vidokle and Kuan Wood, "Breaking the Contract."

institutional critique, the artwork offers a set of factual propositions that relies on an already given subjectivity of its viewer (as an educated, left-leaning, liberal progressive); the documents and situations that constitute the work inadvertently present a state of surrender to the neoliberal police order. What is at stake today, in contrast, is for the artwork to leave the subjectivity of the viewer open-ended, with the awareness of the unaccounted-for excess that Rancière speaks of. It is the movement beyond the analytical exposure of the institution's past and present; it is rather the potential for transformation of subjectivities through novel collective enunciations, prompted by and embodied in the materiality of the artwork.

The second salient point that characterizes the diagrammatic approach is the idea of a new type of collectivity creating the meaning and value of the artwork—one that has to do with the active practice of de-individuating the creative act. It is, however, as we will see below, quite different from relational aesthetics, which focused on the critique of authorship as a patriarchal trademark, acknowledging the anthropological parallels between the origins of authorship and those of private property. To begin demonstrating this point of difference, I'd like to revisit an argument Joselit puts forth in the same article on institutional responsibility, according to which we can identify three distinct approaches to art. The first is the idea of art as sign, which encompasses certain modes of modernism and the historical avant-garde, and which roughly corresponds to the category of "the *positively* reflective, or avant-garde model of mimesis in which social forces are said to cause, or more mildly, to account for (either directly or indirectly) the work's revolutionary qualities."[30] The Cubism of Picasso and Braque, and Russian Constructivism, are examples. The second is "the *negatively* reflective model of mimesis, otherwise known as 'subversion,' in which a curt and startling act of appropriation (i.e., reflection with minimal mediation) or other forms of mimicry are granted the power to 'reveal' the social."[31] The Pictures generation is a prominent example of this approach. The third is "thematically reflective mimesis in which 'social content' is

30. Joselit, "Institutional Responsibility," 112.
31. Ibid.

imported directly into the work of art."[32] Joselit proceeds to argue that the art that is most relevant today belongs to none of these three categories but instead to what he describes as "a productive aesthetics of open platforms," which he finds manifest in the work of artists such as Rirkrit Tiravanija and Liam Gillick.[33] He uses as a demonstrative case study of this type of art the penultimate exhibition at Orchard, titled *From One O to the Other*, which took place in March–April of 2008, and included works by R. H. Quaytman, Amy Sillman, and Rhea Anastas. It is my contention that the distinction between the second and third categories together, as still-traditional categories, *and* what Joselit designates as the most interesting type of art today, which in fact amounts to none other than a hybrid form of institutional critique and relational aesthetics, is not sufficiently problematized. In the end, all three can be categorized under the deconstructive attitude that had to do with the crisis in representation that characterized much of the art and art theory of the 1980s and '90s. This wide category, as elaborated by Simon O'Sullivan, had roughly two representative camps: "'postmodern' practices, as characterized by Craig Owens amongst others," which "self-consciously utilized previous forms (this was the so-called allegorical turn tracked by *October* and its writers)," and Nicolas Bourriaud's *Postproduction*, in which he makes the argument that contemporary art today utilizes existing signifying material as well as previous artistic and other cultural forms.[34]

It is true that contemporary art trades in multiple regimes of signification, but ultimately both these camps manifest a recursive impulse, and a self-reflexive practice that focuses on the past and the present. Relational aesthetics, despite dissolving the idea of the singular locus of authorship concentrated in the figure of the artist, and opening it up to an actively participating community, does not supersede existing social forms of interaction, which are imported

32. Ibid.
33. Ibid.
34. Simon O'Sullivan, "From Aesthetics to the Abstract Machine: Deleuze, Guattari and Contemporary Art Practice," in *Deleuze and Contemporary Art*, ed. Simon O'Sullivan and Stephen Zepke (Edinburgh: Edinburgh University Press, 2011), 192.

into and recast in the realm of art. This was the case in the example of the Orchard show, which included a selection of press coverage on Orchard presented by Anastas in vitrines; Sillman's gouache and ink portraits on paper of Orchard participants and friends, which were available for the visitors to page through and rearrange on a long table instead of hanging on the wall; and silkscreen paintings by Quaytman depicting the architectural details of the Orchard space itself, stored in an open shelving unit, which the visitors were invited to handle, prop on top of the shelf to view or hang on the wall. Another contribution by Quaytman was *Orchard Spreadsheet*, which outlined in financial terms the life of the organization just like that of any other commercial enterprise. The high dose of transparency and self-reflexivity here is indisputable; my interest, however, lies in whether there is movement beyond the mimetic model in which the artwork describes and/or replicates social formations and/or its own place within those formations—in other words, whether the artwork effectively calls into question, without presupposing, the very distribution of the parts, places, and functions, given in the neoliberal system. *Orchard Spreadsheet* is an interesting tentative recording of certain kinds of capital circulation. Its conceptual function is to map, among other things, the social and cultural capital the group generated during its existence. It is a document of Orchard's vision and exhibition program, presented in a graphic design format that self-consciously references 1960s conceptual art practices. Both the right-to-left reading orientation and the Circumcision font used for the word Orchard reference Hebrew. Furthermore, the amount of the loan to rent the space and its address allude to "the Jewish roots of Orchard's neighborhood," as noted by David Platzker.[35] Quaytman's gesture of appropriating these forms as a gallery director indicates her reflection on her own place within these power structures. In this way, the exhibition as a whole might have gestured at the questions of the archive in general, beyond the art world, and social responsibility by hinting at the gallery's emplacement, as a for-profit cultural enterprise, in a particular neighborhood on the cusp

35. David Platzker, "Orchard Spreadsheet," *Specific Object*, accessed July 26, 2016, http://www.specificobject.com/objects/info.cfm?object_id=13418

of gentrification, including participants with a certain set of socio-economic demographic attributes. This approach, however, is more descriptive than diagrammatic. Materially speaking, appropriative document-based artwork, notwithstanding the exposures it achieves, still runs the risk of becoming an intellectual fetish. This is, of course, not to assert that projects at Orchard were never diagrammatic. The previous exhibition, organized by Schneider, and titled *Image Coming Soon*, presented similar operations of loosening fixed forms of identification and perception, and overturned the distinction between solo and group shows, and between the roles of curator, artist, producer, art historian, and fabricator.[36]

<p style="text-align:center">*</p>

I will now expand on the characteristics of the diagrammatic approach with an eye to applying it to the field of contemporary art, following in the footsteps of Manuel DeLanda's account of the Deleuzian conception of the diagram. As a comprehensive yet compact entry point, I reproduce below in its entirety the abstract of DeLanda's article "Deleuze, Diagrams, and the Genesis of Form."[37]

In contrast to the visual approach displayed in the current revival of diagrams and diagrammatic thinking in various disciplines, the French philosopher Gilles Deleuze sees no intrinsic connection between diagrams and visual representation. Deleuze stresses the morphogenetic capability of matter to generate form on its own and argues that the role of virtual singularities and of the diagrammatic and problematic nature of reality can only be grasped during the process of morphogenesis; that is, before the final form is actualized. Deleuze focuses on far-from-equilibrium conditions since it is only in

36. See p. 161 in this book for a thorough description of several diagrammatic projects in which Schneider, one of the cofounders of Orchard, has been involved.

37. Manuel DeLanda, "Deleuze, Diagrams, and the Genesis of Form" *Amerikastudien/American Studies* 45, no. 1 (2000): 33–41.

these "phase spaces" (as he calls them in his 1994 book *Difference and Repetition*) that difference-driven morphogenesis comes into its own and that matter becomes an active material agent which does not need form to impose itself onto it from the outside. The process behind this formation is a double movement of sorting and consolidation. The essay maps this diagrammatic operation described by Deleuze onto the fields of society, geology and evolution.

Deleuze's theory of immanent morphogenesis is related to both philosophy of mathematics and thermodynamics, that is, the branch of physics that deals with material and energetic flows. Deleuze argues that the role of virtual singularities, and of the diagrammatic nature of reality, can only be grasped during the process of morphogenesis, that is, during the genesis of form, before the final form is actualized, and in this sense, before difference disappears. Here, it is important to remember Deleuze's distinctions between matter vs. substance, function vs. form, possibility vs. virtuality, and real vs. actual.

> An abstract machine in itself is not physical or corporeal, any more than it is semiotic; it is diagrammatic (it knows nothing of the distinctions between the artificial and the natural either). It operates by matter, not by substance; by function, not by form. ... The abstract machine is pure Matter-Function—a diagram independent of the forms and substances, expressions and contents it will distribute.[38]

As recounted by DeLanda, the ability of abstract machines to give rise to many different physical instantiations is a process of "divergent actualization," an idea that comes from Henri Bergson, who at the turn of the century criticized the inability of the science

38. Gilles Deleuze, *Difference and Repetition* (New York: Columbia University Press, 1994), 141.

of his time to think the new, the truly novel. The first obstacle was, according to Bergson, a mechanical and linear view of causality and the rigid determinism that it implied. As DeLanda explains: "Clearly, if all the future is already given in the past, if the future is merely that modality of time where previously determined possibilities become realized, then true innovation is impossible. To avoid this mistake, he thought, we must struggle to model the future as truly open-ended, and the past and the present as pregnant not only with possibilities which become real, but with virtualities which become actual."[39] Today, far-from-equilibrium thermodynamics meets the objections that both Bergson and Deleuze raised against its nineteenth-century counterpart. "In particular, the systems studied in this new discipline are continuously traversed by a strong flow of energy and matter, a flow which does not allow the differences in intensity to be cancelled, that is, it maintains these differences and keeps them from cancelling themselves."[40] The biological counterpart of this can be found in the genetic account of the developing embryo. The DNA that governs the process does not contain, as was once believed, a blueprint for the generation of the final form of the organism, an idea that implies an inert matter to which genes give form from the outside. "The modern understanding of the processes ... pictures genes as teasing out a form out of an active matter, that is, the function of genes and their products is now seen as merely constraining and channeling a variety of material processes, occurring in that far-from-equilibrium, diagrammatic zone, in which form emerges spontaneously."[41]

Parallel to the diagrammatic thinking that applies to physics, geology, biology, and sociology, we can think of contemporary art, the art world, or art as institution, as an ecosystem of interconnected and overlapping elements and assemblages (*agencements*)—artists, galleries, museums, critics, curators, assistants, magazines, journals, not-for-profit organizations, online aggregators and publications, art fairs, biennials, and social realms which include less formal entities

39. DeLanda, "Deleuze, Diagrams, and the Genesis of Form," 34–35.

40. Ibid., 37.

41. Ibid.

such as the tacit communities that form around specific artists and galleries, and capital's ability to incorporate them fully as institutions—the social media account of a collector/advisor can be as influential in incorporating elements into the discourse as certain modes of socialization with their own aesthetic codes such as dress, attitude, and lifestyle. Stylization is an institution unto itself; various types of downtown styles can be as legitimizing as, and in fact go hand in hand with, affiliations with certain galleries and not-for-profit spaces—in other words, the ideology of "cool." There are rigid and supple strata that govern the relations among these elements by means of social, economic, and aesthetic codification, articulated through their functional complementarities. Just as one of the main features of an ecosystem is the circulation of energy and matter in the form of food, facilitated by various symbiotic and predatory relations, one of the main features of art as institution is the circulation of artworks, money, data, and discourse through physical, technological, legal, and financial resources and their relations of dependence and interdependence. All of this, needless to say, leads to dominant nodes in the networks of these assemblages (*agencements*), to territorialization, stratification, hierarchization, and codification—in other words, a tendency toward equilibrium and general equivalence that cancels out differences of intensity.

Art perhaps should be thought of as a diagrammatic space of energetic possibilities, an immanent morphogenetic zone, that is, a space-time continuum in which an artwork, an exhibition, a conversation, or a publication can generate form utilizing its own capabilities, and can function as an abstract machine, influencing other abstract machines. It is useful to remember here, as DeLanda highlights, that both Deleuze and Guattari are realist philosophers (as opposed to idealist, humanist, or rationalist), and what we have inherited from them is a way of treating a wide range of natural, cosmological, and social entities, from persons to nation-states, as assemblages (*agencements*) constructed through specific historical processes—processes in which language plays an important but not a constitutive or exhaustive role.[42] It is not the human mind (or

42. For passages on assemblage theory, see Deleuze and Guattari, *A Thousand*

cultural conventions expressed linguistically) that imposes form on inert matter. Assemblage (*agencement*) is about objective processes of assembly. In the field of contemporary art, then, a practical ethico-aesthetics would entail the diagrammatic movement in real space and time of material and energetic systems and the human participants prompted by these systems.

It implies a morphogenetic space in which art is produced and disseminated that "holds heterogeneities together without their ceasing to be heterogeneous."[43] It envisions an art world that is a hybrid of stratified and diagrammatic structures, always having spaces for intense matter at its limit of destratification. How, then, to keep art as institution (or a specific art institution) far from equilibrium? Here it is useful to think of Deleuze and Guattari's more directly political writings in *A Thousand Plateaus*, in which they flesh out the idea of the machinic assemblage (*agencement*) in relation to the State, apparatuses of capture, and the war machine (*machine de guerre*).[44]

> We cannot, however, content ourselves with a dualism between the plane of consistency and its diagrams and abstract machines on the one hand, and the strata and their programs and concrete assemblages on the other. Abstract machines do not exist only on the plane of consistency, upon which they develop diagrams; they are already present, enveloped or 'encasted' in the strata in general. ... Thus there are two complementary movements, one by which abstract machines work the strata and are constantly setting things loose, another by which they are effectively stratified, effectively captured by the strata. On the one hand, strata could never organize themselves if they did not harness diagrammatic matters or functions, and formalize them. ... On the other hand, abstract

Plateaus, 71; 88–91; 323–37; 503–5. Also see DeLanda, *Intensive Science and Virtual Philosophy* (London: Continuum, 2002).

43. Deleuze and Guattari, *A Thousand Plateaus*, 329.

44. A thorough treatment of these ideas can be found in Valentin Schaepelynck's essay in this book, "From the Institution to the War Machine: Political Experimentation and Instituting Practices," p. 65.

machines would never be present, even on the strata, if they did not have the power or potentiality to extract and accelerate destratified particle-signs (the passage to the absolute).[45]

War machines (*machines de guerre*) are born from within the established and coded strata of the institution and take part in two simultaneous movements: on the one hand, they set the strata loose and bring about destratification, demonstrating not only new possibilities out of the past and the present, but also setting in motion virtualities that can be actualized. On the other hand, they are harnessed, formalized, and stratified by the apparatuses of capture embedded in the institution. This is why we don't have to, nor should we, seek an exit or an outside. The outside must necessarily generate itself from within the inside, turning the institution into a morphogenetic space, a diagrammatic zone, in which many forces are working in many directions, both adding to one another's intensities and going against and subtracting from one another's intensities, thereby keeping the space and its participants alive, their subjectivities in flux—always keeping the institution in an active state of institutionalization and deinstitutionalization, always far from equilibrium.

But, what could these war machines (*machines de guerre*), these forces of destratification and restratification, deterritorialization and reterritorialization, residing within and working through the institution, be? When Deleuze presents his "image of thought" in *Difference and Repetition*, he "proposes that thinking consists not in problem-solving (as most treatments of diagrams and diagrammatic reasoning suggest) but, on the contrary, that given the real (though virtual) existence of problems in the world itself, true thinking consists in *problem-posing*, that is, in framing the right problems rather than solving them. It is only through skillful problem-posing that we can begin to think diagrammatically."[46] From within the institution, problems must be posed. And it is precisely through their

45. Deleuze and Guattari, *A Thousand Plateaus*, 144.

46. DeLanda, "Deleuze, Diagrams, and the Genesis of Form," 40–41 (emphasis added).

morphogenetic capabilities that artists, art professionals, artworks and exhibitions can act as war machines (*machines de guerre*), unfixing prevailing signs and predefined forms, generating new semiotic, social, political, and economic virtualities, not only the possibilities already found in the past and the present. The aesthetic activism in question lies precisely in the production of virtualities that might become actual; this is the only way new subjectivities can be born. Actualization, or morphogenesis, occurs in things themselves through spatio-temporal dynamisms, which are ordinarily hidden by constituted qualities and extensities. The starting point is an artistic practice that puts into motion a reshuffling of the roles, functions, and procedures that have been taken for granted, a practice that carries out various operations that destabilize prevailing codes, mechanisms and dynamics.

Before exploring how such a practice could function micropolitically, carrying out the operations of destratification, deterritorialization, decoding, and dehierarchization, as a war machine (*machine de guerre*), generating form immanently from within the strata of the institution, it is useful to further situate the art world within the world at large in economic terms. This relation of the art world as an assemblage (*agencement*) (in turn consisting of several smaller assemblages) to the larger assemblage of globalized contemporary liberal democratic capitalism can be found precisely in its tendency toward equilibrium and the establishment of general equivalence through *speculation* and *credit*. To substantiate this relation, I turn to the account of the neoliberal condition advanced by Michel Feher.[47] It is my conviction that Feher's methodology can shed light on the real dynamics of the art world, which is a microcosm of the larger neoliberal order, and Feher's proposal of "investee activism" can provide invaluable pointers for the aesthetic activism I have set out to explore throughout this essay.

<div align="center">*</div>

47. Michel Feher, "The Age of Appreciation: Lectures on the Neoliberal Condition." Lectures delivered as part of Operative Thought: An Annual Lecture Series on the Political Practices of Ideas, Goldsmiths College, London, 2013–2015. Of particular interest in this context is "Lecture 8: Investee Activism."

In his Goldsmiths lectures, Feher outlines what he believes is an anthropological shift caused by processes of financialization that began with the rise of global financial markets in the 1970s. This condition is premised on a new logic of corporate culture, which has moved away from maximizing profit to perpetually raising the value of the company's stock. This is an economic shift: moving from an economy of exchange and profit to a financialized economy of speculation and credit. Such a transformation provides a model through which we can understand the transformation not only of institutions (companies and governments) but also of the subject. Whereas in Michel Foucault's analysis of the neoliberal condition, the individual was the rational subject of classical liberal economics, with the qualification that now she was competing for profit like any other enterprise, Feher demonstrates that financialization has produced a subject who has become a manager of her own portfolio, seeking investment. In other words, the subject is the "invested self" whose activities constitute her as a project that is worthy of investment from employers, sources of financial credit, and so on. Today, investors do not fit the profile of the classical business owner. Undoubtedly, they continue to extract profit in the form of dividends in the stock market or interest in the bond market. But their main goal is not the appropriation of the laborer's surplus value; rather, it is the power to "select the endeavors that deserve to receive resources."[48] Investors speculate and bring projects to fruition by allocating credit to those they deem worthwhile. Precisely for this reason, resistance to neoliberalism cannot be formulated through the classical relation between the employer and the worker. Instead, the investor addresses prospective investees, who they see as "projects" or potential "assets." Governments, corporations, loan seekers, non-governmental organizations, students, artists, museums, and so on, can be investees. It is precisely the relation between investors and investees that must be understood as the prime relation of neoliberal capitalism.

The concept of exchange between employers and employees was the prime relation that characterized classical liberalism; therefore, resistance in this model necessitated the mastery and disruption,

48. Ibid.

by the working class, of the very model of exchange (by collective bargaining through unionization and strikes, for example, as useful tactics for negotiating the improvement of their wages and their conditions of production). In a similar way, Feher argues, in the neoliberal era an investee movement must appropriate the condition of credit seeking itself in order to change the conditions under which credit is allocated on the capital market. It follows that any new movement must be proficient in appropriating the means of investing and the workings of speculation. It is thus a question of whether it is possible for investees to make alternative speculations that can divert or overthrow the speculations of investors. At present, the effective practice of this strategy is still in its embryonic stages, and it very much depends on experimentation and refinement—which is characteristically the nature of non-governmental politics and micropolitics. This new movement must be predicated on a new class formed out of the relationship between investors, that is, the shareholders or potential shareholders of the institution, and investees, that is, stakeholders or those implicated in the functioning of the institution without owning any part of it (employees, governments, taxpayers, and even the environment). For Feher, the possibility of resistance hinges on the question of whether stakeholders can be united as a collectivity in order to make alternative speculations, imagining alternatives to prevailing systems. "The problem is not credit per se," Feher reminds us, "but who gets it and for what. In other words, instead of lamenting the hegemony of predatory speculators, opposing real neoliberal agencies should be about challenging them on their own turf. Against the self-depreciating effects of left melancholy, 'another speculation is possible' could be a valuable rallying cry."[49]

Art professionals, including artists, have not evaded the accelerated financialization of the subject by the sweeping anthropological shift of the 1970s, and have become invested selves or investees, perpetually seeking investments in their projects. The assemblage (*agencement*) of shareholders and stakeholders spans the nodes of the network discussed above: galleries, assistants, museums, trustees,

49. Feher, "Disposing of the Discredited: A European Project." Lecture, Neoliberalism + Biopolitics Conference, University of California, Berkeley, February 27, 2015.

collectors, curators, critics, the public, publishers, foundations, the Internet, government, public officials, tax authorities, legal consultants, corporate sponsors, art fairs, biennials, and so on. Styles, lifestyles, and the cult of persona have also become instruments of investment. This mode of institutionalization of subjectivity—the use of the self and the body to enhance one's creditworthiness—is in fact a biopolitical problem. The higher the number of individuals participating in a particular chain of symbolic and financial value production associated with particular modes of authorship, the higher the value of authorial share in that endeavor. The rewards within this collective enterprise, distributed heavily among upper-level shareholders, trickle down to the stakeholders approaching zero. In this molar mode of production, affect—that is, the encounter of intensities and becomings, affecting and becoming affected by another—is limited to predetermined functions that increase the value of stock. According to Schneider, "given the heterogeneous movement that art/thought always generates, artistic production should never be limited only to the re/distribution of the symbolic/capital."[50] Affect has the potential to undo, or to break with, typical ways of thinking and feeling, creating the space for active production of subjectivities and/or extracting new subjectivities out of the strata. What is at stake in this new way of thinking is the possibility of different modes of collective hacking into the existing infrastructure of speculation and credit, which could disrupt the prevailing notions of creditworthiness in the art world.

In Schneider's exhibition, SD (@DL/NY, 2016), the roles of the shareholders and the stakeholders are sometimes shuffled, in a way that expands credit to studio assistants, fabricators, artistic collaborators, gallery workers, gallery visitors, certain activist organizations, and so on. Some of the proceeds from the sale of each artwork will be distributed over time to those who have played various roles in the conception and materialization of the works and the exhibition, channeling resources in the interest of furthering the practice of diagrammatics. The operation of exchange is not merely the exchange of a predetermined amount of monetary currency for an artwork,

50. Schneider, "Situational Diagram," p. 233.

which would amount to a mimetic, as opposed to a diagrammatic, practice. Value in a Situational Diagram is determined in an immanent process of collective enunciation. In this sense, the exhibition is an exercise in meta-modeling, which Schneider describes in her essay in this volume as "a process of auto-modeling that appropriates all or parts of existing models in order to construct its own cartographies, its own reference points, and thus its own analytic approach, its own analytic methodology."[51]

Each artwork in SD (@DL/NY, 2016) embodies the virtuality of an operation waiting to become actualized by its participants. It is an exercise in the usage of morpho-syntaxes including but not limited to the following abstract machines that give rise to many different physical instantiations: Amalgamation, Cancellation, Dependable, Extraction, Index, Monochroming, Naming, Obstruction(al), Situation, Split, and Void.[52] Each of the objects and the constellations of objects in the exhibition are equipped with morphogenetic capabilities that enable them to lead to divergent actualizations. Built into the matter of the work are energy flows that diagrammatize affect in space and time, both geographically and historically, through the prompting of a multitude of actions and associations with the various typologies in which the object participates, along with the relevant codes of exchange and circulation. Among these typologies are blackness and the monochrome—as manifested predominantly in the paintings of Ad Reinhardt, Mark Rothko, and Barnett Newman. These two typologies are elements in the abstract machines of Cancellation, Index, Obstruction(al), Naming, Split, and Void, which here come into physical existence as paintings by Schneider. Another such typology is the nude female figure in

51. Schneider, "Situational Diagram," p. 233.

52. See the complete Glossary of SD (@DL/NY, 2016) in this book for an explanation of each of these categories, p. 197. Each one is a broad conceptual category that describes a specific mode of operation. Every time, for instance, Amalgamation is physically realized, it is the amalgamation of different forms embodied in different materialities. Naming in SD (@DL/NY, 2016), for example, is materialized as paintings that amalgamate the two parallel strands in Ad Reinhardt's practice: black monochromes and comics. The fact that Situational Diagram trades in the amalgamation of specific tropes within the artistic styles of Tarsila do Amaral and Ad Reinhardt is incidental, rather than essential, to the category of Amalgamation. This applies to all the other categories.

Western modernism and its colonial counterparts, as embodied in the Cancellation painting and the Extraction sculptures. Neo-Concrete art prized the activation of the object; SD (@DL/NY, 2016) pays homage to Neo-Concretist thinking with its soft rubber sculptures and paper-thin steel sculptures whose *forms* have been *extracted* from the *images* of famous female nudes in art history, such as Henri Matisse's *Nu Bleu* cutouts (1952) and Tarsila do Amaral's *Abaporu* (1928),[53] engaging with the question of how an object that is activated goes on to activate the social.

The black paintings in Schneider's exhibition appear to have been painted in ways that appropriate the painting techniques of the aforementioned historical figures. They do, in fact, do so in a way, but with an almost imperceptible yet materially crucial difference: in addition to the use of the Mars Black pigment with oil extraction, like Reinhardt, they incorporate coal and petroleum variously added to the mixture. Void has the exact same size and stretcher-bar depth as the single panel installed on the south wall at the rear entrance of the Rothko Chapel (180 × 105 × 4 inches); it features the same pictorial organization as the Rothko painting, but it is painted with coal and petroleum compounds. Instead of hanging on the wall, it is placed face up on the gallery floor. Splits are painted after Barnett Newman's *Onement I* (1948) and the *8th Station* in *The Stations of the Cross: Lema Sabachtani* (1958–66). In the Split meta-modeled after *Onement I*, Newman's first zip painting, the size of each panel corresponds to the size of the space around the single zip. In the Split meta-modeled after the *8th Station*, the size of each panel corresponds directly to the size of the two zips. This sense of physical fragmentation finds its counterpart in the contractual agreements

53. Tarsila's painting *Abaporu*, "the man that eats people," in Tupi-Guarani, features an androgynous figure (without the female markers) with a tiny head and a disproportionately large body, the sun, and a cactus. It inspired Oswald de Andrade to write the Anthropophagic Manifesto and to subsequently lead the Anthropophagic Movement, intended to "swallow" European culture and turn it into something uniquely Brazilian. The metaphor of cultural cannibalism was the model used by de Andrade to react against European colonization and the nation's cultural and economic dependence on Europe. The style of *Abaporu* can be traced back to the French modernists, especially Fernand Léger, who taught Tarsila in Paris in 1924. This painting is considered to represent Tarsila spewing out her European education. See Glossary entry "E for Extraction," p. 209.

for the sale of a Split: the same buyer cannot acquire both panels of a Split. This echoes the fact that Newman never repeated the same zip or painted two zips in the same way. The idea of physical variation here is important in relation to the Deleuzian understanding of art as nonexistent without physical matter and its divergent actualizations, in other words, the inseparability of concept, percept, and affect; and that of theory and practice—the primary tenets of diagrammatics.

Despite formal resemblances, the paintings of Rothko, Newman, and Reinhardt are not simply replicated or appropriated; Schneider's paintings are charged with future-oriented energetic virtualities. There is an activation of both physical and cognitive movement, as the participant will most likely slow down in their navigation of the space and their encounter with the objects. This encounter is likely to lead to a set of conceptual and historical associations with the black monochrome, a canonical aesthetic device of negation, existentialism, and humanism in the aftermath of the Second World War, in the context of the political and economic climate of Cold War America, and continuing to our present day. The encounter could also make the participant reflect on the various factors that have led to the tremendous appreciation of the financial (and aesthetic, as consensus) value of these artists' works over the past half century, which had not necessarily been the case in their lifetimes. In a 1966 interview, Reinhardt reflected on the reception of his black paintings: "When the Museum of Modern Art had its last fifteen or sixteen *Americans* show in 1963 they had to rope off my room, and the public got angry only with that room. They accepted everything in the rest of the show—the Pop art, the plaster hamburgers and everything else."[54] Newman's first solo show in 1950 was received badly by the critics, if at all; one of the works in the show was even vandalized. Nor was he ever to receive much critical success during his life. The son of socialist parents, Reinhardt was committed to social justice, and he joined the leftist tabloid *PM* in 1942. He despised the commercialism and sensationalism of the art world; he asserted that it was wrong for artists to

54. Ad Reinhardt, *Art As Art: The Selected Writings of Ad Reinhardt*, ed. Barbara Rose (Berkeley: University of California Press, 1991), 15.

claim that their work could educate the public ethically or politically, or that their work should decorate public buildings. Newman and Rothko, though independently, shared these views; they were both self-professed anarchists. Reinhardt was against the proliferation of images in visual culture; regarding his black square paintings, he claimed that he was "merely making the last painting which anyone can make,"[55] and described it as "a free, unmanipulated and unmanipulatable, useless, unmarketable, irreducible, unphotographable, unreproducible, inexplicable icon. A non-entertainment, not for art commerce or mass-art publics, non-expressionist, not for oneself."[56] Reinhardt died in 1967; Newman and Rothko both died shortly after, in 1970. In the nearly half a century since then, much has changed. There is still a rope in front of Reinhardt's black monochromes in museums—not because they are inexplicable but because of their no longer contested but universally recognized aesthetic value, their insurmountable conservation issues due to the unique oil extraction method he used to arrive at the specificity of his surfaces, and also, of course, due to their internationally institutionalized and financialized value.

The associations with Reinhardt's thinking and practice prompted by Schneider's paintings are important for many reasons. As an artist and thinker, Reinhardt continues to be a pivotal figure for us today, encouraging us to keep thinking about Art with a capital A. His painting practice, his writings, and his intricately drawn, erudite yet never didactic, witty and provocative, and hilariously funny comics on the nature and history of art and the workings of the art world, are all part of one and the same philosophical and artistic program. In their prescience and radicalism, they are more relevant today than ever.[57] Schneider's Naming paintings, which engage in an operation of Amalgamation, bring together these two seemingly disparate yet intricately related visual strands of Reinhardt's practice—the black paintings and the comics—into the materiality of one and the same

55. Ibid., 13.

56. Ibid., 83.

57. See *Ad Reinhardt: How to Look: Art Comics* (Berlin: Hatje Cantz and David Zwirner, 2013); and pages 60 and 215 in this book.

object.[58] A group of Schneider's paintings situated under the operational heading of Obstruction(al) are black monochrome squares that are half the size of Reinhardt's iconic black square paintings. They do not feature a trisected pictorial structure (the cross form that subtly emerges in Reinhardt's paintings); instead, they each have a central square painted in one tone of black within the larger square painted in a different tone of black. The trisected structure of Reinhardt's black paintings, however, lends the architectural form to the black steel structure in the gallery space, from which these sixteen paintings protrude into the space in different directions, each implying a relationship to one of the nine squares delineated on the gallery floor. Obstruction is defined as a thing or action that impedes or prevents passage or progress; an obstacle or blockage. In this case, it is conceived as an act of deterritorialization; and as such, it could take the form of a disruptive occupation, but it does not have to. It could materialize itself in subtle forms of affirmation of negation, carried out through collective activity over time with an uncertain set of results. It moves diagrammatically, activating its participants in different ways, at different points in time, and to varying degrees. It also implies an entity—a host, an institution, a space, an artwork, a process, in this case, spectatorship of an image and the process of ownership of that image—that is being obstructed in its course. Reinhardt strove to obstruct the proliferation of images. By making the last painting that anyone could possibly make, he strove to negate Pop and its inextricable relationship to the invasive and exploitative strategies of mass media, marketing, and advertisement. Schneider's black paintings can be understood as pushing this vein of negation to another level. The only image they allow is the black square within another black square; and the very mechanism of their acquisition negates the image by building into the materiality of the work the futurity of obstruction. As a norm, the moment one buys something, or invests in something, one assumes (1) its existence and (2) its longevity. In this case, the act of buying itself leads to the obstruction of ownership of this particular image-object. Time (as in the amount of time until this painting will stop existing as it is) is impregnated

58. See the entries "A for Amalgamation," p. 202 and "N for Naming," p. 214.

into the materiality of the work. The anthropological link between private ownership and authorship/signature style is problematized through the sale of an image-object over which the buyer cannot retain ultimate and indefinite control.

Instead of using a traditional method of exchange, these paintings engage in alternative modes of speculation and credit within the matrix of shareholders and stakeholders in virtue of the divergent value of artworks (images, in a way, analogous to a certain number of shares of stock). The price of any one of these paintings is listed in a price list of sixteen different paintings (analogous to a list of several different stock portfolios), each price reflecting an amalgamation of the market indexes of Schneider's work and that of another artist, who is thereby given the right to *obstruct* by painting over or otherwise negating the image—that is, Schneider's painting. The initials of the artist will be incorporated into the title equation for the painting, but the identity of the artist will be withheld until after the transaction has been finalized. The buyer will make a decision solely on the basis of the listed prices that incorporate the respective cultural capital of each one of the sixteen artists, in addition to that of Schneider. In this way, the investor commits to wagering on a bet that has already been partially carried out on undisclosed grounds by the investees. The obstruction will occur at an agreed-upon date, and must happen within two years of the sale. If the owner would like to delay the obstruction, they are permitted to pay a nominal amount of "rent" in order to do so. All pragmatic aspects are to be detailed in a contract-certificate hybrid to accompany each sold Obstruction(al).

Alternative speculation also occurs by virtue of the sheer materiality of Schneider's paintings. Against habitual and normative methods of valuation (such as a public market index, auction results, private sales records, and so on), the values (prices per share) of Schneider's Obstruction(al) and Cancellation paintings are to be calculated using algorithms that are a function of the per-unit values of the four tones of black—blue, red, yellow, and green (the Google colors). Paint in each of these tones has been applied in varying degrees to each canvas, while the per-unit value of each of the four tones (analogous to one share) is embodied in each of the Index paintings. The Cancellation painting, for example, includes each of the four tones

of black applied to different areas of the form, which has been extracted from the image of *Abaporu* in Tarsila's painting.[59] Accordingly, while each Obstruction(al) painting has its own base value equal to the total of the values of the shares it embodies, its listed price is either higher or lower than that value because it also encapsulates speculation as to how the amalgamation of the values of the work of two artist-investees of distinct levels of creditworthiness could behave in the future.

A similar method of valuation is at work in a Dependable, which physically consists of a PhotoTex adhesive print of the image of an existing artwork by another artist and a black monochrome by Schneider. The Dependable in this Situational Diagram features the photographic image of a painting by Christopher Wool taken at the artist's Guggenheim survey in 2013–2014. This print and the black monochrome are of the same size and they hang on the wall side by side, yet they exist in different temporalities. A Dependable does not compress time in one single object. On account of this futurity, it has no free market. Its value is always attached to the vagaries of that of its counterpart. The value of this particular Dependable must incorporate a fluctuating price index of the work of Wool.

"I see form and speed in everything," Schneider once said to me. What is at stake in Situational Diagram is the proposal of counter-technologies that decode and recode existing technologies. Diagrammatized as a performative de/restratification of institutional apparatuses, the operations at work in SD (@DL/NY, 2016) seek to produce new feedback loops, variously slowing down and accelerating processes along the way, short-circuiting the given channels in the system to divert flows into new and different circuits. SD (@ DL/NY, 2016) proposes to hack into the logic of the institution to produce unanticipated results, not sanctioned by and not easily assimilable into the existing knowledge of the institution. Diagrammatic thinking can use any entry point into a given system and incorporate its laws into its practice. A project of extreme and deliberate invisibility and economic failure like CAGE[60] can be continued with

59. See the diagram for Cancellation (p. 204) marking the four tones of black, which have been applied to the different areas of the form extracted from the image of Tarsila's *Abaporu* (1928).

60. I mean "economic failure" here in the sense of failure as categorized by the police

SD (@DL/NY, 2016), a project that takes place at an institution of extreme visibility and a model of guaranteed profit. The diagrammatic approach can produce critical meaning in any given point of a network without falling into contradiction or guilt—because these notions make sense only in the police logic of the proper, which is radically negated by the very existence of *les sans-parts* (the unaccounted for), the yet-to-come, in the orders of the visible, sayable, and comprehensible. By incorporating futurity into its present, the diagrammatic approach eschews the self-defeating parables of the type of institutional critique in which the critique fails to supersede the institution and continues to depend on it to dialectically and economically exist. It also avoids the pitfalls of relational aesthetics, in which relations other than already-known ones rarely take place, and the aesthetics always sell. Situational Diagram does not seek to make a statement or to drive home a conclusion; it is a testing ground for the form-generating capabilities of matter through molecular movements within molar contexts. With the understanding that the outside must necessarily generate itself from within the inside through problem-posing, Situational Diagram aims to see if we can problematize the possibility of a workable ethico-aesthetics through the application, to contemporary art, of the methodology of a realist ontology of institutions and practices, if we can reevaluate our own places and functions within this multitude of assemblages (*agencements*). It aims to see if we can foster, in Guattari's words, "an ethics and politics of the virtual that decorporealizes and deterritorializes contingency, linear causality and the pressure of circumstances and significations which besiege us."[61] It is an exercise in aesthetic activism on neoliberal turf, to see if we can keep phase spaces beyond the public-private dichotomy and their participants alive, their subjectivities in flux—keeping institutions in active states of simultaneous institutionalization and deinstitutionalization, always far from equilibrium.

logic of the proper in the economic sense; in other words: that which does not generate enough revenue to cover its operational costs (rent, insurance, labor, and so on), let alone to earn profit. In 2010, Schneider cofounded CAGE, a space/program for dialogue, support, and production that involves changing membership in ongoing response to material conditions.

61. Guattari, *Chaosmosis*, 29.

From the Institution to the War Machine: Political Experimentation and Instituting Practices

Valentin Schaepelynck

Reflecting on the singular relationship between the text and its reader, as well as that between the text and ordinary everyday practices, Gilles Deleuze uses the analogy of the relationship between the surfer and the wave. He says surfers "never stop stealing into the folds of the wave," and that "for them, the wave is a group of mobile *folds*."[1] This can be read as a description of becoming free of the binarisms in which critical thought has sometimes enclosed itself. In the name of Marxism, it was sometimes considered possible to judge the meaning, the truth, and the intensity of an idea from the perspective of an evolving *praxis*. Deleuze and Félix Guattari, for their part, clearly formulate the necessity to leave any dichotomy between theory and practice far behind: "A book exists only through the outside and on the outside"; it is a "small machine," of which we must ask above all what its "relation" is "to a war machine (*machine de guerre*), love machine, revolutionary machine."[2] The question is the way writing travels, the way it comes to enter into relationships with other flows: desiring, political, sensible, aesthetic, since "writing has nothing to do with signifying," but rather with "surveying, mapping,

1. Gilles Deleuze, in Michel Pamart, Pierre-André Boutang, *L'Abécédaire de Gilles Deleuze*, "C comme culture," Arte, 1988.

2. Gilles Deleuze and Félix Guattari, *A Thousand Plateaus*, trans. Brian Massumi (Minneapolis: University of Minnesota Press, 1987), 4–5.

even realms that are yet to come"[3]—a multitude of expressions that refer to gestures that the hand is just as capable of as the mind.

That concepts are first and foremost inventions of thought does not mean that they are simply the products of an intellectual act, or that they function as totalities enclosed onto themselves. On the contrary, in all their complexity, concepts express a movement that brings with it the ideas and practices that meet in a singular assemblage (*agencement*).[4] Suely Rolnik reminds us how, from the perspective of Deleuze and Guattari, the concept takes on "a meaning defined as a function of the field of experimentation with which it is articulated" and that it is precisely on this basis that "one concept or another is convoked, invented, or reinvented."[5] From a political point of view, our collective experiences don't simply stand to be reflected, communicated, or mediated, if only because they never cease to configure and reconfigure the territory of the thinkable.

The concept of the war machine (*machine de guerre*), developed by Deleuze and Guattari in *A Thousand Plateaus*, proves to be a productive hypothesis for a political anthropology and a genealogy of the relations between war and the State. But it also broaches questions, difficulties, and stakes of political experimentation. A social formation performs as a war machine (*machine de guerre*) when it becomes irreducible, heterogeneous in relation to the State conceived

3. Ibid.

4. Ibid., 3–4. "In a book, as in all things, there are lines of articulation or segmentarity, strata and territories; but also lines of flight (*lignes de fuite*), movements of deterritorialization and destratification. Comparative rates of flow on these lines produce phenomena of relative slowness and viscosity, or, on the contrary, of acceleration and rupture. All this, lines and measurable speeds, constitutes an assemblage (*agencement*). A book is an assemblage (*agencement*) of this kind, and as such is unattributable. It is a multiplicity—but we don't know yet what the multiple entails when it is no longer attributed, that is, after it has been elevated to the status of a substantive. One side of a machinic assemblage (*agencement*) faces the strata, which doubtless make it a kind of organism, or signifying totality, or determination attributable to a subject; it also has a side facing a *body without organs*, which is continually dismantling the organism, causing asignifying particles or pure intensities to pass or circulate, and attributing to itself subjects that it leaves with nothing more than a name as the trace of an intensity. ... Literature is an assemblage (*agencement*). It has nothing to do with ideology. There is no ideology and never has been."

5. Félix Guattari and Suely Rolnik, *Molecular Revolution in Brazil*, trans. Karel Clapshow and Brian Holmes (New York: Semiotext(e), 2008), 224.

as an "apparatus of capture," encompassing the processes of administration, hierarchization, division of labor, and seizure of income. A revolutionary group, a guerrilla corps, a Mafia gang, a religious organization, a transnational company, and even a technological invention can perform as a war machine (*machine de guerre*), without any necessary intersection or convergence among their political perspectives. Deleuze and Guattari insist on the point that the war machine (*machine de guerre*) designates war as its object, in other words, it wages war, only contingently—only when the State appropriates the war machine (*machine de guerre*) for its own purposes: mercenaries recruited for its secret wars, multinational corporations that establish the colonial domination of the State over new territories, social or artistic practices that are ultimately administered and promoted by propaganda, or revolutionary dynamics that end up being integrated into the normality established by a governmental regime. War machines (*machines de guerre*) and apparatuses of capture refer back not only to social objects but also to processes of autonomization or capture by the State and its operations. Such processes interact with each other and span the whole social field. One of the main illustrations of this kind of interaction and the tensions it breeds is the way entities such as empires and the State try to capture and subordinate mercenaries—stateless and in certain respects autonomous agents—for their purposes. Thus, Deleuze and Guattari show how institutions like the cleruchy, a politically dependent colony of Athens in classical Greece, or "Hatru" in Babylonia, for example, positioned mercenaries on a State territory by giving them a piece of land in exchange for their military allegiance and service.[6] It also means that originally stateless forces like mercenaries retain the capacity to fight back and threaten the State, as several examples of "coups d'état" in modern and recent history demonstrate. In the Deleuzian-Guattarian perspective, the liberating or oppressive nature of autonomization versus capture is never ensured or prescribed *a priori*, for these forces themselves are engaged in power relations that continually displace their meanings and effects. A leftist guerilla against an authoritarian

6. Guillaume Sibertin-Blanc, *Politique et État chez Deleuze et Guattari* (Paris: PUF, 2013).

State can also generate its own state and oppressive structures, mimicking its own enemy. The urban guerillas led by Carlos Marighela in Brazil at the end of the '60s is a case in point, reproducing a kind of microstate organization.

Here again, any binarism is immediately refuted. In *A Thousand Plateaus*, supple segmentarities—referring to what anthropologists call segments such as clans, tribes, and so on—are not the privilege of stateless (*non étatisées*) societies. First, one must not forget that those societies also have "nuclei of rigidity or arborification that as much anticipate the State as ward it off." Conversely, the rigid segmentarities—administration, hierarchized stratification and division, scientific organization of labor—of statified (*étatisées*) societies would have no hold or effect if they did not also surround themselves in supple material.[7] Every society, but also every individual, is continually traversed by these two segmentarities: one molar, the other molecular.

Bureaucracy can never be reduced to the rigidity and the clean separation of its organizational strata. There is a "suppleness," a perverse creativity that subverts administration itself, as well as its regulations, in order to allow the bureaucratic machine to spread and to disseminate, to challenge its own limits. For these reasons, according to Deleuze and Guattari, the theses of the anthropologist Pierre Clastres[8] must be relativized, in part against themselves, in order to be amplified. Clastres's work focuses on the idea of "society against the State," conceived as social formations that ward off the appearance of the State. The Clastrian theses certainly allow us to reject the evolutionist hypothesis that would decipher, within the State, the symptoms of the emergence and development of the forces of production: The State's designation of the political as a division between the governing and the governed emerges all of a sudden. But this anthropological thesis fantasizes a hardly credible autarky that presumably characterizes societies against the State. This proposition is contradicted by archeology, which, on the contrary, tends to demonstrate that these societies have always been connected through

7. *A Thousand Plateaus*, 213.

8. Pierre Clastres, *La société contre l'État* (Paris: Éditions de Minuit, 1974).

complex relations of exchange and interaction with the State. With Clastres and against him, Deleuze and Guattari assert that to ward off the State is always, in one way or another, to anticipate it, that it is only warded off to the extent that it is already virtually there, that it acts even in its absence. The understanding of statification (*étatisation*), autonomization, and their interactions directly affects the political practices and forms of subjectivity that they put into place. If the concept of the war machine (*machine de guerre*) allows us to theoretically rethink the genesis of the relations between war and the State, it also refers to an entire series of gestures, concrete operations, *dispositifs*, and practices.

In "Three Group-Related Problems," the preface to *Psychoanalysis and Transversality*,[9] a collection of political and clinical texts written by Guattari between the end of the 1950s and the beginning of the 1970s, Deleuze articulates two distinguishing modes of the concept of the war machine (*machine de guerre*). First, that of a revolutionary organization that makes itself irreducible to the State and to its anticipation in the form of the Party, in other words, a revolutionary organization in which political battles would come to intersect in a transversal way without cancelling out their desiring singularities. Second, that of institutions that distinguish themselves as spaces of creativity, of liberation, and not of repression, such as the La Borde psychiatric clinic. Founded in the early 1950s by the psychiatrist Jean Oury, Guattari, and several other doctors and patients, La Borde was established as a space of hospitality for psychosis, where psychological alienation and social alienation could be thought about—and welcomed—together, through an alliance of Lacanian psychoanalysis and Marxism, maintaining the singularity of each of these discourses and issues.[10] This experiment was foundational in France for the movement of "institutional psychotherapy," which manifested itself as a singular school of thought and practice. For Deleuze, this movement had the advantage of allowing for a rethinking of the institution by rigorously differentiating it at once

9. Félix Guattari, *Psychoanalysis and Transversality: Text and Interviews 1955–1971*, trans. Ames Hodges (New York: Semiotext(e), 2015).

10. In French, the word *aliénation* has two meanings: alienation in the Marxist sense and insanity.

from the liberal contract (he evokes the two-person psychoanalytic contract on which the cure is based) and from juridical authority that would repress or justify the segregation and imprisonment of those deemed mad.

In French, the notion of "institution," although broad and vague, most often refers to stabilized and recognized social formations that are legitimated by society. But we can also conceive it as an active occurrence—that of the action of institut*ing*, of creating new configurations of socialization and subjectification. The movement of institutional psychotherapy certainly explores the diverse possibilities offered by this ambiguity. François Tosquelles and Oury insist on the necessity of radically distinguishing between the establishment and the institution. For them, the establishment refers to a contract, to an economic, juridical, and architectural reality, hence "this" school or "this" hospital, which we enter, where we take account of the functions, roles, and positions assigned by the administration, such as teachers, students, doctors, nurses, patients. In this model, the institution refers to the series of strategies that enable a group or collective to refrain from allowing its unconscious and political investments to fall back into only bureaucratic divisions and meanings. This distinction is not simply deduced from these notions themselves, but must be implemented by the act of instituting practices. The encounter, the Deleuzian-Guattarian assemblage (*agencement*) finds one of its points of articulation around this approach, among others, around this surveying, this original mapping of institutions.

According to Guattari, there was a certain reductionism in the critique that came out of May '68 and the 1970s, which envisioned institutions simply as pathogenic structures against and from which it was necessary to liberate the creative spontaneity of groups and individuals.[11] Deinstitutionalization meant, among other things, liberation from the fatal hold of capitalist institutions with regard to most everyday forms of life. Neither Guattari nor Deleuze denies that we are continually confronted with molar spaces, with rigid segmentarities, with striated spaces, with functions of the State. But such experimental movements around psychosis as La Borde, as well

11. See *Molecular Revolution in Brazil*.

as many others in the fields of addiction, social work, and education, invite us to consider "processes of institutionalization" that do not function as a "monody" but as a "polyphony," open to the singular and the unforeseen.¹² Those who address or are addressed by specialized institutions—for all kinds of reasons, be they psychotics, addicts, or delinquents—are the bearers of intense social and political problematics. Those who work in these spaces can, of course, conceive their profession in the manner of bureaucratic management, by applying the formulas dictated by the administration or the different versions of the *DSM* (*Diagnostic and Statistical Manual of Mental Disorders*), and settle for concentrating on the social and behavioral *rehabilitation* of individuals. But Guattari insists that this "police" approach of "social control" is in no way the "fate of their profession": "From the point of view of micropolitics, any praxis may or may not be of a repressive nature; no scientific body, and no body of technical reference can guarantee a correct orientation. ... The guarantee of a processual micropolitics can only—and should only—be found at each step, on the basis of the assemblages (*agencements*) that constitute it, and through the invention of modes of reference and modes of praxis."¹³ In this way, "institutionalization" does not necessarily signify the normalization of the war machine (*machine de guerre*). As a process, it can refer to a positive creative force, to empowerment and the affirmation of freedom.

Teachers, psychologists, social workers, but also artists who intervene politically in society are therefore well disposed to attempt an institutionalization that leads no more to normalization than to repression, for their professions take subjectivity—theirs and that of others—as raw material. In certain conditions that have to do with a certain praxis, situated and singular, institutions can be sanctuaries, places of asylum and hospitality, open to the most treacherous reorganizations, the unpredictability of situations and encounters, to the singularity of those who arrive.

In this sense, it is not a matter of subordinating theory and practice to one another, but of reassembling (*réagencer*) the

12. Ibid., 376.
13. Ibid., 41–42.

71

production of concepts and of institutional *dispositifs*. Describing Guattari's volume *Psychoanalysis and Transversality*, Deleuze asserts that the book must above all else appear to us as "a montage or installation of the cogs and wheels of a machine."[14] It must therefore be thought of as the concrete, desiring, subjective motor of a micropolitics. And it is precisely in this regard that the effective transformation of institutions requires war machines (*machines de guerre*), processes that manage to render heterogeneous the bureaucratic and normalizing tendencies at work. Guattari sees in La Borde, among other experiments, a space in which this operational preoccupation is permanently at the heart of daily collective practice. Yet, is it a matter of simply warding off the emergence of processes of statification (*étatisation*) or subjugation within collectives? Deleuze, speaking of Guattari's text as a machine of desire, reminds us that "a machine of desire [is], in other words, a war machine (*machine de guerre*), an analysis machine."[15] It is therefore not simply a question of the avoidance of subjugation. Beginning in the 1960s, Guattari distinguished between "group-subjects," which achieve self-regulation, and "subjugated groups," which receive their laws from the outside. By this distinction, he does not intend to establish a sociological topology, but to situate his account as closely as possible to the transformations of subjectivity that constitute the life of the institution. The group-subject is not merely an active pole in opposition to a passive pole. It is an analytic process, in the psychoanalytic sense, a way of exploring and implementing a practice of transversality. It means navigating through a new diagram of positions, roles, and functions—doctors, nurses, patients, political militants, etc.—and resisting hierarchical and oppressive verticality as well as any principle of horizontality that does not allow for encounters *of any kind*. The State can always be resurrected, even in paradigms of self-management, even in the modes of management that seem most democratic and horizontal. This is one of the lessons of the critical return to Clastres's anthropology: One can never be sure of being finished with the State, with subjugation, with the institution of new forms of knowledge and

14. Deleuze, "Three Group-Related Problems," in *Psychoanalysis and Transversality*, 21.

15. *Ibid.*, trans. mod.

power. All apparatuses of capture are ever ready to be reborn notwithstanding the impression of having been left behind.

The war machine (*machine de guerre*) is not a method or a simple anthropological reality, a type of social structure or group that would oppose itself to statified (*étatisées*) societies; it is not the perfect political method of an anarchist organization. It has no organizational chart or fixed social composition. The operative transition from anthropology to political practice is necessarily experienced in forms of radical experimentation, which implicate subjectivity and its collective assemblages (*agencements*). "Never interpret, experiment!" Deleuze and Guattari advise us. There is an irreducible dimension of political practice that will never be deduced from any knowledge, be it sociological, anthropological, historical, or even psychoanalytic. This is why we must experiment and experiment again, tirelessly, as the inexorable and irreducible exigency of a world in which we must urgently relearn to believe.[16]

16. Gilles Deleuze, *Pourparlers* (Paris: Éditions de Minuit, 1990).

On Rendering the D/recomposition of Context and the D/recomposition of Form in [Global] Contemporary Art

Jaleh Mansoor

> The smooth switching of surpluses of capital and labor from one region to another creates a pattern of compensating oscillations within the whole...[1]
>
> —David Harvey

> Line can no more escape the present tense of its entry into the world than it can escape into oil paint's secret hiding place of erasure and concealment. This fundamental condition can bring it, therefore, much closer to the viewer's own situation than can the image. Drawing … always exists in parallel to that other permanently present time—that of viewing.[2]
>
> —Norman Bryson

What does "context" mean for Art History, a discipline founded in the nationalisms of the nineteenth century, wherein place, time, and style have triangulated to form a coherent heuristic frame at different historical moments: after 1945, after 1973, and again now? And how do we find the terms to describe prevailing tendencies in contemporary art among the numerous, scattered, and apparently unrelated trends

1. David Harvey, *The Limits to Capital* (London: Verso, 2006), 428.
2. Norman Bryson, "A Walk for a Walk's Sake," *The Stage of Drawing: Gesture and Act Selected from the Tate Collection* (London and New York: Tate and the Drawing Center, 2003), 149–58.

encountered at art fairs and biennials, and in established museums and institutions of the bourgeois public sphere, as Jürgen Habermas once called them, although what *bourgeois* means under global capitalism is shifting as rapidly as the term *context*? These two questions appear unrelated until a pattern begins to emerge suggesting the dependence of one question on the other. The diagram is one (aesthetic) operation within which the questions converge, or are shown to be already entwined. Already operative in the historical avant-gardes of the interwar period (Brancusi, Duchamp, Picabia), this modality of graphic practice has risen to dominance over the last fifty years: Piero Manzoni, Vincenzo Agnetti (fig. 1), Barry Flanagan, Adrian Piper, Joseph Beuys, Dan Graham, Hans Haacke, Marcel Broodthaers, Dorothea Rockburne, Richard Hamilton, Agnes Denes, Nancy Holt, Lee Lozano, Anna Maria Maiolino, Richard Tuttle, Mark Lombardi, Gabriel Orozco, Ellen Gallagher, William Kentridge, Kara Walker, Cristobal Lehyt, Julie Mehretu, Daniel Zeller, and Nobuya Hoki.[3]

Running more fundamentally perhaps than even the question of art-historical "method," the question of context presses on criticism, given that art practices have shown the degree to which the "de-" and "reterritorialization"[4] of the world have affected the basic availability of forms of representation, such as drawing, to cohere and to make sense—to show and to tell about this "world." And so, for instance, one sees the rise of the diagram, or indexical functions of line. Line is tasked to convey data, information, rather than to establish contour, divide a figure from ground, and present the rudiments of representation, its historical function. That the

3. Pamela Lee, "Some Kinds of Duration: The Temporality of Drawing as Process Art," *After Image: Drawing Through Process*, organized by Cornelia H. Butler for An Exhibit at the Los Angeles Museum of Contemporary Art, April–August 1999 (Cambridge: MIT Press, 1999). See *Vitamin D: New Perspectives in Drawing* (London: Phaidon, 2005); de Zegher, *The Stage of Drawing: Gesture and Act, Selected from the Tate Collection* (Tate Publishing and the Drawing Center, New York, 2003); Briony Fer, *The Infinite Line: Remaking Art After Modernism* (New Haven and London: Yale University Press), 2004.

4. For a discussion of the "deterritorialization" or disarticulation and reorganization of space and time in relation to the specific configuration of capitalist integration, see David Harvey, *Justice, Nature, & the Geography of Difference* (Oxford: Blackwell, 1996). See also Harvey, *The Condition of Postmodernity* (Oxford: Blackwell, 1989).

basic tools of representation are shown to fail in the wake of world changes that exceed their own representability by the old forms as we recognize them is already an extreme symptom of the need for new forms and new terms. Art, and rarified cultural production, presciently symptomatize the yet inarticulable seismic shifts that occur first in the economic sphere and begin to resonate throughout the social field. It does so by means of appropriating/re-appropriating the very devices, such as the diagram, which traditionally belong to forms of rationalization foundational to significant shifts at the level of what was once known as "the base" in relation to a "superstructure."[5] Circular as the description of this process may seem, artistic production is one place along a circuit of cause and effect to locate an etiology of the real movement of time and the metabolic exchange with resources, value, and social reproduction. That from the 1960s on the chart and diagram have increasingly overtaken the image in many contemporary practices is a strong symptom of seismic changes on the register of the real. This of course rests on my conviction that art, especially when it is most autonomous, prefigures and symptomatizes changes in the field of the real before they are symbolized and formalized in discourse.

It has long been noted with reference to Constructivism and other practices of the early twentieth century that while "the diagrammatic line is drawn from the realm of science and technical drawing ... the final work has elements of notation. The works do not 'represent the world' if that is taken to be the model used in figurative art, but they contain allusions to the world in which they were produced by the currency of associations, materials, methods."[6] Less elaborated, perhaps, is the degree to which the shift reverberates

5. Michael Baxandall, *Painting and Experience in Fifteenth Century Italy* (Oxford University Press, 1988); Walter Benjamin, "One Way Street" and "The Work of Art in the Age of its Technological Reproducibility" in *Collected Writings of Walter Benjamin*, Howard Eiland and Michael Jennings, eds. (Belknap Press of Harvard UP, 2006).

6. Briony Fer, David Batchelor, Paul Wood, *Realism, Rationalism, Surrealism: Art Between the Wars* (Yale University Press, 1993), 108. On the dominance of industrial design and commercial drawing as the matrix of the French and American avant-gardes, most notably Duchamp's practice, see the seminal text by Molly Nesbit, "The Language of Industry," *The Definitely Unfinished Marcel Duchamp*, ed. Thierry De Duve (Cambridge: MIT Press, 1992).

through the century and, replacing figuration, renders perceptible otherwise unfigurable and invisible shifts in the mediation between the real and its reception, or between the base and the superstructure. The key here is the shift in the register within which line is expected to deliver meaning. Replacing contour and mimesis with notation, this transition at the heart of basic visual practice signals a more profound relation to the de- and recomposition of content and meaning at a fundamental level, perhaps not unlike the transition the image underwent in the wake of technological reproducibility as famously described by Benjamin. It is the gambit of this essay that the in/coherence of context rides in on the question of the diagram in late capitalist modernity.

As noted above, the list of artistic practices that mobilize the turn from contour to diagram clearly crosses the century, from 1915 to 2016. We could tendentiously situate these practices as so many cultural instances marking the elaboration and development of the purely aesthetic appropriation of the diagram as a heuristic device. But this unfolding of a cultural development, in turn, could be shown to track a parallel, double movement of culture nested in and against the movement brought about by the disintegration of the capitalist mode of production and the reintegration of global resources and demographics. While it would be impossible to map the one (the internal telos of the diagram) onto the other (the historicity of capitalist subsumption), a pattern nonetheless emerges. In the absence of any causal correlation, the transformation of line marks the progress of capitalist immiseration and the transitional points between moments of progress. It is as though the deterritorialization of line somehow recorded, indexically, the de- and recomposition of (cognitive) mapping in "line" with "globalization," itself another name for capitalism. In what follows, I will try to isolate a couple of such practices to attempt to "read" them as indices of real abstraction.

In the mid twentieth century, Manzoni's *Linea* (1959) radicalized the modernist preoccupation—from Duchamp to Adorno to Cage—with the ascetic reduction of artistic process, particularly the transformation of drawing, formerly conceived and practiced as a means to demonstrate skill, into other modalities of agency (fig. 2).

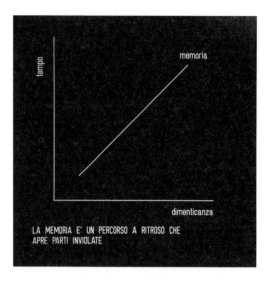

Fig. 1
Vincenzo Agnetti, *La memoria è un percorso
a ritroso che apre parti inviolate*, 1972
Bakelite engraved with white nitrocellulose lacquer,
31 ½ × 31 ½ inches (80 × 80 cm)

Fig. 2
Piero Manzoni, group of *Linee*, 1959
Ink on paper, cardboard tube, 752 ³/₈ × 321 ¹¹/₁₆ × 1324 × 622 ⁷/₁₆ inches
(1,911 × 817 × 3,363 × 1,581 cm)

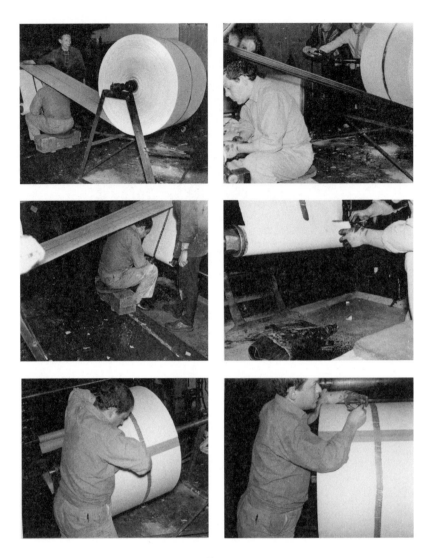

Fig. 3
Piero Manzoni executing *Linea m.7200* in
Herning, Denmark, on July 4, 1960

Each work consists of a cardboard tube, a scroll of paper with a black line drawn down it, and a simple printed and signed label, which contains a brief description of the work: the artist's name, the date it was created, and its length. This work about the very possibility of line thinks through the vanishing conditions of mark-making within predetermined systems enforced by disciplinary everyday life in mimetic inscription to value-productive labor on the factory floor. In other words, the work of art demonstrates the way in which disciplinary labor comes to inevitably limit historically established forms of culture believed to transcend lowly matters of economic determination. *Linea* dialectically, and negatively, foregrounds the problem from the point of view of the artist, who, while far from the worker in terms of class identification, was expected to deliver consciousness within and against the dictatorial determinations managed by the capitalist logic of value. Manufacture and authorship alike came to be reticulated exclusively to the same form of general equivalence, irrespective of the numerous qualitative differences among types of workers. The *Linee* posit "self-reflexivity"—that lynchpin of modernism—in terms of manufacture, and the vanishing possibility of artistic agency in an era accelerated in the interest of abstracted value. As ever, Adorno is adept at translating the issue of subsumption back into cultural terms; hegemonic liberal culture mediates the same processes, legitimating them. "Bourgeois society is ruled by equivalence. It makes dissimilar things comparable by reducing them to abstract quantities."[7]

Manzoni "made" the *Linee* on an assembly line in a factory in Milan. The lines' foreclosure of any expressive, sensual, libidinal content (the role of line from Surrealism through Expressionism, having been lately liberated from its instrumental role in mimetic representation), set into tension with exaggerated packaging, implies the works' embedded dependence on an anonymous subject, the worker/maker whose substantive trace generates the parameters of the very product that doubles back to cancel that presence. Indeed, something is missing. We could call this an object lesson in the

7. Theodor Adorno and Max Horkheimer, *Dialectic of Enlightenment: Philosophical Fragments*, trans. Edmund Jephcott, ed. Gunzelin Schmid Noerr (Stanford: Stanford University Press, 2002), 4.

preconditions of the commodity fetish that makes things of people and ascribes agency to things, but there's a little more and a little less to it than this.

The agent's (artist standing for worker) trace is recorded and enables the accumulation of canisters and cans, of labels and the many frames of the market. One is confronted with cascading frames, *en abyme*: label, can, pedestal, museum, so many containers, so many forms, but the content seems to withdraw as if by a negative will of its own. This use of modernist hermetic withdrawal nevertheless yields to a frustrated acknowledgment of the active erasure, rather than ontological withdrawal, of both content and agency. Manzoni shifts registers from Heidegger back to Marx: not *this*, but *other* than this entangled *in* this, constituting it and comprising it is a function of particular labor conditions, specifically a relationship to skill that makes of the grapheme an empty placeholder for value. The *Linea* doubly withholds the corporeal trace: by folding into the industrial procedure and through its packaging. It thus paradoxically shores up the corporeal trace, designating its absence *as* absence, and marks it as *other*.

<p style="text-align:center">*</p>

Returning now to the larger problem of abstraction and the diagram, what is "real abstraction" if not just another term for reification, signaled by the ontological shifts in everyday life brought about by the triumvirate of wage, anonymous labor, and the commodity?[8] How do these ontological shifts move in time? The terms *financialization*, *post-Fordism*, even *postmodernism* suggest a sequence, however accurate or erroneous each may be. They describe a succession of developments in the political-economic reality felt and suffered by workers, masses, and multitudes all over the world, one by any other name, one that generates a condition frequently evoked as "neoliberalism." What is neoliberalism? In *A Brief History of Neoliberalism*, David Harvey argues that the term describes the result of a succession of

8. Georg Lukács, *History and Class Consciousness: Studies in Marxist Dialectics*, trans. Rodney Livingstone (Cambridge: MIT Press, 1968).

events in the consolidation of the relationship between the IMF (International Monetary Fund), the World Bank, the WTO (World Trade Organization), and Wall Street. "The process of neoliberalization has entailed much creative destruction not only of prior institutional frameworks and powers (even challenging traditional forms of state sovereignty) but also divisions of labor, social relations, welfare provisions, technological mixes, ways of life and thought, reproductive activities, attachments to the land and habits of heart."[9]

Against the narrative according to which a succession of state and institutional alliances policed the globe into so-called neoliberalism, many note that the far reach of capitalism is structurally inevitable, the logical outcome of capitalism's cycles of accumulation necessitating greater territories to be mined for labor and resources. Recent theories (which return to older theories such as those of Rosa Luxemburg, Georg Lukács, and others) of crisis capitalism challenge Harvey's account by pointing to the basic structural condition of capitalism, namely the need to keep ahead of its inherent tendency to falling profits.[10] And this very tendency is at the heart of the immiseration necessary for generating profits, *unless* capital can absorb resources and sources of labor into its machinery to abet its own structural entropy, thereby returning to accounts of capitalism at odds with Harvey's approach to causality. Paul Mattick's thesis in *Business as Usual*, for instance, acts as a corrective to Harvey in its insistence on structure over the unfolding of secondary political negotiations among global bodies of governance and regulation. But the question is not what Marxist luminary is better than the other, but rather the lacunae that open up in how each tries to describe and periodize emergent conditions *impossible to figure.*

I will go ahead and pose the problem on the larger scale of a historical grand narrative. Given the situation, I am granting myself the freedom to think against decades of postmodernism and its demonization of the attempt to totalize. With Jameson's "Always totalize!" in mind, I am relying as much on the work of David Harvey

9. David Harvey, *A Brief History of Neoliberalism* (Oxford: Oxford University Press, 2005), 3.

10. Anwar Shaikh, *Capitalism: Competition, Conflict, Crisis* (Oxford: Oxford University Press, 2016).

as on Giovanni Arrighi, Robert Brenner, and others who have pro-
posed ways of thinking historical causality after the complications
wrought by the forces of globalization and, above all, financializa-
tion, which have come to determine communications networks and
to reshape what we mean by time, place, and cause.[11] For Harvey,
Arrighi, Brenner (despite numerous differences) and others, the
oil crisis of 1973 is a signal moment for how it marks strategies on
the part of first-world nations to keep profits high, strategies that
we now refer to in the unexamined shorthand of "globalization":
cheap labor in the underdeveloped world, moving from Fordist to
post-Fordist production techniques, emphasizing supply chains
over production on the factory floor in the interest of exacting
profits more efficiently (to bear the expense of labor less), not to
mention new rounds of primitive accumulation exacted by the IMF
during the new economy of the Thatcher-Reagan years in the wake
of stagnating growth caused by the crisis. In short, we need to a)

11. As detailed in the introduction to *Marshall Plan Modernism*, my work relies
 on scholarly accounts of the Marshall Plan defined by the rise to international
 dominance of the US dollar under the Bretton Woods policy, an early and
 pioneering form of "financialization" structuring the Cold War. Here, in the
 historical and political conjuncture named by "Bretton Woods," statecraft
 and capital mutually reinforce the integration of a world power. Salient here
 is the account of world banking reticulated to the US dollar after the Second
 World War, and the role of the US dollar in the global balance of power
 beyond the Cold War, in the oil crises of the 1970s. As elaborated by Giovanni
 Arrighi in *The Long Twentieth Century* (London: Verso, 1996), the problem of
 "restructuring" after the oil crisis of 1973 was already implicit and inevitable
 in the reorganization of political and economic power during Bretton Woods.
 Gopal Balakrishnan's "Speculations on the Stationary State" in *New Left Review*,
 no. 59 (September–October 2009) relies on Arrighi's work, using the thesis
 of *The Long Twentieth Century* to address the decline of the nation-state in the
 face of transnational corporations on the one hand and banking on the other,
 while updating Arrighi's model of systemic crisis as structurally inherent to the
 capitalist state conjuncture. See also Robert Brenner, "Persistent Stagnation,
 1973–93," *The Boom and the Bubble* (London: Verso, 2002). The best-known
 and certainly most popular text in English on the organization of the world in
 the interest of global neo-imperial domination is Antonio Negri and Michael
 Hardt's *Empire* (Cambridge: Harvard University Press, 2000). The problem
 with that thesis, however, is the degree to which it displaces forms of capitalist
 reconsolidation, which is neocolonialism, with issues of constitutionality and
 the limits of national and international law. The task I've set myself is to trace the
 way in which these shifts ramify in cultural production, through recourse to the
 question of work and what it meant to make work (autonomous or instrumental;
 artwork or value productive work) in the global situation.

describe and b) trace—through the etiology provided by cultural production—this hornet's nest of complex determinations wrought by capitalist forms of valorization predicated on the mass movement of people across the planet. What Harvey would call "deterritorialization" and "reterritorialization"—enforced by the creative destruction and reconsolidation of everyday life under the dictates of advanced capital—change the very notions of context and causality.

Enter "the post-medium condition."[12]

*

The recurrence of the question of displacement may begin to suggest the question of the very meaning of placement. It might be said that in an institutional and professional order, itself born of the Cold War, in which specialization is prized, art practices become the last underdetermined (or, by contrast, overcoded) space to enable the exploration of problem sets saturating so many aspects of everyday life as to be otherwise impossible to contain in a circumscribed field of study. From Adorno to Said, the structural condition of diaspora is frequently understood to be, however violent, one of the given processes of collective transformation born of modernity. And yet within the historicity of modernity, it might be noted that forms of violent displacement are accelerating in intensity and frequency. Diaspora is a form of mass social reorganization across nation-states and continents necessitated by the acceleration of capitalism's creative destruction, as it periodically restructures in the interest of resource mining on the one hand, and on the other hand, ever more efficient ways of extracting surplus value from labor.

The shifting relationship between labor and capital, required by capitalism's peripatetic need for surplus labor pools, has redrawn the coordinates of time and space for much of the world's population. Over the course of the twentieth century, in the histories of capitalism and rounds of accumulation and subsumption, some periods have seen more violent transitions than others. 1945 and 1973 are

12. Rosalind Krauss, *Voyage on the North Sea: Essays on the Postmedium Condition* (London: Thames and Hudson, 2000). See also Krauss, *Perpetual Inventory* (Cambridge: MIT Press, 2013).

both crucial dates that, I would argue, fundamentally affect the basic meanings of context, origin, and causality. Changing empirical and historical conditions begin to demand scholarly inquiry, including the humanities, to explore the basic coordinates that subtend classical forms of analysis, of which context, understood as a stable place and time, is fundamental.

The paradox (or dialectical involution) here is that while context (defined as the time and place in which a work is produced) continues to be one of social art history's most basic certainties, it also becomes one of its primary questions. What constitutes a stable time and place, that is, a context, in the wake of the deracination and reconstitution of its perception necessarily governed by networked communication, intimately bound up with financialization, which has made "the bank" (a set of operations) across the globe more causally active in a life than s/he who is experiencing this "life"? Agency and the formation of subjectivity have been pressing matters of concern over the last several decades in the wake of theories critical of determination (structuralism, post-structuralism), and yet context has remained a stable category.

I have arrived at a sense of the urgent necessity of this inquiry into "context" through my own research into abstract art born of the accelerations within capitalist abstraction in the aftermath of the Second World War, during the period known as the "Economic Miracle." Under the aegis of the Marshall Plan, Italy's late and accelerated modernity also coincided with its special role in the Cold War. The factory floor's activity, using surplus labor dredged up from the poorer south, intensified in response to American investment. This work on modernist art during the Marshall Plan has led me to frustration with the received notion of context in practicing a responsible and up-to-date form of social art history—responsible to questions of historicity and causality as much as to the formal operations of works of art. Artists happen to symptomatize anxiety of the moment, its productivist expectations, and its concomitant subject-to-capital relationship, in their own aesthetic "production." Context, then, is born of contingencies having to do with networked markets buffeted by the Iron Curtain and the ideology that has kept that dynamic spinning, as much as by national identity and territory. At the level

of method, it becomes clear that a new tool kit is required when the guarantees of time and place, a geopolitical site and a historical moment, no longer adequately account, if ever they did, for either art practices or artists themselves. As I have argued elsewhere in an analysis of the labor to capital relationship, at once allegorized and organized by the relationship between the IMF and the Global South, whereby the world is literally drawn and quartered in the interest of policing labor-to-capital dynamics outside of the sovereignty of the nation-state, "in a globalized art world, the local is always shown to be refracted through a market that is, *a priori*, structurally antithetical to the notion of place and time."[13] This is not a general or formal condition, as elaborated in Benjamin's well-known discussion of how the multiple shatters the aura; specific forms of international accumulation demand an attendant culture. "One problem with this redrawing of the world to accelerate the flow of goods and services for those capable of paying for them was and is those who were and are not capable of paying for them, namely, the working class that produces the surplus value necessary for those circuits."[14] Or as Arrighi puts it: "The conspicuous consumption of cultural products was integral to a state making process, that is, to the reorganization of the territory into a system. The new and anomalous character of the ruling group meant that they could not rely on the automatic customary allegiance that was available to more traditional kinds of authority. Hence these groups had to win and hold allegiance by intensifying community self-awareness."[15]

<p style="text-align:center">*</p>

The gambit of this essay is that context itself, the basic matrix of time and space fundamental to cultural coherence, must be redefined given the fact that it has been already restructured by capitalism, thereby restructuring lines of causality. The urgent need to find

13. Jaleh Mansoor, "Cristóbal Lehyt's Concrete Abstraction: Un-Mapping the 'Global South,'" Cristóbal Lehyt, America's Society, New York, Spring, 2014.

14. Ibid.

15. Arrighi. *The Long Twentieth Century*, 85.

coherence again in response to the movement of history wherein capital has redrawn the lines of time and space rides in on the diagram because of its singular capacity to respond to both real abstraction and reification in late modernity. It has no doubt found its way into art, away from the realms of science, technology, and economics where it originated, because of art's peculiar form of autonomy: at its most "autonomous," art both symptomatizes and eerily prefigures changes in the field of the real, long before those transitions are formalized within discourse.

Atomic Time:
On Karin Schneider's
Black Paintings

Aliza Shvarts

In the art-historical narratives of twentieth-century painting—
discourses resonant with the long-standing biases of Western
aesthetic theory and steeped in the material histories of colonial
conquest—there is an over-determined relationship between black-
ness and nothingness. Blackness is darkness, the absence of light.
Blackness is the repudiation of color. Blackness is the negation of
form. Blackness is emptiness, void. Yet for those of us whom this
art history does not serve, for those of us categorically excluded
from the axioms of value, power, and beauty through which white
supremacy and heteropatriarchy endure, black painting offers a
powerful site of contention.

Karin Schneider's new body of work, Situational Diagram,
explicitly invokes three iconic approaches to black painting within
the history of modern art: Ad Reinhardt's black square paintings
(1953–67), Barnett Newman's black "zips" or lines in his four-
teen-canvas series "Stations of the Cross" (1958–66), and Mark
Rothko's fourteen black color-hued paintings (1964–67) installed
in the Philip Johnson–designed Rothko Chapel in Houston, Texas.
Schneider engages these modernist monuments in order to turn
them into resources for her production. Distilled in the pigment of
Reinhardt's squares, Newman's "Stations," and Rothko's Chapel is not
just a history of modern art practice, but a longer tradition of percep-
tual and ideological distinction. Black appears in these works at the
upper and lower poles of color experience, as either achromaticity

or chromatic saturation. None of these iconic black paintings are monochromatically black; rather, each uses black pigment with formal or tonal variation to interrogate a limit of the painted surface—the limit of the image, the limit of abstraction, the limit of representation. Black appears as a formal abstraction and as a marker of value; it is an extreme against which difference can be calculated and against which distinctions can emerge. For Schneider, black becomes a lens through which to parse the genealogies of value and valueless-ness that mediate systems of global capitalism and everyday lived experience. In this sense, these modernist masterworks provide not only a resource for production but also a methodology for critique.

Let us consider the black painting a measure, a medium that registers the sub-visible narratives of power that structure the over-determined meanings of the pigment. Black is a metonym of that Manichean logic that separates light from dark, meaning from non-meaning, value from valueless-ness, or in Reinhardt's infamous phrasing, "art" from "everything else."[1] In the context of modernism, black paintings are always at least partially an archive: a crystallization of that binary that positions blackness as darkness, emptiness, void. As such, black paintings register what I want to propose is an *atomic time* of aesthetic production—a historical record and time-keeping mechanism embedded in bare matter, in its most elemental units. The atomic clock and black post-painterly abstraction were both developments of the American midcentury, both effects of the nuclear age. Both are premised on a confluence of materiality and measure—on the capacity for elemental physicality to bear ideological meaning. As a heuristic, atomic time is a way of making tangible, making material, the historicity of matter. It throws into sharp relief several modes of labor expropriation that enable the illusion of freely circulating value: colonial conquest, genocide, enslavement, sexual discipline, and patriarchal domination. This labor continues to be disproportionately extracted from brown, black, and effeminate bodies—bodies that are evacuated from the aesthetic projects of abstraction but are

1. Ad Reinhardt, *Art as Art: The Selected Writings of Ad Reinhardt*, ed. Barbara Rose (Berkeley: University of California Press, 1991), 51.

foundational to its value, bodies that atomically inhere. To speak of an atomic time of painting is to speak of those movements, those histories, that inhere in the medium. Through the lens of atomic time, we can see the ways in which black painting as a genre can be used to either maintain or recalibrate a binary logic of value that continues to structure our current geopolitical moment.

Time is a measure of movement, and most clocks work by counting the motions of a regularly oscillating mechanism known as a resonator. In mechanical clocks, the resonator is the regular swing of a pendulum, controlled by gears. In digital clocks, it is the oscillation of electric current through a quartz crystal. In atomic clocks, it is the resonant frequency of atoms themselves. As a technological discovery of the nuclear age, atomic time reorients temporality around the movements in matter. The atom is at once a measure of duration as well as the thing that endures. This nuclear logic makes possible a critical premise previously unavailable: it's not just that time can be told from atoms, but that matter itself can be a measure of historical movement. These developments in nuclear science ran concurrently with the rise of abstraction in postwar American art: physicist Isidor Rabbi first theorized the possibility of an atomic clock in a 1945 lecture given to the American Physical Society and the American Association of Physics Teachers; the first working atomic clock was developed by Harold Lyons at the US National Bureau of Standards in 1949.[2] While there is no evidence of a direct causal relationship between these two midcentury innovations, both reflect an ideological turn to objective rather than interpretive values—a belief in material forms and substrates as the determinants of meaning. This nonpartisan stance of science and abstraction testifies to a politics held in common. As Eva Cockcroft argues in her article "Abstract Expressionism, Weapon of the Cold War," originally published in *Artforum* in 1974:

> The alleged separation of art from politics proclaimed throughout the "free world" with the resurgence of ab-

2. Michael A. Lombardi, Thomas P. Heavner, and Steven R. Jefferts, "NIST Primary Frequency Standards and the Realization of the SI Second," *NCSL International Measure: The Journal of Measurement Science*, 2, no. 4 (December 2007): 77–78.

straction after World War II was part of a general ten-
dency in intellectual circles towards 'objectivity.' [...]
Abstract Expressionism neatly fits the needs of this sup-
posedly new historical epoch. By giving their painting
an individualist emphasis and eliminating recognizable
subject matter, the Abstract Expressionists succeeded in
creating an important new art movement. They also con-
tributed, whether they knew it or not, to a purely political
phenomenon—the supposed divorce between art and
politics which so perfectly served America's needs in the
Cold War.[3]

Throughout her text, Cockcroft emphasizes the mobilization of
artwork as a cultural export in programs developed in collusion
by museum heads and government bodies, which often trumped
the politics of individual artists. The political activism of artists
such as Barnett Newman did not prevent the use of their work for
these propaganda purposes; rather, "from a cold warrior's point of
view, such linkages to controversial political activities might actu-
ally heighten the value of these artists as a propaganda weapon in
demonstrating the virtues of 'freedom of expression' in an 'open
and free society.'"[4]

No artist understands themself as an operation of ideology.
From romantic models of individual expression to the postmodern-
ist paradigm of critique, the premise of art practice is the possibility
of subjective agency. Yet the stark materialism of atomic time offers
a lens through which to reexamine aesthetic production—a type
of absolutism grounded in the endurance of matter. It offers the
possibility of reconfiguring art practice from the perspective of the
object, where the object is a condensation of something happening
in time. Through this lens, we might understand that in addition to
being innovative experiments in negation and perception, the black
paintings of Reinhardt, Newman, and Rothko are also a measure

3. Eva Cockcroft, "Abstract Expressionism, Weapon of the Cold War," in *Pollock
 and After: The Critical Debate*, ed. Francis Frascina (New York: Routledge,
 2000), 154.

4. Cockcroft, 151.

of their ideological moment, of the aesthetics and politics of the nuclear age. Indeed, it is perhaps the absolutism of black as a color, concept, and symbol that interested Reinhardt. For him, the color offers both a historical record of metaphysical and ideological associations, as well as the negation of those meanings. As he writes in "Black as Symbol and Concept":

> I suppose it began with the Bible, in which black is usually evil and sinful and feminine. I think a whole set of impositions have affected our attitudes toward white and black—the cowboy with the white hat and white horse, the villain with the black gloves. And then the use of black all the way through the Bible, through Chaucer, Milton, Shakespeare, and a few others. Even in terms of color caste there are blacks and colored, what Harold Isaacs in *Encounter* once called a yearning for whiteness in the West, like high yellow and so on. There is a relation in Christianity to the black hell void and the white heaven myth, the blackness of darkness that is involved with formlessness or the unformed or the maternal, the hidden, guilt, origin, redemption, faith, truth, time. Black can symbolize all those.[5]

Even without reference, black is steeped in the social histories of religious warfare, Western domination, and gendered labor discipline that condition moral value. What seems at stake for Reinhardt is whether the color can be used in isolation from the narratives with which it is imbued—whether it can function performatively as a mode of negation removed from the contexts of metaphysics, morality, or lived experience. As he goes on to assert,

> I want to stress the idea of black as intellectuality and conventionality. There's an expression "the dark absolute freedom" and an idea of formality. There's something about darkness I don't want to pin down. But it's

5. Reinhardt, 86–87.

aesthetic. And it has *not* to do with outer space or the color of skin or the color of matter.[6]

Yet even as an intellectual operation or convention, as a negation of representation or spectacle, blackness remains an atomization of histories that cannot be parsed from space, matter, or skin.

In his article "The Case of Blackness," Fred Moten contextualizes Reinhardt's remark as part of a larger conversation on the subject of blackness between Reinhardt and five other interlocutors, which was published by the journal *artscanada* for their special "Black" issue in 1967. Moten focuses specifically on the exchanges between Reinhardt and the jazz musician Cecil Taylor. As he notes, the "chromatic saturation" that is blackness refers to fundamentally different material experiences for the white painter and black musician. Reinhardt's focus on the visual appearance of color is distinct from Taylor's engagement with the sonic scales of sound. Accordingly, blackness as a concept takes on different stakes. As Moten writes:

> Unfortunately, as we'll see, Reinhardt reads blackness as sight, as held merely within the play of absence and presence. He is blind to the articulated combination of absence and presence in black that is in his face, as his work, his own production, as well as in the particular form of Taylor.[7]

What Reinhardt does not see, according to Moten, is the lived experience of blackness, which confronts him not only in the figure of Taylor, but also in the formal operations of painting. Painting, for Moten, as a formal negotiation of color, can be a site of contestation for the political theorization of lived experience, particularly the lived experience of race. Or, as he puts it, "chromatic saturation in painting" can put "the set of questions that are black social life into relief."[8] Moten's critique reminds us that chromaticity, as a

6. Reinhardt, 87 (emphasis in original).
7. Fred Moten, "The Case of Blackness," *Criticism*, 50, no. 2 (Spring 2008): 190.
8. Moten, 189.

formal element, is both material and temporal. Even without reference, color exists in relation to time—in relation to the matter and movement of atoms and light that produce the physical experience of color, as well as the materiality of history that conditions its perception, meaning, and use.

What moves Moten from the focus of his essay—black social life—to his analysis of Reinhardt's black paintings is a formative interdiction that he situates at the beginning of his essay, an excerpt from an oft-quoted chapter in Frantz Fanon's 1952 book *Black Skins, White Masks*: "I came into this world imbued with the will to find a meaning in things, my spirit filled with the desire to attain to the source of the world, and then I found that I was an object in the midst of other objects."[9] Analyzing Fanon's fall from subjecthood to objecthood, Moten considers the difference between objects and things through Martin Heidegger's concept of "The Thing." Simply put: an object exists for a subject and contains a potential for use; the thing, on the other hand, sits beside this hierarchal organization of subjecthood and objecthood, and is temporally displaced from this capacity to be used. Either before it is fixed to a particular use, or after it can no longer be used, the thing is filled with "an always already mixed capacity for content that is not yet made,"[10]—a capacity immediately annihilated once or when the thing becomes an object for a subject, which is to say, useful. From this philosophical discussion, Moten concludes that "perhaps the thing, the black, is tantamount to another, fugitive, sublimity altogether. Some/thing escapes in or through the object's vestibule; the object vibrates against the frame like a resonator, and troubled air gets out."[11] Here, in the resonator's "troubled air," there is not only a reference to music, to the vibrations of sound, but also to the mechanism of time's measurement—to what I am calling atomic time.

<hr/>

9. Frantz Fanon, *Black Skins, White Masks*, trans. Charles Lam Markmann (1967; London: Picador, 1970), 77–78. These lines come from a chapter titled "The Fact of Blackness," from which Moten's essay, "The Case of Blackness," takes its name. As he notes, the English title of Fanon's chapter is a mistranslation of the original French, which is closer to "The Lived Experience of Blackness"—a telling misprision which Moten takes up in his analysis of blackness.

10. Moten, 184.

11. Moten, 181–82.

Can the painting itself function as a resonator—a vibrational ground, a troubling site, from which some/*thing* might escape? I want to be careful in my use of Moten's work not to repeat the erasure he critiques—that is, not to conflate subjects for objects, the lived experience of blackness for chromatic saturation in painting. Rather, what I take from Moten's critical intervention, and what I find in Schneider's Situational Diagram, is the understanding that black painting has social and performative dimensions. Those dimensions give painting political relevance and stakes. Blackness, as an abstraction in both art and social life, is not simply a record of discursive erasures, but also an accumulation of enduring materialities. It's this materiality that makes it possible to talk about an atomic time in painting—a way of apprehending the medium as both an archive and an operation, as a history that is still happening. In Situational Diagram, something quite literally escapes the black paintings. Strewn about the gallery floor are figures, paper-thin stainless steel and neoprene sculptures that have been extracted from canonical paintings in art history. These figures thrown onto the gallery floor are the crumpled bodies of historically significant nudes: Henri Matisse's *Nu Bleu III* (1952), and importantly, Tarsila do Amaral's *Abaporu* (1928), which inspired Oswald de Andrade's concept of *antropófago* (the critical cannibalizing of European culture—an important image in postcolonial critique). Rather than maintaining the coloring of the paintings from which they were extracted (and abstracted), these figures are all black. Through the continuity of black paint, Schneider creates a point of contact between two seemingly opposite aesthetic sensibilities: modernist figuration and hard-edged abstraction. In doing so, she invites us to consider what historical figurations are embedded in the abstract surface. In a broader sense, she asks us to consider what bodies, what labors, power the abstractions of value.

The extraction of three-dimensional figures from the two-dimensional ground of painting parallels the logic of liquid extraction that is found in the mechanisms that power capitalist configurations of monetary value. After all, capitalism functions through a series of extractions and abstractions: the extrication of life from the body in the form of labor power from the worker; the expropriation of the

commons from the community through systems of accumulation and dispossession; and the ongoing search for new grounds upon which to stage the former—from the "discovery of New Worlds" that euphemized genocidal colonial conquest, to the continued privatization of public assets, such as the corporate mining of natural resources. Through her mediations on blackness, Schneider isolates the alchemy that turns bodies into time, time into money. She lifts those discursive erasures that cloak the surface of the black canvas, concealing its enduring materiality, its reproductive ground. By rendering black painting operative and active, she shows it to have bodily dimensions; she shows its force to be both figurative and temporal. Calibrated to the historical expropriations of life and labor, the colonial legacies of conquest that continue to impact daily life, these black paintings tell an atomic time: they make visible the history of movement that exists in material form. These black paintings act as a vibratory ground, a troubling force, which provides an interface between the walls of art history and the social world. As a mechanism, a resonator, they connect abstracted materiality and lived materiality—that is, the concomitance of "art" and "everything else" that cannot be overlooked.

Decanted from the programs of modernism, the black paint in Situational Diagram thus functions as a material substrate for art-historical discourse, as a physical calibration of the ideological, social, and economic relations that inhere in color. Its chromaticity tells an atomic time. As a site of heterogeneity, the black painting becomes a materially reproductive ground—a site in which other meanings emerge. By repurposing the midcentury trope of black painting, Schneider uses a formal operation to excavate the material history of the political present. She interrogates how abstraction can function as a relational modality, maintaining or destabilizing entrenched aesthetic and political values. Her black painting becomes a political operation: an expedient way of summoning the axiological fission that separates something from nothing—an aesthetic as well as political distinction upon which so much depends. The feminism of such a gesture is formal, embedded in the physical processes of the work rather than representations of identity. Instead of staging a contrast between the universalisms of black paintings and the

specificity of gendered experience, Schneider puts black paintings to use: she engages their active elements to produce a new lexicon of aesthetic forms. Yet in her reworking of modernist masterworks, we might recognize something even more pointed: an iteration of that unsettled question that continues to circulate in feminist and anti-racist circles, of whether the master's tools can be used to dismantle the master's house.[12]

12. The master's tools/master's house question was first raised by Audre Lorde in "The Master's Tools Will Never Dismantle the Master's House," in *Sister Outsider: Essays and Speeches* (Berkeley, CA: Crossing Press, 1984), 110–14. It is a question since taken up by other feminist scholars such as Naomi Wolf and bell hooks.

Candomblé and Resistance

Abrahão de Oliveira Santos

The Encounter: Kavungo Is Talking

I met Karin at the *Colloque Deleuze: virtuel, machines et lignes de fuite* in August 2015.[1] We were both interested in practices of occupation and the production of animist spaces, especially in relation to contemporary forms of resistance. Karin and I discussed New York's Occupy Wall Street, which occurred in 2011, and the subsequent occupation of Cinelândia Square in Rio de Janeiro. Even now, in 2016, we continue to talk about the innumerable street gatherings and occupations throughout Brazil—the people's reaction to the recent coup d'état staged by political oligarchies against the fragile Brazilian Republic. In this recent global strategy of occupying urban spaces to effect social change, we see traces of the diasporic African religions of Brazil, Candomblé and Umbanda, which were developed by African slaves in the sixteenth century. In this line of thinking, we talked about interventions in public space and their affinity to Umbanda offerings made to spiritual entities and left on the streets, squares, and viaducts of Brazilian cities; Macumba, the set of rituals and acts that comprise Candomblé and Umbanda; lines of flight (*lignes de fuite*); and processes of assemblage (*agencement*).

1. The conference took place at the Centre Culturel International de Cerisy, France and was organized by Anne Querrien, Anne Sauvagnargues, and Arnaud Villani.

French sociologist and philosopher Georges Lapassade considered Macumba an essentially cathartic art form created by Brazilian slaves.[2] In contradistinction to this, I propose Macumba as a form of black resistance, black art. Rather than being considered a limited function of the condition of slavery, Macumba should be understood as a *dispositif* of Négritude—as a model for resistance within a white capitalist economy.[3] Macumba encompasses the ceremonial practices carried out in Candomblé and Umbanda: lighting a candle on the street, performing an *ebó* (an offering to the gods or a healing ritual), placing cassava flour[4] in a corner for an *orixá*,[5] taking an herbal bath, going to a waterfall, a river, or the sea; Macumba is an activity, a spell, an offering—it is an act of magic (fig. 1). Macumba animates; it brings its practitioners the energy necessary to renew their fighting spirits; it rejuvenates them so that they might continue their everyday struggle for freedom from all kinds of oppression. Although it involves various African rituals and religious rites, Macumba is not a return to Africa. Rather, it involves the use of *dispositifs* from the black diaspora, empowering practitioners to continue their fight for justice.

2. Marco Aurélio Luz and Georges Lapassade, *O segredo da macumba* (Rio de Janeiro: Paz e Terra, 1972).

3. Négritude is a political and literary movement founded by the poets and politicians Aimé Césaire, Léopold Sédar Senghor, and Léon-Gontran Damas in the 1930s. The term was coined by Césaire in his *Notebook of a Return to the Native Land*, 1939. Senghor wrote that Négritude "is neither racialism nor self-negation. Yet it is not just affirmation; it is rooting oneself in oneself, and self-confirmation: confirmation of one's being. It is nothing more or less than what some English-speaking Africans have called the African personality."

4. Cassava or manioc flour is a staple food in Brazil, and is closely related to tapioca, arrowroot, and yucca starches.

5. *Orixá* is the generic name of enchantment or deities in the African Yoruba religion, from which Candomblé and Umbanda are derived. It takes various forms in the different diasporic African religions of Brazil. There are a total of 401 *orixás*. From the seventeenth century on, the Nagô, Gêge, Ijexá, and other ethnic groups of the African diaspora were brought to Brazil as well, and each developed different iterations, or "nations," of Candomblé. The different sects of Candomblé and Umbanda refer to enchantments, saints, or cosmic energies as *inquices, orixás*, and *voduns*. In this essay, these terms will be variously used to refer to the same entities. The Nagô nation calls them *inquices orixás*; the Gêge Candomblé calls them *voduns*. *Inquices,* which take various forms, can be understood through the Guattarian concept of *chaosmosis*, or complexions of forces. Each enchantment has a different name in the various iterations of Candomblé—in the Nagô nation, for example, the lord of disease and healing is called Obaluaê or Omolu, whereas in the Bantu Candomblé, he is known as Kavungo.

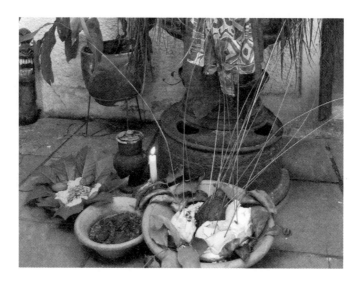

Fig. 1
Macumba offering made to the *inquices/orixás*

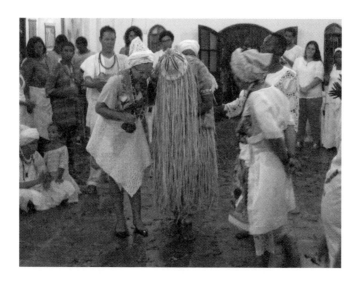

Fig. 2
Kavungo in the Lumyjacarê Junçara house,
Nova Iguaçu, Rio de Janeiro

As if by coincidence, Karin and I met and talked about Candomblé—especially Candomblé Bantu from Angola, the sect in which I am most involved. Candomblé Bantu was brought to Brazil and preserved by black descendants of slaves from N'Gola and Kongo who spoke Bantu languages. Taken to colonial Brazil from the southern region of Africa in the sixteenth century, the Kongo were the first group to be enslaved under the Portuguese empire. In the tradition of Kongo religions, practitioners of Candomblé Bantu worship *inquices* (cosmic, sacred, and ancestral energies or enchantments).[6] In Candomblé, all that came before man is considered an ancestor of man: land and stone, water, sun, fire and iron, air, mountains, and herbs. Kavungo, a prominent enchantment in the Candomblé Bantu, embodies care of the self, of the people, and of community; he is the healer of wounds, both bodily and spiritual, and the energy of health and transformation. Makota Valdina,[7] a ritual elder in the Candomblé community and *filha-de*-Kavungo (holy daughter of Kavungo), calls Kavungo the earth, the energy of the earth, the spirit that nourishes herbs and feeds people. It is, therefore, in praising and dancing for the spirit that practitioners receive the energy that *is* Kavungo[8] (fig. 2).

ê, viva Kavungo
ê, viva Kavungo
ê, viva Kavungo

6. The *inquices* (enchantments or saints) are natural gifts (*dom*), each of which is aligned with different elements in nature. Kayala is the blue or emerald-green sea, the energy of the sea, the spirit of water. Iemanjá is the maternal force, the origin of all living things, the mother of the Nagô tradition. Matamba is the expressive force of lightning and thunder, who in the Nagô nation is called Iansã or Oya. Mother Ndandalunda is the waterfall and the forest, potable water, fertility, and the embodiment of femininity (incarnate in the colors yellow and gold); she is also called mother Oxum.

7. RENAFRO (National Network of Religions of African Origin and Health) & Ministry of Health, *O Cuidar no terreiro* (documentary), 2013.

8. Candomblé followers call themselves sons-of-saint and daughters-of-saint. Saint, in this context, means *inquice, vodun,* or *orixá,* which manifests itself in the body of the son or daughter, in the phenomenon which was once called possession. The father-of-saint or *Tata of inquice* is the highest leader of the Candomblé house of worship or *terreiro.* In this tradition, the holy children act as mediums for the manifestation of spirits and/or divine forces, and prepare themselves for this manifestation by practicing Candomblé rituals.

Nzila, another important ancestral force in the Candomblé Bantu, is the most unrestrained of the *inquice* constellation. In the Candomblé Nagô, Nzila is called Exú. Originally an *orixá* of the African Yoruba religion, Exú later takes on various forms in the different diasporic religions developed by slaves in Brazil. Nzila, or Exú, is both formative and transformative: he is the way by which paths meet and the place wherein time changes, the *encruzilhada* (crossroads). He is the concentrated energy of change, the unexpected encounter, the master of the accidental, of new futures, of communication and exchange. Without communication there can be no encounter, no construction of networks or collectivities. Whenever Nzila is invoked, everything can start anew in a different way, as if the world were child's play. A mischievous and deceitful god who sees all that happens at night, Nzila is what is outside; he is multiplicity, and the source of everything that exists. Exú's consort is Pomba Gira, an independent and free woman spirit who can never be dominated by man, and who, like Nzila and Exú, is an *orixá* of the *encruzilhada*.

Ebó, the Chaosmic Exchange

Macumba, as previously mentioned, is a wide-ranging series of protocols, including taking herbal baths, going to the sea, and doing *ebós*. An *ebó* is an important technique for virtualizing the everyday, catalyzing transformation, performing an energy exchange (of *axé* or *ngunzo*[9]) between the human body and the immanent realm of intensities, the *orun*.[10] This exchange enacts an *encruzilhada*. The story of the *encruzilhada* in Candomblé tells of Icu, the arrogant son of the sky enchantment Oxalá, who, in order to demonstrate his power before the community, announced that he would capture Death. He consulted the oracle and then made an *ebó* to enact his plot. Where would Icu find Death? He laid himself down at the *encruzilhada* to think; pedestrians stumbled upon his body stretched out in the middle of the road. A passerby said: "What is this man doing stretched

9. *Ngunzo* or *axé* is the cosmic energy that forms all that exists.

10. Originally the sun deity in the Yoruba religion, *orun* comes to signify the beyond in Candomblé; the other world to which practitioners gain access by means of Macumba.

out like this in the middle of the road, with his head pointing to the house of Death, his feet toward the realm of illness, and his sides to the places of disagreement?" Hearing this, Icu rose, saying, "I now know all I need to know." Then he went straight to the place where Death lived.[11]

In the spiritual purification process associated with the *ebó*, the *mãe de santo* passes several dishes of saints' food (for example, beans, corn, eggs, cassava flour, vegetables, cachaça, animal sacrifices, flowers, and candles) over the entire body of a *cliente* (client), from head to foot, while murmuring prayers in a low, almost inaudible voice. Transported into an altered state of spiritual experience, the *cliente* receives intense radiations of energy, experienced as a stream of colors, from the *orixá*. This is the gift of the *orixá*, which radically reorders the world of the *cliente*, giving them knowledge of how to change or correct a situation and granting insight into the direction they should take at their own *encruzilhada*. The energetic exchange is not received from the outside: it comes from within the *cliente*'s body. The *ebó*, a force that grows in intensity, is the agent of cosmic energy exchange. As in the story about Icu, the *ebó* alters the *cliente*'s perception on multiple levels, changing the way they experience existence. The exchange operated therein is not merely an interpersonal transmission of knowledge from the *mãe de santo* to the *cliente*, nor does it happen on the anthropophagic level, as man eating another to obtain his power, his spirit, and his knowledge. The experience of becoming within the *ebó* ritual is, rather, akin to cosmophagy, "the devouring of the world by consciousness."[12]

The energy received from the *inquice* mobilizes the body and induces something I would like to call, following Félix Guattari, the "aesthetic decentering of points of view ... preliminary deconstruction of the structures and codes in use and a chaosmic plunge into the materials of sensation,"[13] making possible a recomposition of the

11. Where this story ends and what Icu achieves, the reader may learn in: Reginaldo Prandi, *Mitologia dos Orixás* (São Paulo: Companhia das Letras, 2001).

12. As suggested by Susan Sontag in "Sartre's Saint Genet," in *Against Interpretation and Other Essays* (New York: Penguin Group, 2009 [1963]), 93–99.

13. Félix Guattari, *Chaosmosis: An Ethico-Aesthetic Paradigm*, trans. Paul Bains and Julian Pefanis (Bloomington: Indiana University Press, 1995), 90.

self and an opening of new perspectives. An *ebó* is a point of differentiation, a transformational operator. Through the *ebó*, the body is decentered into an animized space, and heterogeneous subjectivities—subjectivities of the outside—are produced, for the *ebó* is capable of changing corporeal experience, and thus the perception of reality, by working on the level of sensation. As transformative agents, *ebós* resemble assemblages (*agencements*) that collectivize, altering space and perception, and opening new realms of social possibility—much like the actions staged in city squares and streets in conjunction with Occupy.

Karin brought to my attention the space-altering power of street gatherings, of animist spaces, filled with energies that make space vibrate and shift to such an extent that it seems the entire world might change—that a collective practice of resistance could lead to the overcoming of oppressive regimes. Such a change could be what Guattari called the "animist revival,"[14] the recomposition of "machinic subjectivity"[15] through the communal development of new ways of ethical living-together. Karin and I, both considering the transformative power of the *ebó*, were at the same *encruzilhada* in distant parts of the globe.

In the Candomblé Nagô, existence takes place on two planes: *aiyê*, the world of the living and the earth; and the *orun*, the beyond or the invisible. In the act of making an *ebó*, the exchange of spiritual energy takes place between the existent, or actual, in the *aiyê*, and its virtual double in the *orun*. Nzila operates as the messenger between the two realms, which coexist and interpenetrate. According to Juana Elbein dos Santos, "each individual, each tree, each animal, each city, etc., has a double spirit in the *orun*,"[16] the source of all liberating energy. The energetic exchange between realms incorporates chaosmic principles, the energies of nature, *orixás*, *inquices*, and *voduns*, and the human and the nonhuman—all of which are worked upon to enable the transformation of the current reality and the construction of a new one. In the *ebó,* the actual, by receiving *axé* from

14. Ibid., 77.

15. Ibid., 24.

16. Juana Elbein dos Santos, *Os Nàgô e a Morte* (Petrópolis: Vozes, 1976), 58.

the virtual world, enters into a process of alteration, mutation, and transfiguration.

Exú/Nzila, *Inquice* of the Future and Freedom

At the moment of their capture and enslavement, African people cried out: "*valei me, Exú*" (Exú, give me value). Invoking the double, spiritual world of the *orun,* they called upon the virtual to intervene in the physical reality of the European slave trade; they summoned the *orun* to give them strength to desire a different future, the will to freedom, staking their lives on the hope that time would fold in on itself and open, awaiting the sign from Exú to escape. At Exú's appearance, marked by a sharp snap, the course of linear time itself ruptures. In this moment of liberation, the slave is able to become the runaway, escaping to the forest, to the capoeira, to build their *quilombo*. Here, they developed practices of resistance, forming *terreiros* (places of worship) and distinct communities of saints (fig. 3).

Nzila lives at the crossroads between the *orun* and the *aiyê*; at the point of coalescence between these two worlds, he acts as a line of flight (*ligne de fuite*). The ritual or request made to Nzila works against the current, invoking the potency of transformation. This process finds a resonance in the Deleuzian concept of the crystal-image.[17] Gilles Deleuze writes that in cinema, an image can be reflected to the point that it attaches itself as an actual (that is, present and visible) image to its specular double. In this way, "the actual image itself has a virtual image which corresponds to it like a double or a reflection."[18] Thus, "there is a formation of an image with two sides, actual *and* virtual."[19] The "crystal-image" is the junction of the actual image with the virtual image, Deleuze writes, a point of indiscernibility at which an "exchange" takes place, where the actual enters

17. I am indebted to Barbara Glowczewski for her presentation "Lignes de fuite et cristallisation des hétérogénéités: entre totémisme aborigène et umbanda brésilienne" at the *Colloque Deleuze: virtuel, machines et lignes de fuite,* organized by Centre Culturel International de Cerisy, 2015.

18. Gilles Deleuze, *Cinema 2: The Time-Image,* trans. Hugh Tomlinson and Robert Galeta (Minneapolis: University of Minnesota Press, 1989), 68.

19. Ibid.

into a process of alteration. At this point, actuality bifurcates into a future dimension of possibility and another dimension, which disappears. Virtualizing, fragmenting time and space, the production of this point of crossroads—this crystal of transformation—by Nzila is one of the most important operations in Candomblé.

The Double, a Rhizomatic Power

I walk through the streets of Rio de Janeiro, and around the corner, under a tree, a viaduct, or at an intersection, there is a small offering with cassava flour, cachaça, candles, coins, or a dead bird. The space twists, it seems strange, it is altered. What we know as reality—the street, the asphalt, the cement structure—is transfigured by vibrations coming from this offering. We feel a tremor or imbalance indicating danger, a movement that cannot be seen, at once veiled and explicit in the offering: a connection with a world outside the world, which is not a metaphysical beyond, but rather, immanent—on the plane of sensation. In a city that seems familiar, a moment of sudden virtuality arises. A crystal of knowledge is produced, not as an object, but rather as a vibration that virtualizes, as if the offering carried the other face of reality, its double, its *orun* manifestation, the dark side, the intensity in which the coalescence of the actual with the virtual occurs.

Encruzilhada: An Animist Space

This intense *encruzilhada*, this crystal of coalescence between worlds, is well known to all Candomblé followers and perhaps to all Brazilians. The offering on the street, called a *despacho* or *ebó*, signals another scene; it is impossible to know what happens there, as it is uncertain and errant. At the *encruzilhada*, space twists and changes. Is this not an animist site? I talked to Karin about Exú on the Street, a course I taught in the department of psychology at the Universidade Federal Fluminense, Niterói, Brazil, which considered spatial transformations in the city that occur because of experimental public practices such as Umbanda rituals, in which offerings are made to Exú under the trees or in street corners of the city.

Crowds of people, too, can alter the urban landscape, as in *Ocupa Rio*. The common space of the city opens up to welcome the formation of communities, such as the occupation of Cinelândia Square—the site becomes animated, animized. A certain set of invisible forces emerges within the square, altering its function as a mere public plaza (fig. 4, 5).

Animist space is the inspiration that shaped my conversation with Karin; this concept connects performative actions, the occupation of the city by masses of people, the history of black resistance in Brazil, and Macumba. In October 2011, a crowd occupied Cinelândia Square, located in the city center of Rio de Janeiro. It was the *Ocupa Rio*, inspired by political movements in northern Africa, Spain, Greece, London, Chile, and by Occupy Wall Street. In the assemblies of the occupation and debate groups in Cinelândia Square, the goal was to implement a new form of government, or to dissolve government altogether—for Rio de Janeiro, for Brazil, and for the world, working together and in a lively combination of colors. Even more than that, we desired to bring about a new human solidarity.

David Harvey called these kinds of occupations "heterotopic spaces,"[20] liminal social zones in which something different is possible: something people do, feel, perceive, and elaborate according to the meaning they seek in their lives. In the heterotopic space, people may become aware of the collective possibility of creating or learning something new. Such spaces resist the imposition of the existing order; they are disobedient zones of socialization, for the struggle of those who seek a collective way of living—one that promotes affective, political, and ethical belonging. It seems to me that they are also spaces for the production of heterogeneous sensibilities. Occupation reveals the strength of community in the animization of space, mobilizing against the forces of neoliberal capitalism.

Animist Spaces, *Quilombos*, and *Quilombismo*

There is no doubt that the occupation of Cinelândia Square felt like a kind of immense Umbanda offering, able to animize a common space

20. David Harvey, *Rebel cities: From the Right to the City to the Urban Revolution*, (New York: Verso, 2014), 22–23.

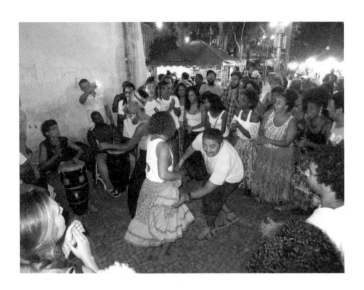

Fig. 3
The Lumyjacarê Junçara community center
in Nova Iguaçu, Rio de Janeiro

Fig. 4
An *Ocupa Rio* camp in Cinelândia Square,
Rio de Janeiro, October 2011

within the city through collective energy, bringing about a new relationship among the people and a new experience of citizenship. The dimensions of the actual and the virtual seemed to be on the verge of splitting open to create an autonomous zone. Such is the ultimate form of political activism: I looked at the square and saw *Exú na rua* (Exú on the street).

Those who know the history of black struggle from the establishment of the nation of Brazil to the present day can see the strength of the connection between insurrection and Candomblé. Sociologist Muniz Sodré emphasizes the capacity of black people in Brazil to generate "forms of autonomous community life"[21] in the face of terrible living conditions and the exclusion from citizenship that they suffered even after the abolition of slavery in 1888. During the colonial period, runaways (as colonial power defined slaves who sought freedom) created politically, socially, economically, and culturally autonomous zones called *quilombos* or *mocambos*, where they developed and enacted new forms of resistance.[22] *Quilombos* were city-states within Brazil, created and populated by escaped slaves. Within these zones, Candomblé played a prominent role. The entire colonial economy was gradually dissipated by the formation of these autonomous city-spaces. The largest *quilombo* (with over 30,000 citizens at its height), and the most important zone of resistance created by Brazilian slaves, was Palmares. This *quilombo* is possibly the most important heterotopic space in the history of Brazil; its last leader, Zumbi dos Palmares, whose name comes from Nzambi, meaning "Great Creator" in Bantu language, could also be considered the country's first democratic leader. Palmares lasted from 1605 to 1694, when, after years of resistance and war, it was destroyed by the Portuguese army.

Inspired by the long experience of resistance and the formation of *quilombos,* Abdias Nascimento, in the Second Congress of Black Culture in the Americas (1980) in Panamá, articulated the concept of

21. Muniz Sodré, *O terreiro e a Cidade* (Petrópolis : Vozes, 1988), 42.

22. Clovis Moura demonstrates that the *quilombo* or *mocambo* is the basic unit of resistance created by groups of escaped slaves. See Clovis Moura, *Rebeliões da senzala: quilombos, insurreições, guerrilhas* (São Paulo: Anita Garibaldi Edições, 2014), 163.

quilombismo.[23] *Quilombismo* is the Afro-Brazilian practice of continuing the tradition of political and social resistance and preserving the long history of this struggle. It operates through a network of associations, confraternities, *terreiros, afoxés* (ritual dances of Candomblé), and samba schools, in cities and throughout the countryside (fig. 6). *Quilombismo* was fully active and enacted when, for example, the Agbara Dudu *afoxé* group sang, in a carnival parade in 2016, "I want to have a quiet *quilombo* to live in."[24] Indians, mestiços, dissenting whites, Jews, Muslims, and various other disenfranchised people were also welcomed in the *quilombos* during the colonial period, participating in collective decision-making in village assemblies and community duties. Today, more non-black Brazilians are exploring religions of African origin[25] (fig. 7).

In *afoxé*, samba, capoeira, and Candomblé, everything is sacred and worshipped; these traditions are affective zones of celebration as well as resistance. The cult of natural forces stands as a key aspect of resistance and lends to the re-creation of the self and the world. African descendants do not engage in struggle without first feeding and worshipping their gods, without celebration, without nourishing themselves reciprocally from the sacred force, *ngunzo, axé, asuwa.*[26] These animist zones carry the winds and the energies of change. They are the crystals that reveal the dimensions of the future, the time they promise will come. In the time of their emergence, the *quilombos* pointed to a revolutionary liberation for a people yet to come: they were places for the practice of freedom, of ethnic and ancestral ties, of black solidarity and communitarianism. *Quilombismo* persists

23. Abdias Do Nascimento, "Quilombismo: an Afro-Brazilian Political Alternative," *Journal of Black Studies,* 11, no. 2 (1980): 141–178.

24. Today, black Brazilians have been granted the constitutional right to their *quilombo* in the form of land—a right that is rarely, and only begrudgingly, enforced by the government. A key struggle of *quilombismo* today is that the descendants of escaped African slaves be able to maintain their ancestors' land: essentially, the fight for the largest slavery reparations program in the history of the world.

25. Anticipations of this wider embrace of *Quilombismo* might be seen in Guattari's writing on the production of subjectivity. See Félix Guattari, "De la production de subjectivité," *Revue Chimères,* no. 4 (1986): 1–19.

26. Akinsola A. Akiwowo, "Contributions to the Sociology of Knowledge from an African Oral Poetry," *International Sociology,* 1, no. 4 (1986): 343–58.

Fig. 5
An *Ocupa Rio* camp in Cinelândia Square,
Rio de Janeiro, October 2011

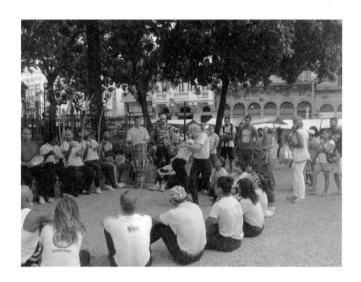

Fig. 6
Jongo circle in Lapa, Rio de Janeiro

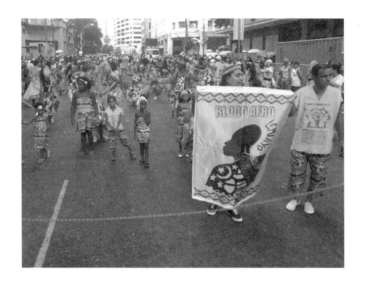

Fig. 7
Afro Carnival Group, Rio de Janeiro
Carnival, 2016

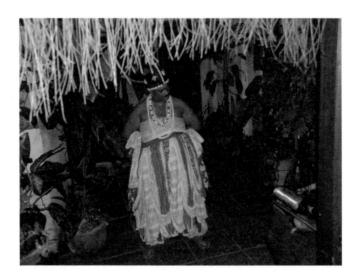

Fig. 8
Nzazi, the *inquice* of justice, manifest in
Tat'etu Luazemi, Roberto Braga

and is rekindled by these zones and assemblages (*agencements*) of black resistance.

Macumba: The Opening onto the Future

The Afro-descendant Brazilian population praises, celebrates, sings, and dances for their ancestors. In resistance, in the continual invention of existence, in the confrontation of pain and racism, the heterotopic spaces or animist zones contain people of all skin colors. The cult of the ancestors—Candomblé—infuses life with the colors of Black Africa: colors in motion, streams of light as if the coming morning were in collusion with the night. Here, there is no sense of sadness, nihilism, or melancholy. Resisting is part of life and black people should augment the animist energy of *ngunzo* in ritual every day, so that life becomes full of joy. These are rituals of joy, like the *orixá* Angorô's rainbow after heavy rainfall, indicating beauty as a gift of nature and connecting the sky to earth; like Nzila's willingness to eat everything; like the golden-yellow emanation of mother Ndandalunda, the blue-green of Kayala; the glowing red-yellow of Nzazi, the enchantment of justice, of the fire, of lightning streaking across the sky; the straw color of Tata Kavungo, which cures the body and the soul. Roberto Braga, named Tat'etu Luazemi in Candomblé, once told me, "Candomblé is pure energy: the energy of the leaves, of the water, of rain. The energy of the slaughter, the energy of the *ebó*"[27] (fig. 8). Even the red of warm blood is pure energy, which will be transformed in the process of calling upon time, saying that the struggle is never-ending, a continuous state of ancestral chaos in which everything becomes transformation and eternal renewal. Black spirituality and black resistance have at their core a set of energies of the earth or animism, a power to transform all that exists, human and nonhuman. The bright colors of blood, of palm oil, of honey, of cachaça, the foods-of-saints, *orixás*, *inquices*, and *voduns*, are also the colors of animism and resistance, of the liberated zone or the zone of new political practices. With this writing, I continue my conversation with Karin, who is now immersed

27. Notes from the author's field journal, October 30, 2015, Roberto Braga's ranch.

in her own work, its movements, its will to animism, to healing, and the search for animist spaces. Karin, we have talked, but we have not yet finished …

Excerpted from Jean-Luc Nancy's After Fukushima: The Equivalence of Catastrophes, *trans. Charlotte Mandell (New York: Fordham University Press, 2015). In this adaptation, a full break between paragraphs indicates excised text.*

After Fukushima:
The Equivalence of Catastrophes

Jean-Luc Nancy

Preamble

The subtitle should not mislead: Not all catastrophes are equivalent, not in amplitude, not in destructiveness, not in consequences.

The "equivalence" of catastrophes here means to assert that the spread or proliferation of repercussions from every kind of disaster hereafter will bear the mark of that paradigm represented by nuclear risk. From now on there is an interconnection, an intertwining, even a symbiosis of technologies, exchanges, movements, which makes it so that a flood—for instance—wherever it may occur, must necessarily involve relationships with any number of technical, social, economic, political intricacies that keep us from regarding it as simply a misadventure or a misfortune whose consequences can be more or less easily circumscribed.

The complexity here is singularly characterized by the fact that natural catastrophes are no longer separable from their technological, economic, and political implications or repercussions.

The complexity of interdependent systems (ecological or economic, sociopolitico-ideologic, technoscientific, cultural, logical, etc.) and the existing chains of constraints (electricity, gasoline, uranium, all the rare minerals, etc.)—and their implementation (their civilian and

military, social and private uses, etc.)—depend on a general inter-connection: that of the money by which all these systems function and to which, in the last analysis, they lead back, since any operation of fabrication, exchange, or distribution must lead to profit. This interconnection expresses an economy guided by the production and self-production of wealth, from which streams an incessant produc-tion of new conditions, norms, and constraints of life—not by the reproduction of conditions of existence or the extravagant hoarding of vainglorious wealth. The morphing of the second into the first was the product of what we call "capitalism"—that is, as we know, the process engendered by the accumulation of capital destined for profitable investment and not for vainglorious ostentation.

Marx called money a "general equivalent." It is this equivalence that is being discussed here. Not to think about it by itself, but to reflect that the regime of general equivalence henceforth virtually absorbs, well beyond the monetary or financial sphere but thanks to it and with regard to it, all the spheres of existence of humans, and along with them all things that exist.

This absorption involves a close connection between capitalism and technological development as we know it. More precisely, it is the connection of an equivalence and a limitless interchangeability of forces, products, agents or actors, meanings or values—since the value of any value is its equivalence.

Catastrophes are not all of the same gravity, but they all con-nect with the totality of interdependences that make up general equivalence. What's more, we must not forget to include wars in this interconnection, more particularly all the modern transformations of the concept and practices of war: "partisan" war, guerrilla war-fare, "total" war, "world" war, police operations called "wars," and so on—the systematic development of both heavy and light arma-ments that favor the proliferation of war and its effects on so-called civilian populations as well as on cultures, herds, soil, and so on. Not to ignore economic warfare, which constantly agitates the system of general equivalence from within.

In brief, it is this equivalence that is catastrophic.

Fukushima, in the beginning of the twenty-first century, revives fears
and questions that the twentieth had unleashed for the first time
on a large scale and that the century before it had manifested, the
century that emerged from the twofold industrial and democratic
revolution, the century of the "conquering bourgeoisie."[1] This con-
quest has changed—into a domination no longer by the "bourgeois"
but by the machine they had served and into a dissipation of what
seemed to give meaning or value to that conquest. Meaning and
value—which Marx called alienated under general equivalence—
themselves become catastrophic, following the Greek etymology of
catastrophe, upheaval, reversal, overturning, collapse.

1

"To philosophize after Fukushima"—that is the mandate I was
given for this conference.[2] Its wording inevitably makes me think of
Adorno's: "To write poetry after Auschwitz." There are considerable
differences between the two. They are not the differences between
"philosophy" and "poetry" since we know those two modes or reg-
isters of spiritual or symbolic activity share a complex but strong
proximity. The differences, of course, are those between "Fukushima"
and "Auschwitz." These differences should certainly not be ignored
or minimized in any way. They should, however, be correctly under-
stood. I think that is necessary if I want to give the question I was
given a conscientious answer.

First of all, we must remember that Auschwitz has already
been several times associated with Hiroshima. The outcome of what
is called the Second World War, far from being conceived as the
conclusion and peace that should mark the end of a war, presents
itself rather as a twofold inauguration: of a scheme for annihilating
peoples or human groups by means of a systematically developed
technological rationality, and a scheme for annihilating entire pop-
ulations and mutilating their descendants. Each of these projects

1. According to the title of the book by Charles Morazé, *Les Bourgeois conquérants,
 XIXe siècle* (Paris: Armand Colin, 1957).
2. Videoconference by invitation, in December 2011, of the International Research
 Center for Philosophy at Tokyo University.

was supposed to serve the aim of political domination, which is also to say economic and ideological domination. The second of the two was, moreover, linked to the first by the fact that the war of the United States with Japan entrained the one in which America engaged with Nazi Germany and also induced anxious relations with the Soviet Union.

<div align="center">2</div>

Here we have now the name of Fukushima. It is accompanied by the sinister privilege that makes it rhyme with Hiroshima. We must of course be wary of letting ourselves be carried away by this rhyme and its rhythm. The philosopher Satoshi Ukai has warned us about this risk in recalling that the name "Fukushima" does not suffice to designate all the regions affected (he names the counties of Miyagi and Iwate); and we must also take into consideration the traditional overexploitation of northeastern Japan by the central government.[3] We must not in fact confuse the name Hiroshima—the target of enemy bombing—with that of Fukushima, a name in which are mingled several orders of natural and technological, political and economic phenomena.

At the same time, it is not possible to ignore what is suggested by the rhyme of these two names, for this rhyme gathers together—reluctantly and against all poetry—the ferment of something shared. It is a question—and since March 11, 2011, we have not stopped chewing on this bitter pill—of nuclear energy itself.

<div align="center">3</div>

What can "after Fukushima" mean?

The "after" we are speaking of here stems ... not from succession but from rupture, and less from anticipation than from suspense, even stupor. It is an "after" that means: Is there an after? Is there anything that follows? Are we still headed somewhere?

3. Speech by Satoshi Ukai at the "Nuits du 4 août" 2011 in Peyrelevade, France.

4

Civilization of the irremediable or an irremediable civilization?

We might wonder if it is truly a matter of civilization in its entirety, since "civilian" use of the atom is distinguished from its military use. First, we must remember that military technologies are of the same nature as the others—they borrow from and contribute to them many elements. But we must say more and must begin by calling into question the distinction (to say nothing of the contrast) between military and civilian. We know that the concept of war has changed considerably since what were termed "the world wars" and after all the "partisan" wars,[4] wars of colonial liberation, guerrilla warfare, and generally, the involvement of war—armed or else economic, psychological, etc.—in many aspects of our communal existence.

If this civilization turns out to be at the same time a civilization of war against ourselves and against the world, if mastery coils back on itself subjecting us to ever-increasing constraints as we try to escape the previous ones, replacing every kind of progress with an aggravation of our condition, and if what had been the power of the people—the power of their technologies but also of their abilities to resist them—finally sets about exercising an autonomous power over them and over the rest of beings, then we are faced with a task as urgent as the task of making the broken reactors of Fukushima and the substances that have escaped from them powerless to cause harm.

Our time—as it has been able to see itself at least since the first "world war"—is the era that knows it is capable of an "end of days" that would be a deed created by humans.

5

Nuclear weapons have engendered by their power a strategy of dissuasion sometimes hailed as a new condition of peace and often

4. Term used by Carl Schmitt.

called the "balance of terror." As we know, this balance itself gives rise to the wish to possess nuclear weapons in order to become in turn an agent of this balance, that is, a threat of terror. Of this terror, it should be said in passing, we might inquire what unperceived links it shares with what we call "terrorism," which existed before nuclear weapons. Generally we can say that terror designates an absence or an overvaulting (*outrepassement*) of relationship: It acts by itself, alone; it does not engage a relationship.

Whereas the balance of power (*le rapport des forces*) was a relationship (*rapport*), despite everything, the balance of terror annuls any relationship. It replaces it by what the word balance designates: the equivalence that annuls tension by keeping it equal and constant. There is no longer strictly speaking a confrontation; there is no longer strictly speaking any confrontation with the other since it is absolutely the same confronting the same. And its power is such that it can almost no longer be thought of as depending on human wills that are supposed to command its use: A mere mistake or a stroke of madness could set off its use and plunge us into the horror of an unspeakable devastation.

<div align="center">6</div>

With equivalence and the incalculable we have already extended our perspective beyond nuclear use by the military. In fact, with these two features we can characterize not just the general use of nuclear energy but, even more widely, the nature of the general disposition of force in this world we have given ourselves.

Equivalence means the state of forces that govern themselves in some way by themselves. Whether it is a question of a broken nuclear reactor or a bomb, whether the reactor or the weapon is more or less powerful, the excessiveness of their effects in space and time makes them equal to the excess associated with the means of controlling them and even more of neutralizing them. This is not absolutely new: Coal, electricity, and oil have already brought these problems with them, sufferings or wounds of civilization that exceed the capacities of technical as well as political control. We can, for instance, struggle

to advocate for the electric car, but as of now there is no likelihood of its replacing gasoline-powered cars. There is a great likelihood, though, of the exhaustion of petroleum resources.

Once we have replaced the given, nonproduced forces (the ones we used to call "natural," like wind and muscle) with produced forces (steam, electricity, the atom), we have entered into a general configuration where the forces of production of other forces and the other forces of production or action share a close symbiosis, a generalized interconnection that seems to make inevitable an unlimited development of all forces and all their interactions, retroactions, excitations, attractions, and repulsions that, finally, act as incessant recursions (*renvois*) of the same to the same. From action to reaction, there is no rapport or relation: There is connection, concord and discord, going and coming, but no relation if what we call "relation" always involves the incommensurable, that which makes one in the relationship absolutely not equivalent to the other.

<div align="center">7</div>

No one can truly calculate the consequences of Fukushima, for humans, for the region, the earth, the streams, and the sea, for the energy economy of Japan, for calling into question, abandoning, or increasing control of nuclear reactors all over the world, and thus for the energy economy worldwide. But all this is incalculable because it challenges the capacities of calculation whereas, at the same time, what we plan or project remains within the order of calculation, even if it is out of our reach.

There has arisen in the world, and it is arising *as a world* (just like that *plurality of worlds* contemplated by contemporary physics), a circulation, an interaction, a communication, and information in the strong, intense sense of these words, which place existences in an ever tighter and more networked interrelation and interdependence. A major element of this interconnection is the incalculable in the form of the very large number. The very large number—from which stem both what we call the cosmic "infinitely great" and also

the subatomic "infinitely small"—is manifested on the scale of our own experience as the human population (soon to be seven billion as I write these lines) as well as in the quantities of energy consumed, transportation carried out, products made, patents registered, contracts concluded. These large numbers are both effects and agents of this general and increasing interconnection. They are also what multiplies the effects of natural phenomena—independent of the fact that these phenomena can be themselves affected or provoked by technological causes. A hurricane, a tsunami, a drought today may have effects of a magnitude incomparably beyond what they had been just a hundred years ago.

8

Fukushima is a powerfully exemplary event because it shows the close and brutal connections between a seismic quake, a dense population, and a nuclear installation (under inadequate management). It is also exemplary of a node of complex relationships between public powers and private management of the installation, not to mention all the other chains of correlation that extend out from that starting point.

These risks are not limited to the nuclear industry—and I think we must, in order best to reflect on our future, go beyond focusing exclusively on the nuclear. We must add to its risks the others linked to all our technologies, whether it's a question of carbon dioxide emissions or depleting various species of fish, whether it's a question of biogenetic and biometric technologies, nanotechnologies or electronic-financial technologies.

There is, however, a technology that gathers into itself in the purest (if we can use that term) state the features of general interconnection, equivalence, and the incalculable. It is the monetary technology from which capitalist civilization has developed—since that is indeed its proper name. By designating money as "general equivalence," Marx uttered more than the principle of mercantile exchange: He uttered the principle of a general reabsorption of all possible values into this value that defines equivalence, exchangeability, or convertibility of

all products and all forces of production. The word *value* should not make us think of those idealist entities that were and for some still are "values," those fetishes, reductions of meanings called "home-land" or "honor," "justice" or "family," "man" or "*care.*"[5] Meaning here is reduced, since it is fixed in place, registered, represented—and these representations are precisely the reified residue of the loss of meaning that takes place in the endless fluxes of equivalence.

5. In English in original. —Trans.

The Masterless Object

Sabu Kohso

The Japanese term *mushubutsu* (無主物) is translated into English as either "masterless object" or "ownerless object," and corresponds to *res nullius* (nobody's property) in Roman law. It refers to anything—land, plants, animals, slaves (or labor power), fire, etc.—that is not yet or no longer the object of any specific subject in the legal sense.

In post-nuclear-disaster Japan, the term captured public attention when the Tokyo Electric Power Company (TEPCO) made a notorious statement at the hearing against the company in November 2011, saying that radioactivity was *originally* a masterless object that did not belong to it, and that therefore the company was not responsible for cleaning up the radioactive nuclides unleashed from their crippled nuclear reactors. TEPCO argued that removing these nuclides from the property of the plaintiff, Sunfield Nihonmatsu Golf Course, would be an unheard-of challenge and would cost an astronomical sum, as the nuclides could no longer be separated from the land.[1]

In using the concept of *mushubutsu*, TEPCO implied that its ownership of the energy commodity—split atoms of uranium—was limited to circumstances in which atomic energy was confined within constant capital (the nuclear reactors), and when the reactors were running smoothly and accruing profit. However, once that enclosure was

1. Asahi Newspaper editorial group, *Prometheus no wana* [The Trap of Prometheus] (Tokyo: Gakken Publishing, 2012), 114–17.

torn apart, the unleashed radioactivity was no longer under TEPCO's *technical mastery* and *corporate ownership*. Simply put, TEPCO claimed that once nuclear energy misbehaved, the company was no longer obligated or even able to take care of it. TEPCO's treatment of this special commodity thus began to mirror the ways in which the company had always treated its variable capital (human nuclear labor): disowning it once it developed radiation-related diseases and began to malfunction. This follows the modus operandi of capitalism, which is to extract resources from society and the environment (in the form of capital) and impose back on them the waste created. Such is the formula of all industrial pollution. But in the instance of Fukushima and all other radioactive leaks, the consequences are catastrophic, as this particular waste cannot be recycled by any known procedure, and its nano-activity will ceaselessly attack and genetically mutate all life forms in the surrounding environment. Nuclear contaminants behave like a group of disowned workers, roaming society and posing a threat to its stability. Following the logic of capitalism, these unleashed objects need to be *reowned* by the company and *remastered* through governance. Otherwise, the situation might lead to an unknown sociobiological mutation—an anarchy.

TEPCO's self-exemption from responsibility was alarming but anticipated; it was not a surprise that the company would sacrifice *anything* to prioritize its corporate interests. At the time of the 2011 hearing, the desperate entreaty of TEPCO executives for permission to abandon the crippled reactors and evacuate their workers from the area was still vivid in collective memory. This request came during a critical phase immediately following the March 2011 earthquake and tsunami, when the exploding reactors could have caused significantly more dire consequences—making a large part of Japan unlivable for years on end—had they been abandoned. Japanese prime minister Naoto Kan rejected TEPCO's request and issued an executive order demanding that the company remain on-site to continue tackling the devastating conditions. As the world knows, it is still doing this.[2]

2. See Keiji Takeuchi's article "Remain or Withdraw," *WebRonza*, accessed July 27, 2016, http://astand.asahi.com/magazine/wrscience/2012032000009.html.

During the past five years, we have learned or have been reminded of the following truths about nuclear energy: (1) It is fundamentally impossible to manage radioactivity; (2) Despite this, the Japanese government, the electric power industry, and the nuclear power industry insist on restarting offline reactors and seek to expand participation in foreign markets in which to sell the nation's nuclear technology; (3) Other nuclear states (consisting of the world's great powers) give these actions tacit approval for their own benefit; (4) Unrecyclable radioactive waste is accumulating without proper protection; (5) No political protests or activist movements in Japan or the world seem able to stop this global threat of the nuclear sublime. And all the while, people struggle endlessly to protect their lives against nuclear radiation.

Strange as it may sound, the concept of the masterless object shares ontological characteristics with that of the commons, which puts forth the idea that all natural resources, human labor, intelligence, and technology be put to communal use, not yet or no longer to be commodified and privatized. The concept of the commons originated in the environment in the broad sense, referring to environmental resources that were not (yet) owned or mastered by particular humans. There are many forms of commoning, beginning with the sharing of solar energy. The sun offers its free and universal gift of endless energy (which it creates via nuclear fusion) to its offspring, the planetary body and its inhabitants. In this scenario, the offspring can sustain itself only by keeping a proper distance from the parent, the sun. From the vantage point of the planet and its inhabitants, the sun can be figured as the primary commons, and a fundamentally masterless object.

Prometheus, who in Greek mythology stole fire from Olympus and gave it to mankind, and who then suffered Zeus's eternal punishment, can now be spoken of as having discovered radioactivity. Similarly, the nuclear reactor is often called a "small sun." In this allegory, the history of nuclear activity—human production of radioactivity in laboratories, the invention of the nuclear bomb by the Manhattan Project, and the subsequent conversion of nuclear power into an energy source for civilian, military, and governmental use—represents humanity's desecration of the sun. The eternal punishment inflicted on humanity for this act is the unprecedented threat of the

nuclear against all living beings. The series of modern nuclear catastrophes, including Hiroshima and Nagasaki in 1945, SS *Lucky Dragon 5* (*Daigo Fukuryū Maru*) in 1954, Three Mile Island in 1979, Chernobyl in 1986, and Fukushima in 2011, has proved that, for the masses, any engagement with nuclear energy—whether in nuclear warfare, possible reactor accidents, or the uncontrollable accumulation of unrecyclable waste—ends up having the same effects on living bodies: namely, the potential for internal and external exposure to harmful radiation. Even when it is used intentionally, either as a weapon or as an energy source, nuclear power belongs to the genetic category of the Accident: the half-life of nuclear decay spans an astronomical length of time (24,110 years); this material can only be artificially and temporarily encased, waiting dormant for the anticipated wearing away or breaking down of its enclosure.

Be that as it may, can we really consider nuclear development an act of "humanity"? Can we really see the catastrophic consequence it has exerted as the "punishment" of humanity by a transcendent force? In light of the political ontology of the commons, it is imperative to account for the effects of nuclear spillage. The principle of commoning prioritizes the willingness and capacity of a community to recycle "negative commons,"[3] or for waste to be treated as commons. In other words, a community must declare itself responsible for taking care of the leftovers of its life processes. Commoning is not only a set of principles for communally organizing access to wealth (natural or social) but also a set of principles for reintegrating waste, toxins, and hazardous byproducts of production and consumption into the regenerative cycles of various ecosystems on which communities depend.[4] It has proven impossible to do this with radioactive waste, which remains in our immediate living environment for a staggering duration of time and can never be assimilated into the ecosystem's metabolic cycles. Radioactive waste is thus

3. Maria Mies and Veronika Bennholdt-Thomsen, "Defending, Reclaiming and Reinventing the Commons," *Canadian Journal of Development Studies* 22, no. 4 (2001): 997–1,023.

4. George Caffentzis, "Against Nuclear Exceptionalism with a Coda on the Commons and Nuclear Power." Lecture delivered at Crisis and Commons Conference, Tokyo, December 2, 2012.

the ultimate form of negative or absolute commons, removed from a safe distance—a distance of many millions of miles, which protects the Earth offspring from its sun parent—and now produced within Earth's own atmosphere.

Historically, however, nuclear waste as a negative commons has never been generated by a community of people who have practiced commoning. It has instead been created by the specific form of industrial-capitalist governance that appeared in the twentieth century, consisting of expansive warring states, the energy and military industries, and vanguard scientists. Nuclear projects were developed by this specific power *dispositif*, and not by humankind en masse responding to a necessity. Despite this, the effects of nuclear governance are imposed on the entirety of humanity and all living organisms. This asymmetry has caused many thinkers to speak emphatically of the nuclear threat as being the concern of all humanity, especially after the bombing of Hiroshima and Nagasaki in 1945—the event that defined antinuclear discourse in the postwar period. Before discussing this further, there are two issues that must be addressed: (1) The effects of nuclear energy affect all humans, but with distinct *unevenness*; (2) Figuring nuclear threats as the punishment of humanity by a transcendent force is misleading, because the word *punishment* blinds us to the fact that these effects function as intolerable and crystallized ways of *governing* human life. They are, essentially, forms of biopolitics—indeed, forms of necropolitics.[5]

Despite early expectations and hopes, the collusion of nuclear capitalism and the nuclear state in Japan has caused five years of wide-ranging disaster. Beginning in December 2011, the state and Fukushima Prefecture set forth a line of policy starting with: (1) Radioactive decontamination; (2) Repatriation of evacuated

5. I here invoke Michel Foucault's idea of biopolitics, first advanced in his 1975–76 lectures at the Collège de France, "Society Must Be Defended," and Achille Mbembe's development of the idea into a theory of "necropolitics," wherein "the ultimate expression of sovereignty resides ... in the power and the capacity to dictate who may live and who must die ... to kill or to allow to live constitute the limits of sovereignty, its fundamental attributes. ... [T]he political, under the guise of war, of resistance, or of the fight against terror, makes the murder of its enemy its primary and absolute objective." Mbembe, "Necropolitics," trans. Libby Meintjes, *Public Culture* 15, no. 1 (Winter 2003): 11–40.

residents; (3) Reconstruction of the region. The publicized goals of the state and industry have grown more and more distant from the actual situation in which commoners are living and struggling, wherein decontamination efforts create endless piles of radioactive soil and debris simply packed into and stored in plastic bags, and attempts to seal the collapsed reactors have been futile. Indeed, in comparison with this reality, statements made by the government and corporations now sound like sheer fantasy. In accordance with this false narrative, state propaganda campaigns have fabricated the image of a "safe Fukushima" by cancelling the evacuation order and rearranging evacuation zones, lowering the level at which radiation is considered safe and areas decontaminated, dismissing consumers' vocalization of fear as "inciting rumors," and so forth. In Miharu Township and Minami Soma City, Fukushima, the Center for Environmental Creation (Kankyo Sozo Center)[6] is being established using ¥19 billion ($174 million) from the budget for the Revitalization of Fukushima, an initiative managed by Fukushima Prefecture, the Japan Atomic Energy Agency, and the National Institute for Environmental Studies. The International Atomic Energy Agency (or Atoms for Peace), too, has relocated one of its offices to Fukushima to conduct research on radioactive decontamination and waste treatment, as well as to educate people on radioactivity.[7]

In this way, the post-nuclear-disaster state absorbs the devastating effects of nuclear spillage and rearticulates them as positive modes for empowerment by means of governance, making profit from nuclear waste (the ownerless object) and recapturing and mobilizing disaster victims, including evacuees (the masterless objects), for the so-called reconstruction of Fukushima. In collaboration with the pro-nuclear powers of the world, the Japanese state is determined to make Northern Honshū (and, eventually, the

6. Indeed, the irony of the word *sozo*, which means "complete restoration of the body, soul, and spirit; to save, heal, and deliver; to be made whole," cannot be ignored in this context, wherein the government is attempting to recast themselves as a rejuvenating and revitalizing force for the country's health.

7. Muto Ruiko, "A Report of the Complainants for the Criminal Prosecution of the Fukushima Nuclear Disaster," in *The Post-Fukushima Philosophy* (Tokyo: Akashi Shoten, 2015), 181.

entirety of Japan) a test site for a new type of commercial enterprise in the form of radioactive-waste treatment—including the doomed attempts to start the *actual* operation of Rokkasho Reprocessing Plant in Aomori Prefecture.

As a consequence of this national project, more and more people nationwide will develop various types and degrees of radiation-related illnesses, but unevenly. The first and most acutely affected will be those living near test sites; nuclear workers; farmers; sanitation workers who handle soil and waste; the homeless population, who are constantly exposed to open air; and infants and children, who are more radiosensitive to leukemia, as well as thyroid, skin, and brain cancers.

It is essential to stress that the primary byproduct of nuclear-reactor activity is reactor-grade plutonium, which contains more than 19% Pu-240, and which can be used in nuclear weapons.[8] Countries that produce large amounts of nuclear energy for civil use as fuel, including the United States, Russia, the United Kingdom, France, China, India, Pakistan, and North Korea, are also overwhelmingly armed, or assumed to be armed, with nuclear weapons—with the exception of Japan. This is to say, Japan tacitly reserves the capacity and authority to be armed with nuclear weapons, or at least to be a part of nuclear-weapons agreements in global politics. The escalating rearmament policy of the present Shinzō Abe administration can be seen, then, as Japan's attempt at reentry into the competition among nuclear states for planetary governance.

The world has moved through different and distinct phases by means of migration, trade, cultural exchange, infrastructural, scientific, and techno-industrial development, and war—all of these in interaction with intraplanetary movements over territories small and large, regional and transcontinental. The driving force behind each phase has always been the impetus of governance toward

8. There are two types of plutonium: weapons-grade and reactor-grade, which are not made in the same processes or using the same equipment. Although both can be used to make atomic weapons (which require at least 92% pure Pu-239), weapons-grade plutonium is far more effective for this purpose. Bombs made with larger amounts of reactor-grade plutonium would be unstable, unpredictable, and dangerous to their creators and handlers.

totalization. As more or less blood is spilled, various totalities emerge from distinct governmental motivations, producing specific "world pictures."[9] But behind and under these main drives are layers of other worlds, all of which contain unrealized potentialities hidden by the dominant world picture. The present world picture is an extension of the imperialist West's colonial expansion and the subsequent formation of global capitalism, which coalesced into the current cartographic configuration of sovereign states and transnational alliances at the end of the Second World War. The rising tensions of the bipolar nuclear arms race between the United States and the USSR during the Cold War invoked memories of Auschwitz, the Nanking Massacre, and Hiroshima and Nagasaki. In the time of this fateful conjuncture, great antiauthoritarian, antinuclear thinkers such as Lewis Mumford, Günther Anders, Hannah Arendt, and Robert Jungk imagined a picture of the coming world as a totality threatened not only by the potential of humankind's self-extinction but also by the governmental mode of total control and the irrationality of techno-industrial development.

At the end of the Cold War, the temporary stasis of nuclear deterrence (in which the United States forestalled the Soviet Union's use of nuclear power by stockpiling its own weapons) was over, and the current age of *preemption* among multiple nation-states had arrived, with the United States and USSR acting increasingly bellicose in order to develop greater spheres of influence vis-à-vis a number of newly participating nuclear states. Now, wars are fought (at least, in an official capacity) less between two nation-states than between individual nation-states and multilateral forces; the world today is, more than ever, driven simultaneously by totalizing impetuses and the resistance to totalization by defined and delineated territories.

At the same time, totalizing threats against humanity are no longer limited to the nuclear. Increasingly, effects of industrial development such as global warming are imposed on us. The philosopher Timothy Morton describes both omnipresent and totalizing threats

9. Martin Heidegger, "The Age of the World Picture," in *The Question Concerning Technology, and Other Essays*, trans. William Lovitt (New York: Garland, 1977).

as "hyperobjects": "things that are massively distributed in time and space relative to humans"; large-scale processes and configurations that are increasingly understood as coexistent with human life, such as "a black hole, the biosphere, or the Solar System" on the one hand and "the sum total of all the nuclear materials on Earth, or just the plutonium, or the uranium" on the other.[10] The revelation of hyperobjects is *epochal*, in the sense that they predetermine the destinies of our bodies, minds, societies, and the environment. Certainly, recent debates and discourses on the Anthropocene epitomize efforts to grasp the effects of humankind on the planet, and vice versa. In this line of thinking, the world (an assembly of human societies) and the planet (a material system that [un]grounds the world) are interconnected and appear—without a transcendental category—as the masterless object, the *mushubutsu*.

Thus, on a certain level, the logic of totality—of humanity, the world, or the planet on the verge of ultimate catastrophe or the apocalypse—captures our *real perception*; however, on another level, this logic fails to convey the multiplicity of existential suffering felt by the masses, which is unevenly distributed and engenders myriad forms of struggle for survival. Discourses based on the logic of totality tend to be oriented toward overarching single-issue solutions by speaking to global powers (such as governments, political parties, NGOs, and the United Nations), rather than empowering micropolitical struggles to dissolve the nexus of factors that have historically caused mass suffering.

This is particularly true of single-issue antinuclear movements in the postwar period, due to what Gabrielle Hecht calls "nuclear exceptionalism."[11] Because of its incomparable power of destruction, the nuclear thing not only encourages warring states to accelerate their race to monopolize it but also implicates individuals in this world picture, making us believe in the primacy of the nuclear and in consequence underestimate the intense impact of other pollutants, atrocities, and forms of oppression.

10. Timothy Morton, *Hyperobjects: Philosophy and Ecology After the End of the World* (Minneapolis: University of Minnesota Press, 2013).

11. Gabrielle Hecht, *Being Nuclear: Africans and the Global Uranium Trade* (Cambridge, MA: MIT Press, 2012).

It is necessary for us to keep in mind the following facts: (1) The logic of apocalyptic totality was created by the very governance that enacted the catastrophes themselves—nuclear or otherwise—for its own expansion; (2) Nuclear energy production and consumption are a global enterprise, the jurisdiction of which extends to uranium mining, the transportation and shipping industry, the electrical power industry, university laboratories, military bases, war zones, sites of nuclear reactors and waste storage, and our homes. The enterprise of nuclear energy production is often controlled by large oil companies in conjunction with the military, the academy, and local and central governments. Therefore, stopping nuclear power would mean undoing the nexus of these entities by forming transversal connections among the nodes of struggle contained within its reach.

After Fukushima, the antinuclear movement in Japan was able to maintain its forcefulness for about two years. Gradually, though, it was taken over by another single-issue movement: namely, the anti-Abe administration, an anti-rearmament campaign led largely by progressive parties and politicians. By 2014, people in Japan and abroad came to wonder whether the nation had forgotten Fukushima or had become numb due to the flood of spectacles and despair, because of the vanishing of the screams we used to hear in the immediate wake of the accident. But this was a falsehood created by the political spectacle of the mainstream media in service of pro-nuclear forces, e.g. the media's parading of rosy pictures of the 2020 Tokyo Olympics. Although mass mobilization of the single-issue antinuclear movement has waned, people's struggles for protecting their well-being have endured, in varied and less visible modes. To name but a few: the voluntary evacuation from northern parts of Honshū, including Tokyo, to western Japan, which is slowly and quietly constituting a mass exodus and changing the normalized geopolitical population map of the archipelago; nuclear workers organizing to improve their working conditions and commencing an initiative to determine the future of the reactor operation; the monitoring of radiation in the environment and food, and the sharing of this information on new social networks; direct actions taken in efforts to block the restarting of reactors or the incineration of

radioactive debris; innumerable legal actions prosecuting TEPCO and the government; and many other projects undertaken to protect the process of subjectification and the care of the self.

Such struggles for life represent wholehearted attempts to live in the time of the Event of Fukushima—namely, to live in common with radioactive nuclides. Meanwhile, the post-nuclear-disaster government seeks to destroy the Event as such by normalizing and subsuming radioactive contamination as part of the process of reproducing capitalist society. Now that the spread of radiation is irreversible, to live with the situation—whether by evacuating or pursuing other ways of maintaining health—is in the hands of the people, subject to their own power, their own wisdom and techniques. Radiation, though deadly and invincible, is in itself *not* transcendent and should not be treated as an enemy. We must find ways to deal with it. Thus, the decision as to whether to live with the Event or to absorb it into the capitalist process is the most radical point of confrontation.

As this bitter lesson has taught us, though, the single-issue antinuclear movements are not able to stop nuclear power altogether. Nor are these struggles for life powerful enough to overturn the nexus of pro-nuclear forces in the world. We need to stage projects on another level—meaning, quite possibly, to form a new world picture that accounts for a multiplicity of struggles. After Fukushima, it is clear that we, the inhabitants of the planet, must acknowledge and affirm our right to disintegrate the global threat of the nuclear sublime, wherein our enemies—the acephalic powers of warring states and forces that cannot stop their own expansion, no matter the consequence—behave as masters and owners of the world and all things in it. It is imperative that we instead envision the world, the planet, as a multiplicity of commons—an assembly of masterless, ownerless objects. We must enact our own sociobiological mutation—an anarchy! This rupture of the prevailing world picture is what must emerge out of Fukushima.

Spaces of Escape and Lines of Flight: The Dialogue Between the Monochrome and Heterogeneity

Anne Querrien

Karin Schneider is now painting black monochromes. How to make sense of this choice in the light of the thought of Gilles Deleuze and especially Félix Guattari, whose schizoanalytic cartographies we have studied together over the course of many Skype meetings?[1] In the past artistic programs she evokes in her own project, black is variously presented as a form of completion, of conquest, achieved at last, of abstraction, as the break (*échappée*) from representation. But completion implies the end of a process, the constitution of a way of delineating identity, which flies in the face of schizoanalytic research. How, then, to map out within the maze "situational diagrams," in Schneider's words, which introduce the possibility of novel paths in the exhibition, which envision new uses of screens? Black monochromes invite viewers to watch as images trace themselves, to imagine the projection of their own histories. The painting is no longer a surface of inscription for a subject or the description of an object, but a surface held before the world for it to take shape through the interaction of those present. Which paths indicate the color-coded differences inoculated into the seemingly identical paintings that populate the exhibition? How to make of this a situational diagram along the cues Schneider suggests to us?

1. Félix Guattari, *Schizoanalytic Cartographies,* trans. Andrew Goffey (London, New York: Bloomsbury Academic, 1989).

143

Escape from the Despot's Eyes

Schneider situates her work in the wake of Ad Reinhardt, for whom black monochromes were nonviolent demonstrations against the established order, virtual cobblestones thrown at the heads of his viewers to alert them to cease to obey.[2] The artist does not express his own experience, but appropriates history and transforms sensations into a desubjectified creative act, free from all forms of anecdote and submission inherent to representation. He delivers a purified and flawless painting, whose matteness has been ensured by the meticulous superimposition of layers of paint from which the solvent has been extracted. The painting is intended to be so perfect that the artist or a conservator must treat it after each exhibition. The painter's revolt is an act of asceticism, the signal that one can and must critique the world if one is not able to transform it here and now. Some have attributed the rise of abstraction in painting, and the relative decline of the portrait and the landscape, to postwar European mass guilt. In fact, photography substituted itself for painting as the medium for representation of people and daily life, which in turn forced painters to transform themselves into artistic researchers.

Around the same time as Mark Rothko and Reinhardt painted their black paintings, black screens began to invade homes. On these screens, matter disappeared and color was approximate. Painting became a discipline for the passionate, off the screen. Pedagogical programs, such as the series *Palette*, attempted to present the painter's work with as much attention to gesture as to the subject, as a handicraft with no message.[3] On television, everything was good, and if one couldn't see what one wanted on it, this meant that one had not sufficiently developed the expertise to look at it. These screens produced an immense, multidimensional dissatisfaction. While they seemed to open the world, they closed it around us. They organized absence on a scale never before seen, an inexpressible desire that turned into its own negation.

2. Cf. Leszek Brogowski, *Ad Reinhardt, peinture moderne et responsabilité esthétique* (Chatou: Édition de la Transparence, 2011), 78, 400.
3. Alain Jaubert, *Palettes*, 18DVD, Éditions Montparnasse, 2007.

For Deleuze and Guattari in *A Thousand Plateaus*, the black holes of despotic eyes, the eyes as vectors of power, first attract the desire of the painter followed by that of the viewers, and submit them to a regime of order. The situational diagram composed of such a situation of submission is described by Michel Foucault in the first chapter of *The Order of Things*. The situation presents possible lines of flight (*lignes de fuite*), but all eyes and bodies are magnetized by the anticipation of the sovereign, by the desire to fix their gaze on him. It is precisely this magnetization that classical painting embodies across the infinite modulation of real situations.

Why speak of black holes? Because it is a matter of the regime of attraction imposed by a power superior to all the small diversions that could be included in the painting to counteract it. It's a matter of the formation of a faciality connected to all the other coordinates of the system of technical, economic, and cultural production that families newly deterritorialized by migration meet with, as they are obligated to enter into new social learning processes. This takes place simultaneously on the individual level, where each person discerns these transformations more or less effectively, and on the collective level of a generation entering new ways of grasping the world. To not let oneself be absorbed by the existing "black holes" means joining a bifurcation generative of another kind of attraction, implicating oneself in new movements, aiming for a new, more powerful blackness. As Gudrun Iboden and Thomas Kellein underline, Ad Reinhardt's abstraction can be seen as an alchemical caricature of the contemporary era, the search for a single path that would allow us to transcend it.[4]

Opening a Becoming

The viewer is attracted to small differences among and within the black paintings and black objects in Schneider's exhibition Situational Diagram. The painted black surfaces are not machine produced as they might seem to be, and they are not all painted on

4. *Ad Reinhardt*, Gudrun Iboden and Thomas Kellein, eds. (Stuttgart: Staatsgalerie Stuttgart, 1985).

the same substrate; some of them are even iridescent and reflect light in different ways. Here, black is not the space of the absolute, of the same, of the impenetrable, of the one, no matter what precautions the artist has taken to remind us of this creed. There is difference, to which the gaze will attach itself, and follow.

Among the black screens, which at first sight induce the viewer to defer to a visual order of submission, or a feeling of great indebtedness in the face of the darkness of our times, it is possible to allow the gaze to dance about and hang upon the play of light it occasions and the reflections it returns, or to imagine other paths of light and color in the interstices it carves out in space along the paths it delineates to direct or redirect our attention. This experience of the multiplicity in black has inspired the painter Pierre Soulages, who told his biographer, Pierre Encrevé, that one day in 1979 when his painting was more than ever invaded by black he stopped resisting and abandoned his work.[5] When he returned to his studio, the light was shining over the multitude of the textures on his black canvas and released different colors. He noticed, in particular, that the reflection of surfaces that he had striated with a knife was not at all the same as that of the surfaces smoothed over by a palette knife. Pierre Boulez noted the smooth versus striated distinction in music in 1963.[6] Deleuze and Guattari adopt it in *A Thousand Plateaus* to describe the two types of spatial occupation—the sedentary and the nomadic, the stable and the mobile.[7] Playing on the complementarity of the smooth and the striated that constitutes the *manière noire* (mezzotint), in 1988 Aurélie Nemours produced a series of monochromatic etchings titled *Nuit Pourpre* (Purple Night), which were created by the successive mixing of red and black ink.

We generally conceive of the exhibition space as bringing a work and a viewer into a relationship isolated from the collective context, whether it is a question of each work considered in isolation, or of the work of the artist or artists exhibited, or of the

5. Pierre Encrevé, *Soulages, Les peintures 1946–2006* (Paris: Seuil, 2007).

6. Pierre Boulez, *Penser la musique aujourd'hui* (Paris: Gallimard, 1963).

7. Gilles Deleuze and Félix Guattari, *A Thousand Plateaus*, trans. Brian Massumi (Minneapolis: University of Minnesota Press, 1987).

concept illustrated. We are asked to abstract from what is presented as an "occasioned difficulty" when this can be the beginning of a rhizome between the artist or artists, the supporters or critics, the guards, the curators; a becoming-alive of the group of people present. Can we imagine that the gallery could be occupied in the sense of the occurrence of free collective discussions that would take up the beginnings of thought that the artist has proposed, and would become active in concretization by the association of ideas on the path of a schizoanalysis exploring a multiplicity of directions, and discovering the lines of flight (*lignes de fuite*) that will position the work in a different light?

The monochrome, even and especially the black monochrome, allows for this situationist *dérive* by its openness, as Schneider aptly affirms in her proposition Situational Diagram. The beginnings of the construction of the virtual rhizome by all the authors of monochromes in the twentieth and twenty-first centuries can be extended through other associations and defined within the public. How to offer surfaces of inscription for everyone, to make of each opening a *performance*? How to give rise to the *happening*, to the discovery of the plurality of becomings that these black surfaces hold? It is a question of altering the labor schema that differentiates these objects, to undermine their power of attraction as autonomous objects, their force as black holes. What *dispositifs* can we envision, to begin the rhizomatic development around their edges, the creation of exquisite corpses, the proliferation of ideas? Black slates, as in the schools of long ago? Or magic slates? Gradually erased, they would require the permanent presence of the artist, the exhausting transformation of the exhibition as it is devoured.

The black monochrome, professed by Reinhardt to be "pure icon, pure perspective ... pure landscape, pure portrait, pure still life, pure monochrome,"[8] seems to me in the last instance to be the enemy of painting even if it implies its possession, just as the claim of purity, the avoidance of mixture, the rejection of heterogeneity,

8. Ad Reinhardt, "Twelve Rules for a New Academy," *Art as Art: The Selected Writings of Ad Reinhardt*, ed. Barbara Rose (Berkeley: University of California Press, 1991), 205.

the abandonment of the challenge to compose within multiplicity, are enemies of life. One of the abstract themes to discuss in this exhibition, where general assemblies will occasionally occupy the space, would be that of purification. In a hall where an assembly is united, in a country gathered around its flag, its identity, someone always arrives who does not belong to this group statutorily, someone who does not have the same skin color, someone who does not have the same language, an other. Is this other, this foreigner, unable to enter the assembly? The openness of the black monochrome does not exclude the other from the prospect of understanding the world presented through this medium; there are no traditions of knowledge required to enter this conversation. The mediation of this black screen, this common space in which to invest, is in a way parallel to the problem of welcoming foreigners or ill people, as shown in the experiments at the Casco cultural center in Utrecht.[9] What is done with the other, the different, in the present situation? What is the diagram of this situation? Using the force of the black paintings, can we find the strength to integrate the other, to give her/him the time to speak, to listen to her/him, and transform these black paintings into mediators, local peacemakers?

9. Casco is a public space for artistic research and experimentation. Founded in 1990 and located in Utrecht, the center uses the urban landscape as its space of critical and social engagement, mobilizing artists, activists, and researchers from around the world to activate and work within this space to micropolitical effect. In their mission statement, they write: "The aim of our work is to contribute to forming non-capitalist cultures and possibilities for life for which we believe art could play an essential role, not as an insular avant-garde but in alignment with other initiatives and social movements. Instead of accumulation, alienation, apathy, and competition, a culture that we envision is comprised of sharing, caring, and living and working together. In this light, we see our organization and space as a micro society that might reflect such vision." In May 2015, Casco put forth the *Convention on the Use of Space*, which they describe as the "first grassroots legal instrument to support the use-value of housing and working space over vacancy and financial speculation," written and organized in resistance to the privatization of real estate in the city of Utrecht and the consequent liberalization of the housing system. This instrument seeks to fight against the effects of gentrification and the privileging of urban space to a select few, in order to initiate a new opening and occupation of public spaces within the city. They call this initiative a "protection of the commons," where this term is understood both in a legal and in a philosophical context. Mission statement reproduced from cascoprojects.org, accessed on May 14, 2016. Also see Choi and Wieder, *Casco Issues XII: Generous Structures* (Berlin: Sternberg Press, 2011).

The presence of black screens for the great majority of us presents new possibilities for collective assemblages (*agencements*). In the context of this exhibition, the small differences that mark each black screen and link it to a singular affect are addressed to each viewer in the form of an invitation to take up this affect on their own terms. Similar to a mode of collective composition in an electronic music concert, this immediate intervention of many, if not all, viewers can inscribe visions induced by the paintings in an electronic diagram that would compose them as a movement of differentiation and condensation, of the constitution of meaning daily and cumulatively throughout the course of the exhibition. The figure of the black monochrome hence traverses across positions with each person's confrontation with her/his own conscience, producing an incentive to think, to seek associations and departure points of desire that can be activated within the very context that the paintings occupy. What comes to inscribe itself on the screen, which retains the messages of all screens that enter into a relation-ship with the exhibition, is the diagram of lines of flight (*lignes de fuite*) that can be explored on the basis of Schneider's proposition. The exhibition moves beyond the status of an offer to potential buy-ers, situated in the lineage of the history of contemporary painting, and transforms itself into a machine that offers hypotheses to all visitors, wealthy or not, academically equipped or not, to trace the lines of flight (*lignes de fuite*) beyond the parameters and limits of the art market and the economic system. What linguistic or imag-istic micro-inventions can viewers provide for the transformation of the exhibition into a collective diagram? How to transform the mobilizable information on these multiplied screens into segments to be shared and connected?

Mapping

Guattari's schizoanalytic cartographies take the world both in the cosmic scale of astronomical black holes and the molecular scale of the atoms that compose the matter that makes us up, as well as everything that surrounds us. We know that this infinitesimal yet no less real material world is a world in flux, which is transformed

by encounters and bifurcations. The same is analogically true of our human scale and of the cosmic scale.

From the perspective of the living—vegetable, animal, or human—the world of flux is divided into existential territories specific to each group or individual. In a particular species, that of currently living painters, for example, each person will develop a particular existential territory, determined to an extent by the trajectory of her/his personal life, to what she/he has inherited from her/his parents, studies, economic means, and the relative facility of her/his access to the resources necessary to pursue a career. In the work of two of Schneider's painters of reference, Rothko and Reinhardt, we find an adamant rejection of the entrance into the dominant existential territory of public administration shaped by the Federal Art Project during the Great Depression. In exchange for a salary, requisite for living, it was necessary to produce the decorative works in demand, to give one's painting the dictated meaning. Both painters emerged from this world determined to paint without conferring a predetermined meaning on their paintings, without allowing their meaning to be controlled. The role of collectors, essential to the painter's existential territory, is partially different; they express themselves in front of completed works that please them, and, in this same pleasure as the painter, can even share with them ideas for new investigations. However, the private order can be as dangerous as the public order when it transforms the painter into a decorator, provides her/him with a frame that is overdetermined, or incentivizes or obligates her/him to repeat what was only a node or step in her/his thought.

The existential territory is, however, only superficially constituted by this group of socioeconomic and relational determinations. More fundamentally, it characterizes the relationship of each person to Earth, to the global world. This relationship is often strongly overturned by history, as in the cases of Reinhardt and Rothko, both children of immigrants in the United States, who were required to construct a possible relationship to Earth on their own terms, in a landscape without adequate familial ties. This necessity to construct a new connection to Earth by means of spiritual work anchored in material production characterizes the subjective position of the

artist. The artist seeks resources to play a part in the historical accumulation of concepts, of techniques, of disciplines from which she/he attempts to borrow, and in relation to which she/he will create her/his trajectory, owing to the technical and material transformations that are at her/his disposal along with the succession of mechanical inventions that characterize each era.

Every artist is at once alone and articulated by this history of the world where she/he has taken her/his place, and where she/he must find at once a balance and the resources to support an original trajectory. This is also the plight of each person, but many never succeed in organizing the existential territory from which she/he would be able to depart and situate her/himself in the flux of history. For the artists who have begun to develop a path, it is not always possible to continue. Schizoanalysis aims to enable us to help one another navigate our respective existential territories.

Preoccupied

Tirdad Zolghadr

"I'm doing monochromes, so I don't really see a lot of things," Karin Schneider explained, rather curtly, during a long conversation last week. A conversation that was actually brimming with stories, ideas, projects, and accomplishments the artist had no intention of publicizing anytime soon. Schneider is exceptionally attentive to the pernicious effects of announcing, promoting, or visualizing the wrong things in the wrong way (or, rather, the right thing at the wrong time). This is also why her SD (@DL/NY, 2016), though marked by a staggering range of ambitions, does not wear its heart on its sleeve. The show is not out to please anyone. Instead, the ambitions are as grand as they are quietly demanding. This is what makes it genuinely ambitious, as opposed to merely loud or pompous. Its objectives are powerful enough without being screamed from the rooftop.

To organize these ambitions, Schneider is plotting to "occupy" the two floors of Dominique Lévy Gallery. Indeed, to accommodate the entire scope of the artist's objectives (political, formal, historiographic, commercial, and otherwise), a mere squatting or inhabitation would not suffice. Instead, her intervention is producing a new location in its own right, claiming the gallery space as its own. Some artists adapt to the available square feet and divide them by a maximal number of artworks. Others engage aggressively, and more or less colorfully, with the architectural matter at hand. In the best of cases, however, the artist's objective is to locate and move the audience through the room in a manner that sparks a particular subject

position. Occupation as an act of "situational diagrammatization," to use Schneider's words, sets its sights not only on the exhibition space but also on the audience and more. In other words, this is *not*, we should hope, another case of contemporary art purporting to fleetingly dislocate, unground, deterritorialize, and so on. This is, rather, an overambitious, synesthetic intrusion of sorts, locating and positioning its public without apology, occupying, and even encaging, however temporarily: Schneider herself refers to her diagram not as a plan or grid, but as a cage, no less (meanwhile, the methodology of the exhibition makes room for the outright subordination of painting to language).

In light of such far-reaching aims, the language of occupation is helpful; admittedly, it might not be if it weren't for the polysemic leeway such language offers. The idea of an occupation can mobilize, energize, and radicalize, as it did, to formidable effect, in the context of the Occupy Wall Street movement of 2010–11. But the term *occupation* remains ambivalent in that it can also imply distance, and, by virtue of that distance, a degree of otherization that is easily misunderstood. After all, you can—apparently—only occupy what is other to you. The famous phrase "We are the 99 percent," for example, implies a distance from the top 1 percent that makes important political sense within a domestic U.S. context. Viewed within a global setting, meanwhile, the *we* cannot be taken for granted, since these percentages no longer hold. To take a radically different, even more dramatic example, to call what is happening in the West Bank an occupation is a political decision in itself. Not only does the term put an act of ecological, demographic, and economic butchery rather lightly, it implies that the Israel Defense Forces may not belong in Palestine, but that they do have a legitimate motherland elsewhere. (The day the "occupation" ends, the IDF return to their rightful home.) When it comes to the contemporary artist, however, things get more complicated. The idea of inherent placelessness, porosity, transversality, which has haunted us since bohemia and been cemented by post-Fordism, suggests that the artist does not have a stable home to "return" to, institutionally speaking. A preordained home of this kind would make her far too predictable, too predetermined, to be an artist worth her salt. The artist, in other words, is the

one who can occupy from nowhere, in a blaze of critical virtue. She can have her political cake and eat it too. Such is the orthodoxy, but there are other ways of reading Schneider's preoccupations.

Schneider's occupational ethos makes sense, almost effortlessly, for two reasons. First, there is no misplaced allure of innocence here. At no point does her diagram suggest it exemplifies an intrinsic other to the system it is colonizing. After all, the objects of occupation—contemporary art's audience, language, history, infrastructure—are the very stuff of art itself. If anything, Schneider's composition is absorbed, irretrievably, by and within the setting that is the New York gallery, both by virtue of soaking up the space architecturally, materially, concretely, and by virtue of mapping the venue as an integral component of art at large. The commercial gallery not as some "different ballgame," let alone a "necessary evil," but as one satellite term among many others within the prevailing moral economy of contemporary art. An economy that no longer allows for ontological divides between the economic, the political, the formal, the research-driven, etc. Distinctions persist, but the overarching processes operate at such a volume and intensity that the value system we've relied on to distinguish between the virtues of one pursuit over another is now all but obsolete. Schneider is not the only artist to notice this sense of flattening, but her Situational Diagram is a rare attempt to acknowledge these facts with discursive transparency and an elaborate exhibitionary strategy in equal measure. To engage in an occupation as an artist, within a historical context such as ours, is to reinvest in location, reterritorialization, cognitive mapping of your own institutional turf—to abandon the idea of occupying some alien turf and critiquing it to the best of your abilities, for the benefit of thinking *through* the structure of contemporary art. The bigger question isn't how Schneider might occupy a private gallery, but how art can occupy an audience, a city, a micro- and macro-economy alike.

There is a second argument in favor of the occupational as a trope: the chronopolitical factor at play. By definition, you occupy an object temporarily; even when you're overstaying your welcome, you will, dead or alive, leave eventually. This, incidentally, is what leads to the all-encompassing, aggressive intensity of the colonizer's presence. As it happens, during the late Renaissance, *occupy* was

considered improper language, since "occupying" someone implied sexual intercourse. It's fair to say there are few options more immersive, and more intense, than fucking (or being fucked with); even when we're talking about a commercial gallery, an audience, or the monochromes of canonical high modernism as the object of your occupation.

The history of the term *diagram* is no less useful, in that it suggests an act of "writing across." In Greek antiquity, the term referred to a geometric figure composed solely of lines. In the parlance of contemporary art, the idea of writing-across is elegantly suggestive of the transversal moments referred to above—crossing boundaries, subverting categories, interrelating the seemingly unrelatable, and so on. Again I'd argue that the diagrammatic lines traced by Schneider—hermeneutic, chromatic, kinetic, and ideological in character—strive less to unground and untether, and more to locate and position, to entrench and settle, however temporarily. As its name indicates, this exhibition is not only diagrammatic but also situational; it functions not by means of the diagram per se, but by means of the way it situates the audience and moves bodies through space. It is situational particularly by virtue of being palpable, three-dimensional, haptic, sensory; by embodying its proposal, over and above representing it. You enter the work, and the confluence of means and strategies at play produces an experience that cannot be disseminated.

The situational, in this sense, is also constitutive of the oeuvre of the late Michael Asher, with whom Schneider has collaborated on occasion, and who seems to be a key reference here. When a practitioner in the vein of Asher uses institutions as her medium, she is typically—and perhaps surprisingly—invested in somatic concerns. More often than not, the work is enmeshed with its venue as an actual physical, architectural, psycho-professional, socio-erotic space, and not merely as a symbol or a website. The work, in other words, becomes one with the materials it uses, and with the visceral impressions, conversations, and atmospherics these materials spark.[1] Very

1. See also Vincent Bonin's excellent essay "Here, Bad News Always Arrives Too
 Late," *Red Hook Journal*, June 15, 2012, http://bard.edu/ccs/redhook/here-bad-
 news-always-arrives-too-late.

little of which is accounted for by JPEGs and hearsay, for example (let alone essays such as mine), as interesting as the myriad miscommunications of such vessels might be. Which is why the renewed ocular imperative of the post-Internet era rarely does justice to Asher's work; JPEGs allow his projects to speedily travel the world, but at the risk of transforming them into one-dimensional caricatures of themselves. ("Oh, see, he removed a wall.")

Schneider's paintings, and the constellation that organizes them within the gallery space, are beholden to a similar spirit of deictic rigor. Every monochrome is a stick in the mud, in that it refuses to be documented and circulated with digital efficiency (nor does it go down well as printed matter). What's more, within the actual space, it imposes a more demanding, not to say languid, sense of spacing and rhythm than other objects of contemplation. At Dominique Lévy, shades of yellow, blue, red, and green are mixed into the black of the paintings, but these are shades that demand a generous span of time to be noticed, let alone absorbed. "In order to see the monochrome painting," Schneider said, "you have to move the body—there's no place to stand still." And it's not only the viewer's sense of commitment that is at stake here, but the painter's. Paintings aside, in previous projects, the artist has had her audience literally bend over to acknowledge an object on the floor. On the floor at Dominique Lévy you'll find a three-dimensional Matisse nude, its abstract painted form rendered with a heightened materiality, which you'd usually be beholding at eye level.

Schneider's is a practice thoroughly invested in thinking through structures. Sometimes visibly so, in the sense of structures that are spatial and tangibly three-dimensional, with work ranging from adventurous architectural excavations to the subtle kinetic mapping discussed in this essay. But physical constellations and movements aside, the structural, in Schneider's case, is also a matter of extensive and complex collaborations, of building alliances and forging institutions, of newfangled contractual stipulations with micropolitical subtexts, of aesthetic objects being converted into functional support systems—even of recurrent offers to turn her exhibitions into platforms for artist peers. Schneider's is the kind of work that does not shy away from claiming (as its aesthetic mode of

engagement) coalition work, technology and administration, shared authorship, and even painstaking political efforts that remain strictly below the radar. Her work proposes and even, at its finest moments, *imposes* a gravitational pull of its own, however briefly. Her structures, in these cases, offer an alternative sense of traction, one that does not necessarily dovetail with the prevailing momentum of contemporary art. "I know I'm difficult. I just have to work slowly, so that I'm sure I know what I'm doing," she said, before adding: "We'll need another ten years in order to be able to talk about this project."

March 2016

Selected Diagrams

Karin Schneider

The following writings describe artworks made from 2001–16 and trace my use of what I call a "programmatic" approach to Situational Diagrams. This approach is part of the work's materiality: Sometimes I incorporate it into the conditions of the production of the work, sometimes into the conditions of the reception of the work, and other times into the conditions of the circulation of the work. Each situation shuffles certain aspects of these relations in order to constantly rethink aesthetic production and the position of the artist within specific institutional frameworks.

Project for Ambiences, 2001

I was invited by Lucio Dorr and Santiago García Aramburu to do an exhibition at Duplus, an alternative art space in Buenos Aires that operated in what would have been the living and dining rooms of a typical middle-class home. Constructed in the 1930s, the venue is located on the first floor of 750 Sanchez de Bustamante Street in the Abasto neighborhood. In *Project for Ambiences*, the space was divided using stainless steel metal sheets, 8 × 4 feet each, which were hung from the ceiling to create various divisions, or "ambiences," in the space. Closed cardboard boxes, each containing seven elements—a text, a diagram to be completed, a pencil, a drawn sign, a piece of rubber cut into a random shape, magnets, and a stimulant drug—were placed on either side of the metal sheets. The night before the opening, ten artists were invited to each open one of the ten boxes, and were instructed to create an artwork with the elements therein. The installation took place over the course of the night, and lasted seven hours. A collective diagram was also produced during the installation and was presented at the exhibition's entrance. The next day, I opened *Project for Ambiences* as a solo exhibition without revealing the names of the collaborating artists. I invited Paulo Vivacqua, a Brazilian musician, to participate; he played a series of sounds recorded in New York below 14th Street in the first week after September 11, 2001.

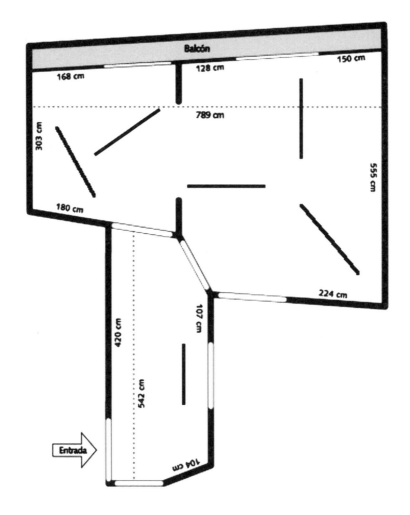

RUBBER: YELLOW LIGHT: YELLOW
 BLUE BLUE
 RED RED
 WHITE WHITE
 BLACK BLACK
 PURPLE PURPLE
 GREEN GREEN
 ORANGE ORANGE

——————— METAL WALLS ⬢ MAGNETS

While I was developing a body of work centered on precisely crafted architectural models of iconic twentieth-century modernist buildings (made in collaboration with Brad Whitermore), I was invited by Horacio Dabbah to present some of these models in Buenos Aires. The buildings' forms were converted into domestic apparatuses and functional objects, bringing the routine of normative reality to bear on the austere modernist structures. Frank Lloyd Wright's Guggenheim Museum was transformed into a toilet, Philip Johnson's Glass House a stylish refrigerator for cans of Coca-Cola, Eero Saarinen's Trans World Flight Center at JFK Airport a hat with a 360-degree field of vision, Vanna Venturi House a vacuum cleaner, Gio Ponti's Villa Planchart a cigar tray held up by a neck-strap, and Rudolf Schindler's Kings Road House a communal sushi table. The utopian promises of these architectures were revisited, criticized, and reconfigured along the lines of gender politics, proposing alternative definitions of family, community, and labor. Quotidian actions and rituals such as drinking, talking, cleaning, smoking, and eating were performed by both the artist and the spectators/participants. In their new utility, the models worked to destabilize the viewer's role in a typical subject-object relationship, allowing viewers to perceive a more complex system imbricating functionality into architectural programs.

Philip Johnson

Frank Lloyd Wright

Gio Ponti

Eero Saarinen

Rudolf Schindler

Sabotage, 2005–07

The word *sabotage* comes from *sabot*, wooden whole-foot clogs worn by the French lower classes from the sixteenth to nineteenth centuries. Workers who wore sabots were considered inefficient. During the first Industrial Revolution, they inserted their sabots into factory machines, damaging the operating mechanisms and interrupting production.

In the three enactments of *Sabotage*, I placed a fog machine, model Eliminator 400W, in three exhibition spaces. The duration of each *Sabotage* was determined by the time necessary to fill the space with fog, thus obscuring the visual aspect of the art on view. Eliminator 400W measured 13 ¼ × 7 × 7 inches and weighed eight and a half pounds; it was able to produce 4,500 cubic feet of fog per minute. For the first enactment of *Sabotage,* I used Eliminator 400W at Orchard, during the inaugural exhibition. The exhibition was divided into three sections. I placed Eliminator 400W in the first section; it filled the room while artist/musician Jutta Koether played sound. The second and third *Sabotages,* held at SculptureCenter, New York, and CAPC musée d'art contemporain de Bordeaux, were part of *Grey Flags,* an exhibition curated by Anthony Huberman and Paul Pfeiffer. At SculptureCenter, *Sabotage* separated Koether and John Miller from each other as they played sound. At CAPC, Koether played sound and Amy Granat contributed a 16 mm film.

Eliminator 400W was acquired by a collector in 2006 under the conditions of a purchase agreement, determined by the price of the machine.

1. Orchard, May 25, 2005, 6:30 p.m. Sound by Jutta Koether
2. SculptureCenter, June 3, 2006, 4:30 p.m. Sound by Jutta Koether and John Miller
3. CAPC musée d'art contemporain de Bordeaux, March 10, 2007, 4:00 p.m. Sound by Jutta Koether

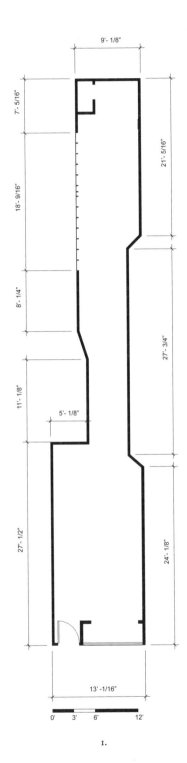

2.

3.

1.

167

Pomerio Grandstand/Labyrinth with Stage, 2005–08

This project was completed as part of an artist residency program coordinated by Art in General, New York, and the Museum of Modern and Contemporary Art in Rijeka, Croatia. I was invited to participate by Branko Franceschi. Instead of doing a solo show at the museum in Rijeka, I proposed that I design a public playground in a semi-empty lot located two blocks from the museum. One of the lot's sides was below street level and the other three sides were surrounded by buildings. Enclosed by the surrounding architecture, the lot had the feeling of a cave. I chose to design the park as a maze or labyrinth: the diagrammatic counter-image to that of the primal cave. In this design, the labyrinth structure could also function as a grandstand for performances. Each level of the tiered structure was formulated to accommodate children of a different age group: the lowest section for children 1.3 to 1.5 years old, the second tier for children 1.6 to 2 years old, the third tier for children 2.1 to 2.5 years old, and so on. The last tier, with the highest elevation level, is a sixty-centimeter-high section for adults. The overall design of the park evokes a particular type of modernist architecture found in the immediate surroundings and throughout the city: a blending of 1930s and '40s Art Deco and Rationalism. Typical to this style are orthogonal shapes articulated through quarter-section circular.............. curves. Ivana Marinac designed a fountain for the park.

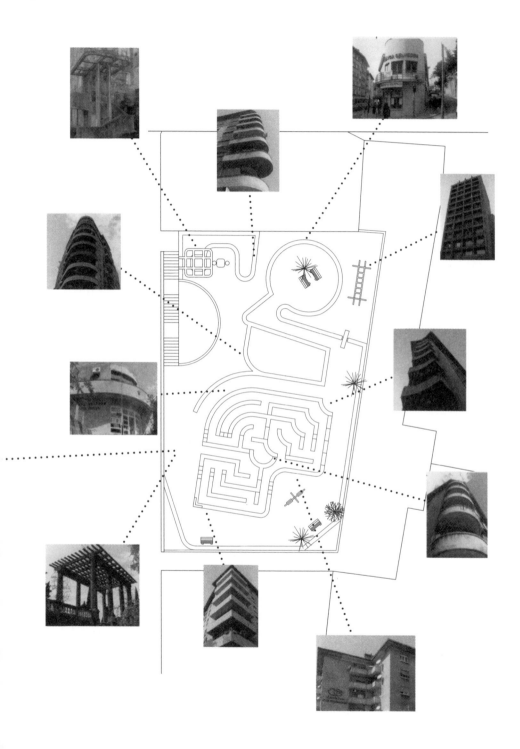

In 2006, Sarina Basta, the curator at SculptureCenter in New York, invited me to do a solo project in one of their basement exhibition spaces. This site shared a wall with the institution's storage room. I removed the existing solid wall, which separated the exhibition space from the storage space, and replaced it with a transparent wall , incorporating the storage room into the exhibition space. I relocated stones from the institution's garden to the basement, covering the floors of both exhibition and storage space. A surveillance camera, installed in the storage room and monitoring one of its walls, was connected to a video projector. Every day, I selected a different image or text to be hung on the storage wall, which was thus projected at the entrance of the exhibition space. A databank mapped and archived the pictures and texts posted over the course of the exhibition. Two nearly white monochrome paintings (one bearing the faintly painted image of a film splicer and the other the image of a 16 mm film camera) were installed. The painting of the splicer was in the exhibition space. A peephole was cut into the door of the storage space, from which the painting of the 16 mm film camera could be seen hanging in the middle of the storage room, completing the "painting" exhibition.

Activity in the storage space was partially illuminated by a flickering disco light, which was connected to a sensor. Four different light configurations were triggered when sounds were made in any of the spaces. Thus, what visitors could see was directly related to the sounds they made while navigating the space. For example, visitors walking quickly would experience a different exhibition than visitors walking slowly, as disparate areas would be illuminated based on the sounds of their movement. The traditional exhibition format promises meaning and closure, a stable center from which to read an object, and a defined subject position. In *Two or three things you should...*, whenever two elements of the exhibition aligned to generate such a reading, a third intervened, destabilizing the situation.

Storage

3'-2"
.9m

5'-7"
1.7m

4'-10"
1.5m

10'-1"
3.1m

12'-11"
3.9m

6'
1.8m

Storage

7'-5"
2.2m

14'-3"
4.3m

5'-10"
1.8m

1'-10"
.6m

10'-6"
3.2m

Elevator

16'
5.0m

42'-8"
13m

C

13'-3"
4.0m

11'-9"
3.6m

12'-3"
3.7m

Storage Storage

10'-8"
3.3m

6'-6"
2.0m

7'-3"
2.2m

8'-10"
2.7m

6'-8"
2.0m

5'-7 1/2"
1.7m

4'-5"
1.3m

7'-8"
2.4m

4'-10"
1.5m

13'-4 1/2"
3.5m

Storage

Transparent Partitions, 2007 to present

Transparent Partitions (TP) are an ongoing series of Plexiglas and wood partitions, each measuring 4 × 8 feet, designed and installed according to specific situations. The title of this series was suggested to me by Dan Graham. TP expand certain notions surrounding a particular branch of artistic production—the individual artwork—by inserting work made by people other than the artist into their display mechanism. In this way, TP hybridize the artwork with the machine and dislocate fixed forms of perception. TP present various degrees of collaboration between myself and individuals working in the production and circulation of art exhibitions. While the architecture of the TP frames these interactions, their diagrammatic approach dislocates the viewer from a fixed viewing position. The artist appears as curator, the curator as artist, the producer as curator, the producer as artist, the art historian as artist, and so on. The myth of a stable, core individuality is here complicated and reconfigured as multiple reflections, all exposing their expanded social reality. TP are a conduit for exploring other forms of interaction and collaboration in the production, exhibition, and circulation of artwork, in which the figure of the artist is usually primary and central. TP have a semi-open program, organized in collaboration with various people, and can incorporate painting, cinema, video, the Internet, music, performance, lectures, street actions, magazines, etc.

1. *Elastic Paintings and a Transparent Partition*, Forde, L'Usine, Geneva, Switzerland, 2007
2. Transparent Partition for *Image Coming Soon*, Orchard, New York, 2007
3. *Two Transparent Partitions, Two paintings* (Collaboration with Olivier Mosset), LMG, NY, 2008

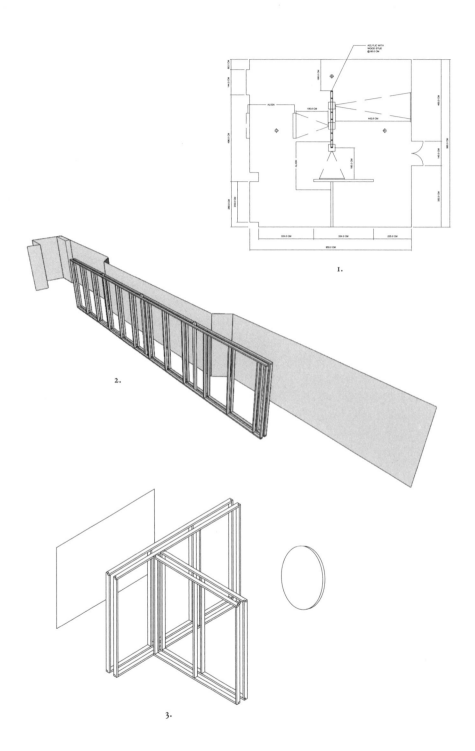

1.

2.

3.

Image Coming Soon, 2007

Image Coming Soon was held at Orchard, an artist-run exhibition and event space in New York's Lower East Side. The gallery's organizing principles stipulated that each member had to present an exhibition in the space. In 2007, I bisected the space with a Transparent Partition (TP), which included collaborations with Amy Granat, Eileen Quinlan, Sarina Basta, and Melanie Gilligan. A pair of Brinco sneakers, designed by artist Judi Werthein, were placed in a vitrine at the entrance. Slide, 16 mm film, and video projectors superimposed specific images onto paintings that were integrated into the TP's display mechanism. In addition to the fixed program of the TP prior to its activation and its program of projected images (activated by the artist upon request), a third program was integrated into the exhibition, in which other artists, musicians, curators, writers, and art handlers staged multiple actions over the course of the exhibition. These included: a film program curated by Francisca Caporali and Brandon Jourdan, a Halloween War Map by Instituto Divorciados, a performance by Matt Keegan, a rehearsal by Japanther, a reading by Elka Krajewska with sound by Alan Licht, a music event by John Miller and Jutta Koether, a film installation by Bradley Eros, a performance of "Today I have changed my mind. I have become truly a feminist" by Fia Backström with Gianni Jetzer and Alexandre Singh, and a deinstallation music event by John Miller, Jutta Koether, Morgan Edelbrock and Turner, among many others.

174

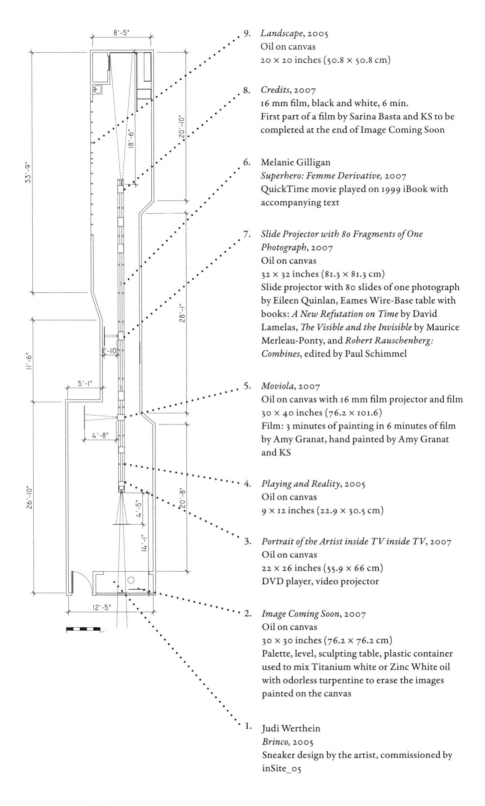

9. *Landscape*, 2005
Oil on canvas
20 × 20 inches (50.8 × 50.8 cm)

8. *Credits*, 2007
16 mm film, black and white, 6 min.
First part of a film by Sarina Basta and KS to be
completed at the end of Image Coming Soon

6. Melanie Gilligan
Superhero: Femme Derivative, 2007
QuickTime movie played on 1999 iBook with
accompanying text

7. *Slide Projector with 80 Fragments of One
Photograph,* 2007
Oil on canvas
32 × 32 inches (81.3 × 81.3 cm)
Slide projector with 80 slides of one photograph
by Eileen Quinlan, Eames Wire-Base table with
books: *A New Refutation on Time* by David
Lamelas, *The Visible and the Invisible* by Maurice
Merleau-Ponty, and *Robert Rauschenberg:
Combines,* edited by Paul Schimmel

5. *Moviola,* 2007
Oil on canvas with 16 mm film projector and film
30 × 40 inches (76.2 × 101.6)
Film: 3 minutes of painting in 6 minutes of film
by Amy Granat, hand painted by Amy Granat
and KS

4. *Playing and Reality,* 2005
Oil on canvas
9 × 12 inches (22.9 × 30.5 cm)

3. *Portrait of the Artist inside TV inside TV,* 2007
Oil on canvas
22 × 26 inches (55.9 × 66 cm)
DVD player, video projector

2. *Image Coming Soon,* 2007
Oil on canvas
30 × 30 inches (76.2 × 76.2 cm)
Palette, level, sculpting table, plastic container
used to mix Titanium white or Zinc White oil
with odorless turpentine to erase the images
painted on the canvas

1. Judi Werthein
Brinco, 2005
Sneaker design by the artist, commissioned by
inSite_05

175

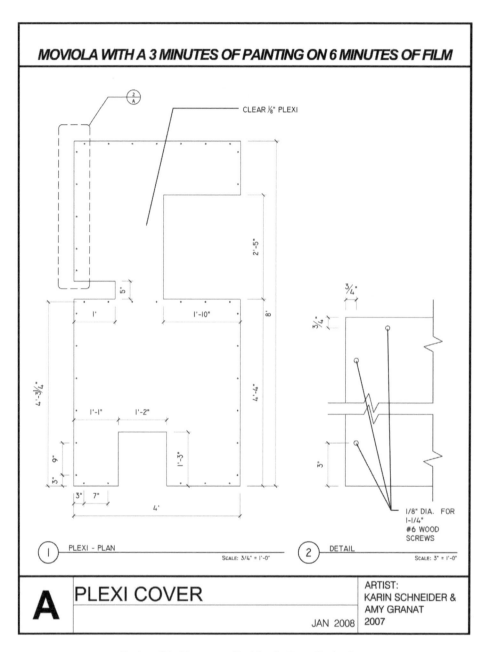

CLEAR ⅛" PLEXI

2'-5"

5"

1'

1'-10"

8'

4'-3¾"

4'-4"

1'-1"

1'-2"

9"

1'-3"

3"

3" 7"

4'

¾"

¾"

3"

1/8" DIA. FOR
1-1/4"
#6 WOOD
SCREWS

PLEXI - PLAN

SCALE: 3/4" = 1'-0"

1

DETAIL

2

SCALE: 3" = 1'-0"

A PLEXI COVER

ARTIST:
KARIN SCHNEIDER &
AMY GRANAT

JAN 2008 | 2007

Section of the Transparent Partition for *Image Coming Soon*

176

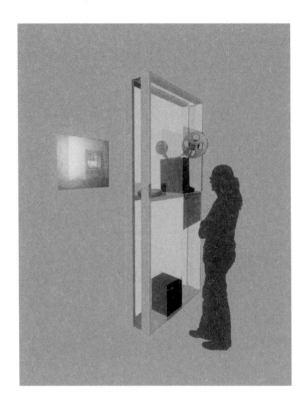

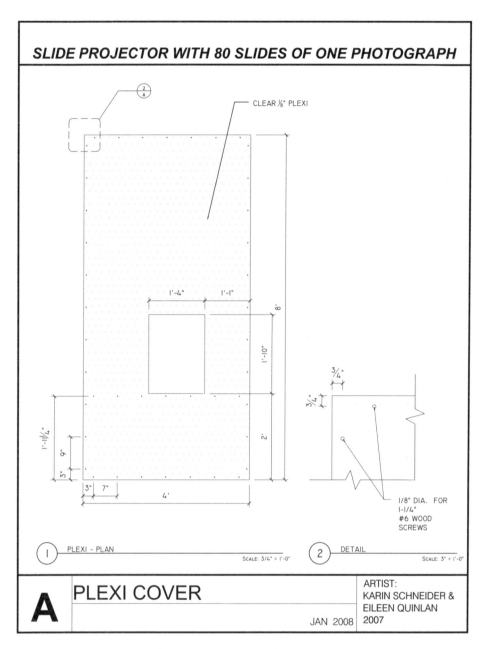

SLIDE PROJECTOR WITH 80 SLIDES OF ONE PHOTOGRAPH

CLEAR ⅛" PLEXI

1'-4" 1'-1"

8'

1'-10"

2'

¾"

¾"

1/8" DIA. FOR
1-1/4"
#6 WOOD
SCREWS

1'-11¼"

9"

3"

3" 7"

4'

1	PLEXI - PLAN		SCALE: 3/4" = 1'-0"

2	DETAIL		SCALE: 3" = 1'-0"

A	**PLEXI COVER**	ARTIST: KARIN SCHNEIDER & EILEEN QUINLAN
	JAN 2008	2007

Section of the Transparent Partition for *Image Coming Soon*

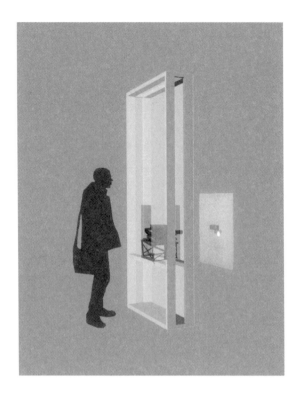

SLIDE PROJECTOR WITH 80 SLIDES OF ONE PHOTOGRAPH

DESCRIPTION: A TRANSPARENT WALL CONTAINING A SLIDE PROJECTOR ON TOP OF A EAMES WIRE-BASE TABLE WITH THE FOLLOWING BOOKS: "A NEW REFUTATION OF TIME", EXHIBITION CATALOGUE OF DAVID LAMELAS; THE VISIBLE AND THE INVISIBLE BY MAURICE MERLEAU-PONTY; AND "COMBINES", EXHIBITION CATALOGUE OF ROBERT RAUSCHENBERG; PROJECTING 80 SLIDES OF ONE PHOTOGRAPH BY EQ ON A OIL ON CANVAS (32 x 32 IN.) HANGING FROM THE CEILING.

ELEMENTS: EAMES WIRE-BASE TABLE
A NEW REFUTATION OF TIME BY DAVID LAMELAS
THE VISIBLE AND THE INVISIBLE BY MAURICE MERLEAU-PONTY
COMBINES BY ROBERT RAUSCHENBERG
35MM 80 SLIDES ROTARY CAROUSEL
OIL PAINTING (32x32 IN)
80 SLIDES WITH A DIGITAL MASTERED
TRANSPARENT WALL
POWER TAP

F	DESCRIPTION AND ELEMENTS		ARTIST: KARIN SCHNEIDER & EILEEN QUINLAN
		JAN 2008	2007

Tubular, 2009

I was invited by Mary Ceruti to contribute to the exhibition *The Space of the Work and the Place of the Object* at SculptureCenter, New York, and presented a Transparent Partition (TP) titled *Tubular*. This iteration of the TP served to demarcate another zone of production: the young artist who works within established art institutions to sustain their own art practice and career, despite the fact that their artwork is generally excluded from the programs of the institutions they work for. Such an artist, Nickolas Roudané, was employed by SculptureCenter as an assistant, and sat at the front desk. I invited him to produce an ongoing work during the exhibition while still performing his official reception duties. The reception desk located at the SculptureCenter's entrance was expanded and relocated into the gallery space and part of the wall between the two areas was removed. A long TP connected the two sections. Roudané's artistic production became part of the exibition's entrance, and his reception duties became part of the exhibition.

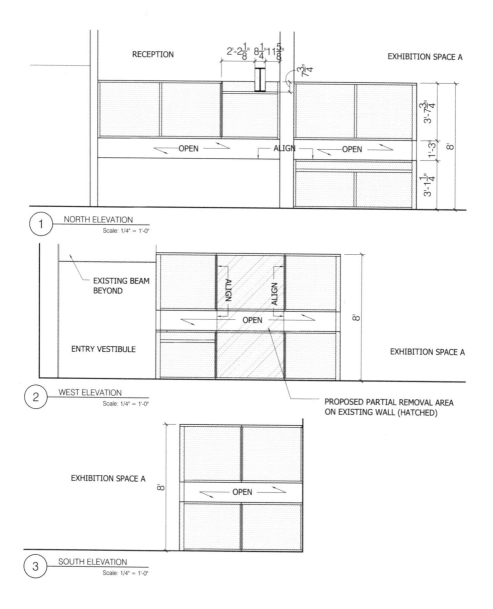

RECEPTION EXHIBITION SPACE A

$2'-2\frac{1}{8}''$ $8\frac{1}{4}''$ $11\frac{5}{8}''$

$7\frac{3}{4}''$

$3'-3\frac{3}{4}''$

$1'-3''$

$8'$

$3'-1\frac{1}{4}''$

⟵ OPEN ⟶ ⟵ ALIGN ⟵ OPEN ⟶

1 NORTH ELEVATION
Scale: 1/4" = 1'-0"

EXISTING BEAM
BEYOND

ALIGN ALIGN

OPEN

$8'$

ENTRY VESTIBULE EXHIBITION SPACE A

2 WEST ELEVATION
Scale: 1/4" = 1'-0"

PROPOSED PARTIAL REMOVAL AREA
ON EXISTING WALL (HATCHED)

EXHIBITION SPACE A

$8'$

⟵ OPEN ⟶

3 SOUTH ELEVATION
Scale: 1/4" = 1'-0"

Maniac Vicious Circles, 2009

Andrew Roth, director of PPP Editions, invited me to do an exhibi-
tion at his alternative gallery space, which occupied the ground floor
of a brownstone on Manhattan's Upper East Side. I installed for-
ty-seven drawings of circles (8 × 10 inches each, from a series of one
hundred) in the space. Each drawing was sandwiched between two
sheets of transparent acrylic, with a piece of Plexiglas on the recto
and a two-way mirror on the verso. A semi-transparent wire attached
to each drawing allowed visitors walking among the drawings to
spin them. The forty-seven spinning drawings were hung from the
ceiling at approximately the same height and with equal horizontal
distance between each drawing, forming a virtual grid within the
space. However, when activated, they reflected the architecture of
the space, themselves, and any person inside the installation, visually
fragmenting the grid and its regimented ideological implications,
in a dizzying vertigo. A website, maniacviciouscircles.com, accom-
panied the exhibition, and included a database that mapped each
drawing and a corresponding song for each drawing. The website
could be visited in multiple Internet browser windows simultane-
ously, with each browser playing a different recording, thus creating
a cacophony of diverse sounds.

ENTRANCE

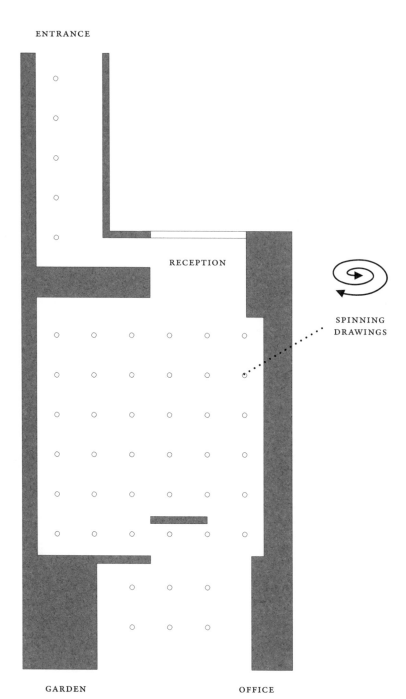

RECEPTION

SPINNING
DRAWINGS

GARDEN OFFICE

Image No.	Song/Film	Year	Composer	Length
1	Two and Three Part Inventions, Invention No. 1 in C major, BWV 772 and Sinfonia No.1 in C major, BWV 787 3. Invention No.2 in C minor, BWV 787.3 . Invention N2 in C minor, BWV 788	1685 to1750	Johann Sebastian Bach	08:12
2	My Way	1969	Paul Anka	04:16
3	Mouvement Électrique et Pathétique and Melody	1932 & 1929	Joseph Schillinger	01:52 01:51
4	-	-	-	-
5	Guerre	2007	Mafia K'1 Fry	06:05
6	Quatre Études De Rythme Pour Piano : Neumes Rythmiques	1949 to 1950	Olivier Messiaen	03:34
7	Sound	1966 to 1967	film directed by dick fontaine	24:41
8	Sympathy for the Devil	1968	Mick Jagger and Keith Richards	09:21
9	Piano Concerto No 21 - 2nd Movement (Andante)	1785	Wolfgang Amadeus Mozart	08:20
10	Lay Lady Lay	1969	Bob Dylan	03:17
11	Angie	1972	The Rolling Stones	04:32
12	Piano Pieces, Opus 76 No. 2 Capriccio and Pieces for Piano, Op. 118, No 2, Intermezzo in A major	1878 & 1892	Johannes Brahms	03:50 05:56
13	Piano Sonata No. 14 in C-sharp minor "Quasi una fantasia", Op. 27, No. 2 1. Adagio sostenuto 2. Allegretto 3. Presto agitato	1801	Ludwig van Beethoven	06:27 02:22 08:17
14	"Death and the Maiden". String Quartet No. 14 in D minor D 810 1.Allegro 2.Andante 3.Scherzo: Allegro molto 4.Presto	1824	Franz Peter Schubert	04:42, 06:45, 05:03, 05:40
15	Instrumental	1966	Otis Rush	04:20
16	O Come Sei Gentile	1619	Claudio Monteverdi	04:49
17	Chega de Saudade	1959	Antonio Carlos Jobim and Vinicius de Morais	03:23
18	Tom Tom Solo and Sing Sing Sing	1959 & 1934	Lionel Hampton and Benny Goodman & his Orchestra	03:08 05:03
19	The End	1967	Jim Morrison	07:29

interpreter	Site (in progress)

lenn Gould	http://www.youtube.com/watch?v=_QsEIUd1TZs
he Sex Pistols	http://www.youtube.com/watch?v=rDyb_alTkMQ&feature=related
oseph Schilinger	http://www.youtube.com/watch?v=w7goH2Y6fs8
lafia k'1 Fry	http://www.youtube.com/watch?v=gv_7y_IrOjw
vonne Loriod	http://www.youtube.com/watch?v=yyjvnn6ePy0
ohn Cage and Rashaan Roland Kirk	http://vids.myspace.com/index.cfm?fuseaction=vids.individual&videoid=50515513
he Rolling Stones	http://www.youtube.com/watch?v=5EOOlEtNedc&feature=related
aniel Barenboim and the Berlin Philharmonic	http://www.youtube.com/watch?v=FNX8QH6hstQ
ob Dylan	hhttp://www.youtube.com/watch?v=uIzpwlBuz1k
he Rolling Stones	http://www.youtube.com/watch?v=2RTWzsGO4Zc
rtur Rubinstein and Glenn Gould	http://www.youtube.com/watch?v=AZrOPORyaXc http://www.youtube.com/watch?v=UjmOx-KaHwM
aniel Barenboim	http://www.youtube.com/watch?v=E10K73GvCKU http://www.youtube.com/watch?v=zs0QAA0eltU&feature=related http://www.youtube.com/watch?v=jSZMYMP8FbU&feature=related
he Alban Berg Quartet	http://www.youtube.com/watch?v=2Yy9szBIKCw http://www.youtube.com/watch?v=SdCJRqH_IqU&feature=related http://www.youtube.com/watch?v=rQwVVH9Ybcl&feature=related http://www.youtube.com/watch?v=5hycEG1PkjA&feature=related
tis Rush	http://www.youtube.com/watch?v=QsXK2zL2-yM
oprani: Cettina Cadelo & Cristina Miatello ioloncello: Caterina Dell'Agnello rgano: Roberto Gini	http://www.youtube.com/watch?v=1dts4Q0P4qk
ão Gilberto	http://www.youtube.com/watch?v=h_NYrl1Mt9I&feature=related
ionel Hampton and Benny Goodman his Orchestra	http://www.youtube.com/watch?v=dy6B4lNixi4 http://www.youtube.com/watch?v=LYkVZgZVAho
he Doors	http://www.youtube.com/watch?v=h-9vPlsE7yQ

CAGE was a space that operated from 2010–14 at 83 Hester Street on Manhattan's Lower East Side. The space originally had no heating. The heating system of CAGE was made by Karin Schneider, Sarina Basta, Mary Rinebold, and David Lisaytan by superimposing onto the floor plan a diagram from *Untitled (The Don and Maureen Campbell Diagram to Be Applied in Any Metaphoric Manner They Wish)* (1977)* by John Knight. This work was part of a fictional narrative first published in the Journal of the Los Angeles Institute of Contemporary Art. The first page of the narrative shows a floor plan of a typical American suburban home. The following pages track movements of a film crew throughout the house over the course of ten days of production. The last image is an abstracted shape in the form of a diagram. This model maps form as circulation, separated from the tectonic aspects of the floor plan. CAGE's program was conceived under such a diagrammatic model; this work became part of the infrastructure of the space: the heating system.

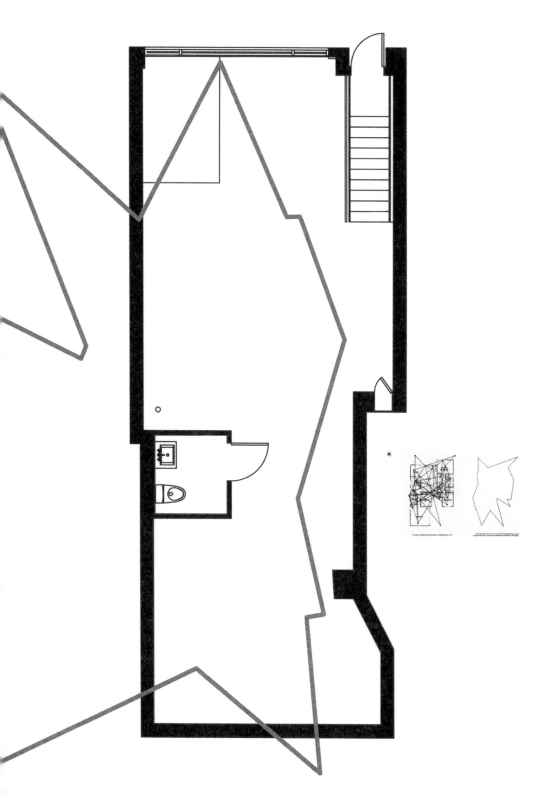

F(-)P (Form Less Painting), 2011

F(-)P, held at Roth, New York, was a painting exercise that explored
the vocabulary of the medium. Various canvases, in dialogue with
specially designed websites, video projectors, and a Mac mini server,
were used to "host" monochrome paintings. Objects in conversation
with the canvases included: a press release written by Heidi Ballet;
a chair designed by Dena Yago, on which visitors could sit and read
a novel which was in the process of being written collaboratively by
four hands over the course of the exhibition, *The Madness of Erica*
(themadnessoferica.com); an online chess game built by Charles
Broskoski ; a website, whitecircleonredandblue.com, designed by
Damon Zucconi; an old computer; a book; and arrows shot by Egan
Frantz at the walls and other object-targets. The concept of mono-
chromatic form was expanded in order to encompass different net-
works and logics of participation.

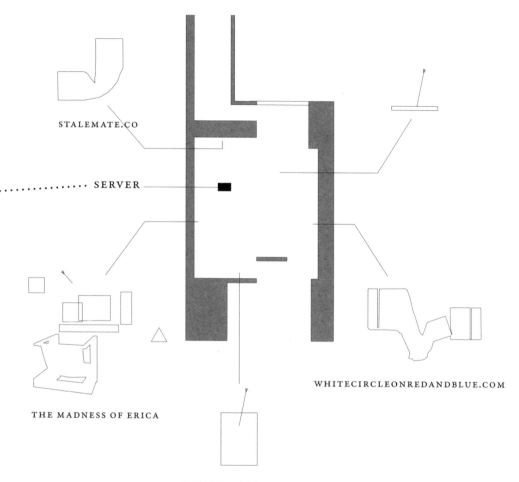

STALEMATE.CO

· · · · · · · · · · · · · · · · · · · SERVER

THE MADNESS OF ERICA

WHITECIRCLEONREDANDBLUE.COM

ARROWS, EROS, ERRORS

I was invited by Jesus Fuenmayor to do an exhibition at Periférico Caracas, a large contemporary art space in Venezuela. I installed a 787 ⅜ × 110 ¼ inch red painting over the entrance door and a yellow painting of the same size on the opposite wall. The colors were selected to match the Venezuelan flag. A projector playing a video I made of Juvenal Ravelo's kinetic work—which is permanently installed on Avenida del Libertador, a main thoroughfare in Caracas—was installed facing the yellow painting. The entrance to the venue was rerouted through the storage area, which was transformed into a fully furnished and functioning ceramics workshop with a kiln, open to the public for the duration of the exhibition. There are very few ceramics workshops in Caracas because of the prohibitive costs of operating a kiln and limited connection to public electrical power grids; for this reason, ceramists are rarely, if ever, able to practice their craft. Venezuelan ceramists Maria Elena Alvarez, Esther Alzaibar, Valerie Brathwaite, Elsa Este, Adreina Franceschi, Amarilis Hannot, Suwon Lee, Javier Leon, Paola Páez, and Milagros Perez acted as facilitators and technicians in the workshop. A white display apparatus, *Compositional Structure (Mondrian)*, was installed in the space between the two paintings to exhibit ceramics produced by participants, including visitors to the exhibition. All ceramics were painted cobalt blue, and were available for sale. Proceeds went to ceramist Paola Páez so that she could open a ceramics workshop in La Bombilla, Petare; the economy generated over the course of the exhibition was a part of the work.

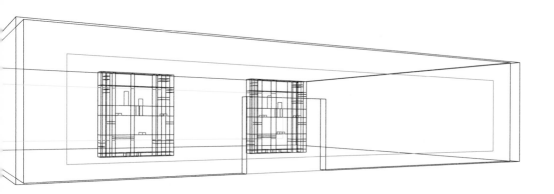

Homage to Michael Asher: Installation for a
Photograph by John Miller, 2014

John Miller invited me to participate in an exhibition at Galerie Barbara Weiss in Berlin. I collaborated with Abraham Adams to create *Homage to Michael Asher*, an environment for a photograph to be taken by Miller (titled *Persistence of Vision*). This photograph was not on display in the exhibition, and was only available for purchase by mail order. The first photograph in the edition was priced at $109 (the production cost) plus shipping; each successive photograph was sold for $1 less than the one sold immediately before it. The price and number of the final edition was to be determined at the end of the exhibition.

Aside from the hidden photograph, *Homage to Michael Asher* included: a waterjet-cut hanging plate designed by John Miller referencing John Knight's *Autotypes*; a photograph I took during the deinstallation of Dan Graham's *Crazy Spheroid—Two Entrances* pavilion at Marian Goodman Gallery in 2009; a masking-tape work indexing the zips in Barnett Newman's *Vir Heroicus Sublimis* (1950–51); and a Marilyn silkscreen by Andy Warhol, placed face down on the gallery floor. Affirming negation as one of the exhibition's "materialities," this phantasmic exercise was situated in the gallery as a series of fragmented elements. The aim of *Homage to Michael Asher* was to resituate historical relationships, putting forth multiple possible significations that demonstrate how meaning-formation operates and how it shapes our modes of thinking. Original artworks, derivatives or copies of artworks, and documentation of artistic practices and production were all included, entangling various networks of social geometry and geometric praxis.

Homage to Michael Asher was for sale under a specific economy: the price of the overall installation was equal to the debt generated during the exhibition by sales of John Miller's photograph. The work (with the exception of the Warhol silkscreen, which was not for sale) was accompanied by detailed instructions for its installation. Further presentations of *Homage to Michael Asher* could include another Warhol (or Sturtevant) painting as a substitute for the Marilyn silkscreen, under the stipulation that the Warhol work always be displayed face down on the floor.

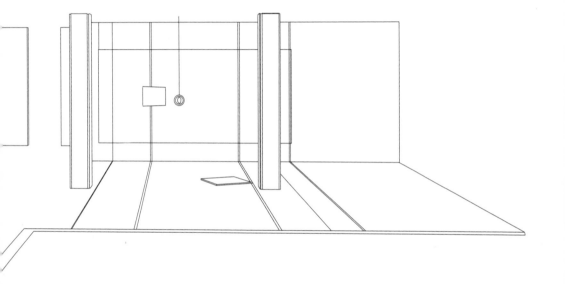

I was invited by Begum Yasar to do an exhibition at Dominique Lévy, New York, last year, after she visited my studio. For some time, I have been making an A-to-Z glossary of the possibilities of black monochrome painting, moving its program away from a fixed historical position and actively relocating it in discourse. SD (@DL/NY, 2016) takes as its point of departure a series of monochrome paintings structured according to the artistic practices of Barnett Newman, Ad Reinhardt, and Mark Rothko as they developed after WWII. These paintings are made with Mars Black pigment, mixed variously with Cobalt Blue, Cadmium Yellow, Cadmium Red, and Phthalo Emerald. I am also blending derivatives of petroleum and coal (two primary energy sources) into the black pigment.

Sixteen black monochrome paintings are installed on the gallery's second floor in a trisected square steel architectural structure, built according to the black-on-black squares that characterize Reinhardt's paintings. Paintings from this group can only be acquired by collectors with the agreement that another artist will at some point alter the canvas by painting over its surface. The name of the other artist is not to be revealed to the buyer prior to acquisition. Also on the second floor is a 16 mm film of the Adriatic Sea projected from a wood and Plexiglas Transparent Partition. An Extraction features the silhouette of the female figure *extracted* as a form from Matisse's *Nu bleu III* (1952), rendered in black rubber and placed on the gallery floor.

On the gallery's third floor visitors will find two Splits, works referencing Newman's *Onement I* (1948) and *Stations of the Cross* (1958–66), and a large Void work referencing a painting at the Rothko Chapel in Houston, TX. The third floor also presents Index, a series of paintings cataloguing the exhibition's various tones of black; a Cancellation work that simultaneously combines and annuls two artistic programs and their corresponding sets of values (in this case, those of Reinhardt and Tarsila do Amaral) within one painting; and an Extraction from Tarsila's *Abaporu* (1928) (this silhouette rendered in black steel).

An advertisement for the exhibition was placed in *Artforum* Vol.55, No.1. It features an image associated with a contemporary geopolitical crisis—a gesture that asserts connections between vastly different but nevertheless interconnected contexts. A copy of this issue, including an intervention created by the artist and Andrew Kachel, occupies the second gallery of the third floor together with three Naming paintings.

Each artwork in the exhibition is to be sold according to specific purchase agreements, structured to generate an economic model that supports collaborators involved in various aspects of the work. SD (@DL/NY, 2016) is an exercise that detours from a politics of aesthetics identified with traditional modes of authorship, viewership, and dissemination. It creates opportunities for multidimensional encounters with artworks. The ways in which the works confront various political, economic, and environmental issues are only detectable through a slowed-down perception of the exhibition. The gallery space can thus function as a political device, proposing a diagrammatic relationship between artist, artwork, and viewer. In this model, diverse forms of engagement can be established in relation to the artistic use of materials, time, space, and the exigencies of our time.

SD (@ DL / NY, 2016)

3RD FLOOR

1 Split	S (BN / ONMI)
1 Split	S (BN / SOC8)
1 Void	V (MR / RC # 1473)
1 Extraction	E (TA / AP)
1 Cancellation	AR (BP) + TA (AP)
Index 1	4 paintings
Index 2	2 paintings
1 Floating	F (FN / WTP)
3 Namings	N (POL) / N (SYR) / N (SRB)
1 Situation	

2ND FLOOR

16 Obstructional(s)	(O) paintings
1 Monochroming	M (AdSea / 16 mm, 1:00 min)
1 Extraction	E (HM / NB III-I)

BOTH FLOORS

1 Wall Drawing	WD#SD (@ DL / NY, 2016)

AdSea:	Adriatic Sea
AP:	*Abaporu* (1928)
AR:	Ad Reinhardt
BN:	Barnett Newman
BP:	Black Paintings
FN:	Friedrich Nietzsche
HM:	Henri Matisse
MR:	Mark Rothko
NB III-I:	*Nu Bleu I-III* (1952)
POL:	Poland
SRB:	Serbia
SYR:	Syria
TA:	Tarsila do Amaral
WD:	Wall Drawing
WTP:	Will to Power

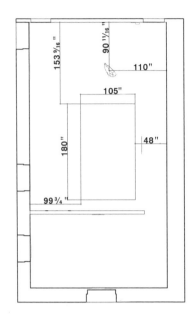

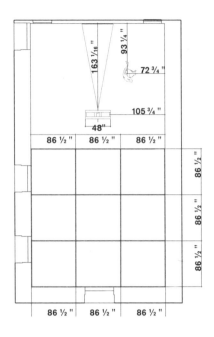

3RD FLOOR

2ND FLOOR

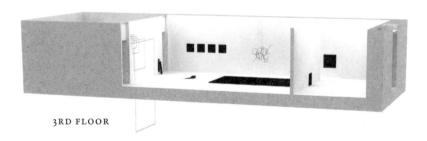

3RD FLOOR

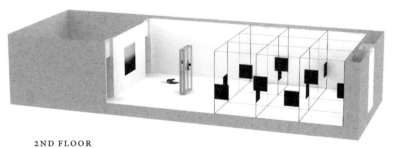

2ND FLOOR

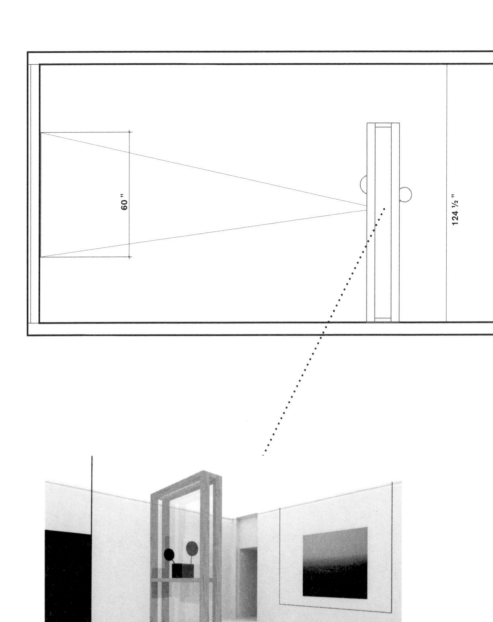

Situation
Transparent Partition with *M (AdSea/16 mm,
1:00 min)* and magazine intervention (displaced to
a separate room)

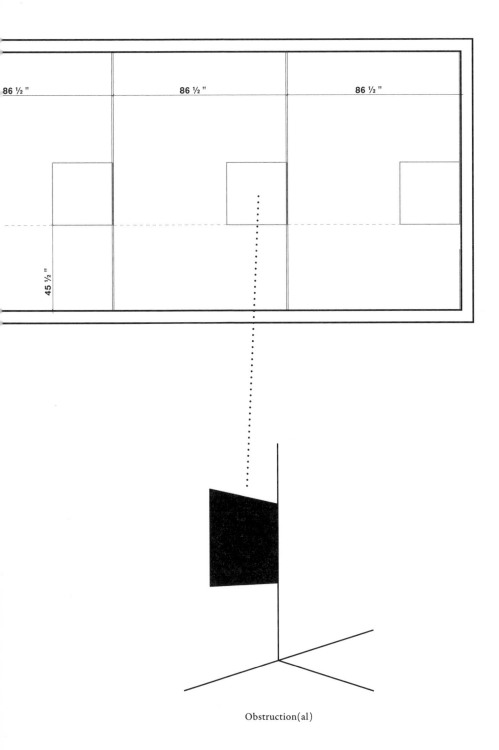

86 ½ " 86 ½ " 86 ½ "

45 ½ "

Obstruction(al)

A for Amalgamation = AR (BP + C) / ME (F)
/əˌmalgəˈmāSH(ə)n/

Ad Reinhardt (AR) said in an interview with Bruce Glaser: "The first word of an artist is against artists."[1] Amalgamation unites in a single canvas two separate programs created by Reinhardt: the black paintings (BP), and his parallel work of satirical comics (C) engaging the history of art, the art market, and the art world at large, which were formally inspired by Max Ernst's (ME) cartoon collages.

In these paintings, the two signature styles of AR are grasped and amalgamated into a single surface that reveals its own structure through the technique of frottage, which was developed as a distinct method by Ernst in 1925. It is painted in Mars Black with oil extraction, measuring 60 × 60 inches. The canvas is painted on the floor using the technique of frottage; a certain degree of pressure is applied on the canvas against the stretcher bars in order to slightly reveal its armature. The painting titled *She is Difficult* features a phrase often used in the art world (or any professional realm, for that matter) on the lower section of the canvas.

Devotion (a certain amount of time and bodily movement) is required to perceive this amalgamated yet heterogeneous schema. One needs to bend down and look at the painting from below to visually perceive the black text on the black background. A third system (value) will be implemented if/when the painting is acquired in exchange for a certain amount of money.

1. Ad Reinhardt interviewed by Bruce Glaser, "An Interview with Ad Reinhardt," *Art International* 10, December 20, 1966. Reprinted in *Art as Art*, ed. Barbara Rose (Berkeley: University of California Press, 1991).

Karin Schneider, *A (AR/(BP+C) + ME/F) (She Is Difficult)*, 2015
Oil on canvas, 60 × 60 inches (152.4 × 152.4 cm)

4 2

 3

1 4

3 1

AR (BP) + TA (AP)

G = Phthalo Emerald
B = Cobalt Blue
R = Cadmium Red
Y = Cadmium Yellow

Index 1

G	B	R	Y
1	2	3	4

Photographic illustration of Tarsila do Amaral's
Abaporu (1928) by Julio Grinblatt

C for Cancellation = AR (BP) + TA (AP)
/kansəˈlāSH(ə)n/

Cancellation is defined as the act of causing something to end, or to no longer produce a certain effect. Cancellation proposes a redistribution of forces that act within a painting so as to simultaneously combine and annul two artistic programs within one painting. This is an act of painting that articulates the signified as form. Painting becomes an exploration of "purport-forms" (purport as the thought in itself), that considers individual languages/artistic programs and their specific styles as typologies.

Negation was the signature mode of operation of AR's BP produced between 1953 and 1967. Phrases such as "art of painting vs. art of color," "the dark of absolute freedom," "black is negation," and "striving for nothing" can be found throughout *Art as Art*, a collection of selected writings by AR.[2] The artist conceived of and produced his black paintings as embodiments of the ultimate possibility in painting. His strategy of "what is not" was one of the main characteristics of his "timeless paintings."

In 1928, Tarsila do Amaral's (TA) painting *Abaporu* (AP) (which means "the man that eats people" in Tupi-Guarani)—whose composition features a man, the sun, and a cactus—inspired Oswald de Andrade (TA's husband at the time) to write the *Anthropophagic Manifesto* and subsequently create the Anthropophagic Movement, intended to "swallow" European culture and turn it into something specifically Brazilian. The metaphor of cultural cannibalism was used by Andrade to react against European colonialism and Brazil's subsequent cultural and economic dependence on Europe. TA described the subject of the painting as "a monstrous solitary figure, enormous feet, sitting on a green plain, the hand supporting the featherweight minuscule head, in front a cactus exploding in an absurd flower."[3] The style of AP can be traced back to the French modernists, especially Fernand Léger, who taught Tarsila in Paris in 1924. However, this image is somehow a spew, a reaction against her European education. (Index 1 is the palette of colors used in Cancellation.)

Cancellation is an impure notion. The end of painting is confronted with the beginning of a new model of thought (Anthropophagia) and vice versa. It produces a bodily effect (painting) that belongs to the space of the neither/nor—a model of suspension. The viewer has to move their body around the Cancellation to be able to perceive all the images that are configured in this particular SD.

2. Ad Reinhardt, *Art as Art*, ed. Barbara Rose (Berkeley: University of California Press, 1991).
3. Aracy Amaral. *Tarsila: Sua Obra e Seu Tempo* (São Paulo: Tenenge, 1986), 104.

D for Dependable = D (CW + BP)
/dəˈpendəb(ə)l/

In *Aesthetic Theory*, Theodor Adorno says, "only artworks that are to be sensed as a form of comportment have a raison d'être."[4] Dependable is defined as capable of being dependent on. Its definition varies from trustworthy to reliable for consistent performance or proven to be a good investment.

A Dependable presents at first glance two systems: a fragment of an image of a work of art and a black monochrome. They both have the same size (18 × 18 inches), but they are of dissimilar materials: a PhotoTex adhesive print and a monochrome (BP made with Mars Black and oil extraction). They hang on the wall side by side, yet they exist in different temporalities. A Dependable does not compress time into one single object.

"YOU MAKE ME" is a photograph of a painting by Christopher Wool (CW), taken in his exhibition at the Guggenheim Museum in 2014. The color of the monochrome is dictated by the color of the letters in CW's painting. The arrangement of the two panels (the adhesive print and the BP) forms an enigma, a puzzle to be solved by its observer, awaiting a proper appraisal. The choice of materials is an essential component of the production of the Dependable. The work is an *écriture* of other *écritures*, an artistic labor of presenting a changing situation of certain historical (and political) motifs: a double ready-made (one that affirms the viewer/consumer, and another that negates it). For CW, "Yes, but" is a very good description of the painterly condition. This SD—that is, Dependable—is created by using the logic of "Yes, but." It is a combinative variant of appropriation that belongs to the order of sign as speech; and as such it embodies an amplifying mode of relation, a neutral point, between two programs.

Dependable has no free market. Its value is always attached to its counterpart. One of the questions to be asked prevails: Can the indicant of its value be deflated over time, causing the Dependable to lose its capital value? Is something being expropriated here rather than appropriated? The value of the work does not reside in itself but on psychodynamics of how the value of its counterpart in the world is created and enhanced by market trends, auction prices, mood and desire—encompassing both speculation and advice. How to rediscover the articulations that man imposes on reality?

4. Theodor Adorno, *Aesthetic Theory*, trans. Robert Hullot-Kentor (London: Athlone Press, 1997), 15.

Karin Schneider, *D (CW + BP) (Dependable)*, 2015
PhotoTex print, oil on canvas, signed artist's statement
each piece: 18 × 18 inches (45.7 × 45.7 cm)
overall: 18 × 36 inches (45.7 × 91.4 cm)

Karin Schneider, *E (HM/NB III-I) (Extraction)*, 2016
Neoprene, 33 × 22 inches (83.8 × 55.9 cm)

Karin Schneider, *E (HM/NB III-I) (Extraction)*, 2016
Painted stainless steel, 32 × 29.5 × 8 inches (81.3 × 74.9 × 20.3 cm)

E for Extraction = E (TA/AP) / E (HM/NB III-I) / E (@)
/ikˈstrakSH(ə)n/

The word extraction comes from Latin, *extrahere* (ex-tract). It is described as the action of taking out something, of separating from. An Extraction has to do with the impression of being thrown on the floor, which implies a gesture that encapsulates an unknown result. It also refers to a certain genealogical lineage. An Extraction in this SD extracts certain images: in particular, forms of nude figures from the walls of art history. Its forms of "language/speech" diagrammatize another "form/function" articulation from its previous historical sign. A meta-language that redistributes its form of expression, its substance, and its form of content. One that escapes and separates (signifier/signified) from its previous existence.

It is not a question of extracting a singular image/material, but placing these extractions in a state of flux and continuous variation. Their final form can have infinite variations. A hard extraction finds its historical anchor in "diálogo fantasmático" with Katarzyna Kobro (*Spatial Composition* 9, 1933). A soft extraction dialogues with Lygia Clark (*Trepantes*, 1964). E (TA/AP) is the extraction of the figure out of Tarsila do Amaral's (TA) *Abaporu* (AP). E (HM/NB III-I) are variously extractions of the figures from Henri Matisse's (HM) three 1952 *Nu Blue* (NB) cutouts.

A digital extraction, E (@), extracts a sign-image from collective outlets around the world. It has a liquid quality. The key aspect is to have a digital extraction in the exhibition that can be sometimes activated, and sometimes deactivated—for instance, an image of a refugee camp taken from a news agency, reprinted in an art magazine. This is included in SD (@DL/NY, 2016) as part of a Situation. The magazine can sometimes be open to that page and at other times can be closed.

The work/concept "extraction" is not the object per se. The object becomes the result of different "ways of interacting" with the concept. It is another logic of production (materially and conceptually).

I for Index = Index 1 and Index 2
/ˈɪn·deks/

In the Cambridge Dictionary, an *index* as noun is an alphabetical list, such as one printed at the back of a book showing the pages on which a name or subject appears. It can also be a number that shows the value of something by comparing it to something else whose value is known. As a verb, it means to make a list of references (an index) for a book, or to arrange information in an index.

This term has different meanings for different writers. For Charles Pierce, an index extends beyond language. It means something that points to something else—such as smoke, which can be an index for fire. Indexes are signs linked to objects by an actual or real connection. For Ferdinand de Saussure, an index is a modality that connects signifier to signified (for instance, a pain, a phone ringing, a clock, a photograph, handwriting, etc.). For Roland Barthes, an index in a narrative can integrate diffuse information. Per Barthes, indexes function as "indicators": "personality traits concerning the characters, information with regard to their identity, notations of 'atmosphere,' and so on."[5] They imply metaphoric relata (in terms of being). However, according to Barthes, one cannot reduce functions to actions (verbs) because "there are actions with indicial value."[6]

In SD (@DL/NY, 2016), Index refers to the color-coding of an A-to-Z Glossary of black monochromes. Each color used in the Glossary exists in the form of a single 18 × 18 inch painting. So far, the Glossary has two indexes: Index 1 corresponds to four combinations of Mars Black, mixed variously with Cobalt Blue, Cadmium Yellow, Cadmium Red, and Phthalo Emerald; Index 2 corresponds to the combination of Mars Black mixed variously with turpentine, coal, and a derivative of petroleum. The indexes' numbers indicate their order of insertion in the Glossary.

5. Roland Barthes, *Introduction to Poetics (Theory and History of Literature)* (Minneapolis: University of Minnesota Press, 1981), 44.

6. Roland Barthes, "An Introduction to the Structural Analysis of Narrative," *New Literary History* 6.2: 1975, 247.

M (AdSea/16 mm, 1:00 min), view through Transparent Partition

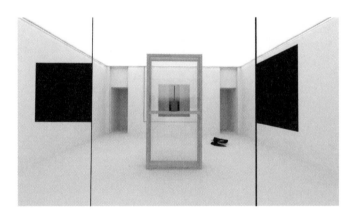

M (AdSea/16 mm, 1:00 min), view from trisected structure

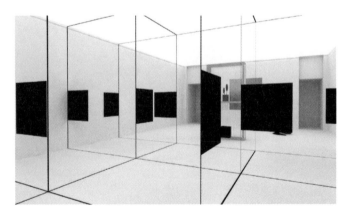

View from trisected structure

M for Monochroming
/ˈmɑː.nə.kroʊming/

Monochrome as an adjective is defined as "using a single color." As an artwork, the monochrome is developed or executed in black or white, or in varying tones of only one color. *Monochrome* could also refer to something boring.

The Centre Georges Pompidou in Paris published an online learning resource, "Le Monochrome," written in 2011–12 by Marie-José Rodriguez. This dossier questions the reasons why artists, in different times throughout history, have reduced their palette to paint in a single color. Kazimir Malevich, Alexander Rodchenko, Yves Klein, Barnett Newman, Mark Rothko, Ad Reinhardt, Robert Ryman, Pierre Soulages, Piero Manzoni, Roman Opalka, Ellsworth Kelly, and others are presented, mapping the history of the monochrome in the twentieth century.

For Louis Hjelmslev, any word can be transformed into a verb. *Word* and *verb* are not necessarily different—they merely mark different functionalities of the same concept. A verb is a word converted into a process, an action in time. Hjelmslev also defines a verb as a conjunction of propositions. Varying degrees of accents or addendums on the same syllabic base are forms of declension/declination of the expression. Expression (as in content) operates under the logic of a nexus. Hjelmslev calls this plane of possible expressions "modulation." Modulation corresponds, then, to the verbal characteristics of an expression, and verbal characteristics in turn correspond to modulation of content.

Monochroming does not exist in any dictionary as a verb. Monochroming started in 2005; it is the act of reducing the experience of color to minimum relations. Reducing color allows for the creation of complex diagrammatic relations that are not necessarily determined by fixed operations, but by infinite modulations.

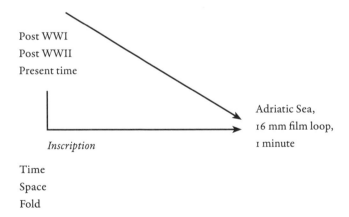

Post WWI
Post WWII
Present time

Adriatic Sea,
16 mm film loop,
1 minute

Inscription

Time
Space
Fold

N for Naming = N (POL) / N (SYR) / N (SRB)
/nām/

Naming comes from the noun *name*: "a word or set of words by which a person, animal, place, or thing is known, addressed, or referred to." As a verb, name can be used to mean "to mention, to appoint, to identify, to specify a place or time." Words are signs. When a word is spoken, a sense of time is incorporated in its system. Some components come (temporally) earlier and some later. In every language, the formation of syllables presupposes rules governing each linguistic structure. There is no natural course or sense of inevitability when it comes to learning different languages. In the act of naming, we demarcate boundaries, insert histories, and create possible analogies and chains of meaning. The meaning of any named thing can thus be socially motivated by desire, interests, networks, etc.

Words are like fingers pointing in a certain direction in that they immediately eliminate all other possibilities. However, fixed names (which form categories, associations, and meta-meanings) can change with time and within usage. The shapes of sounds (letters) became material for art in Cubism in service of the artists' rejection of representation, in Constructivism as propaganda for the Revolution, in Dadaism as typographical revolution, in Pop as an embrace of the society of consumption dictated by propaganda, and in Conceptualism as a negation of art as phenomenon.

Naming in the monochrome Glossary indicates paintings that have words. As a concept, naming has an open meaning, more or less associated with the multiple semiotic chains words can evoke when reader becomes writer.

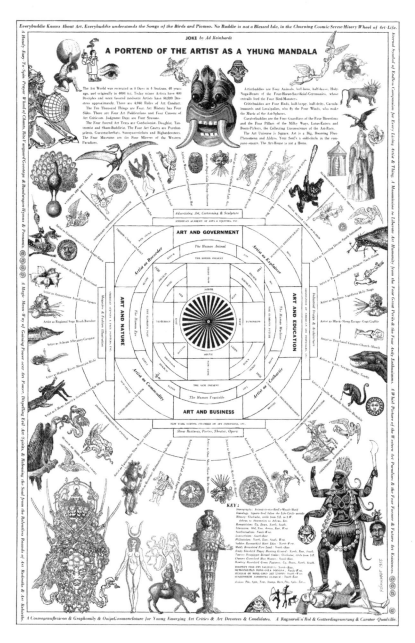

Ad Reinhardt, *A Portend of the Artist as a Yhung Mandala*, 1956

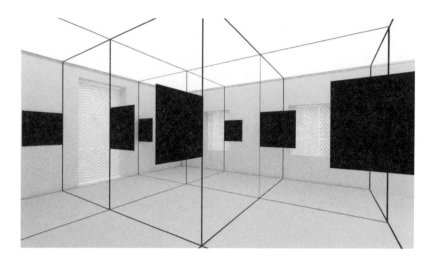

Trisected structure with Obstruction(al) paintings

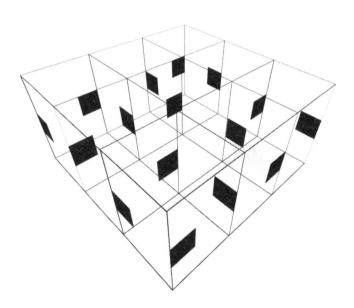

Trisected structure with Obstruction(al) paintings

O for Obstruction(al)
/əbˈstrəkSH(ə)n, äbˈstrəkSH(ə)n/

Obstructional is the adjective for obstruction. An obstruction can be a block, an obstacle, an impediment, an occupation. In law, according to the Cambridge Dictionary, obstruction refers to the obstruction of justice, the act of preventing the police or courts of law from doing their job and functioning correctly.

During a seminar organized by Columbia Law School in 2015, Étienne Balibar presented a paper on Foucault's lectures at the Collège de France, *Penal Theories and Institutions* (1971–1972). He had François Ewald as an interlocutor. At the end of the seminar, Balibar said: "You don't have a juridical system that is 100% normalized; otherwise, it would not be political." Effectively, normalized systems are not political. Ewald gave a brilliant response, presenting a structural reading of Foucault's lectures and describing how power is constituted by the State. He named this power repression. Repression is conceived as discontinuous, emerging when the state apparatus (composed of the military and judiciary systems) is mobilized. Tools and tactics are always used by the military to exercise subjectivation on people and to identify the enemy. Meanwhile, the justice system makes its subjects dependent on the sentence. Any theatricalization of subjects operates on a strategic level, not to create order, but to produce a new form of power.

Any possible decodification of these multiple levels of entanglement requires the exposure of the anatomy of the apparatus (*dispositif*). The posterior effects of such a process, if any, can create oblique forms of inventions and possible transformations of life. According to Jean Oury, François Tosquelles thought of occupation not only as a social and political reality, but also as a psychic structure. For Oury and Tosquelles, the search for true freedom needed to go through a form of psychic "disoccupation."

This body of work is comprised of (O) paintings, Obstruction(al) paintings. Each painting presents one possible two-color combination from the 4 deep shades of black, totaling 16 paintings. Each square painting measures 30 × 30 inches. Each square painting has a painted square at its center measuring 16 × 16 inches. They have matte black frames and are displayed in a specific location within a trisected square structure. Each painting can be acquired by a buyer provided that the buyer agrees that the painting will be altered by another artist without disclosure of the artist's name prior to the acquisition. Each painting creates a specific economy.

The color combinations in the (O) paintings provoke a rupture in our desire to normalize perception into a sustainable order. The smaller squares float in a space that is neither the pictorial plane nor our retina. As a form of rupture, they obstruct our perceptual logic.

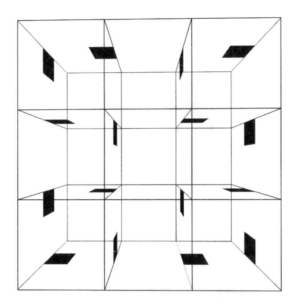

Trisected structure with Obstruction(al) paintings

30 × 30″

Square 1

16 × 16″

Square 2

No image circulation
No statement
No fast engagement
No dispersion
No reproduction
No service economy
No political arrest

1 Phthalo Emerald
2 Cobalt Blue
3 Cadmium Red
4 Cadmium Yellow

1 + 2	1 + 3	1 + 4	1 + 1
2 + 1	2 + 3	2 + 4	2 + 2
1 + 3	2 + 3	3 + 4	3 + 3
1 + 4	2 + 4	3 + 4	4 + 4

Trisected structure

PARTIAL 2ND FLOOR PLAN
1 SCALE: 1/4" = 1'-0"

PARTIAL 2ND FLOOR REFLECTED CEILING PLAN
2 SCALE: 1/4" = 1'-0"

MADISON AVENUE

STRUCTURAL STEEL NOTES

1. STRUCTURAL STEEL HAS BEEN DESIGNED IN ACCORDANCE WITH THE NEW YORK CITY BUILDING CODE. NEW STRUCTURAL STEEL SHAPES SHALL CONFORM TO ASTM–A992 GRADE 50 STEEL UNLESS OTHERWISE NOTED (U.O.N.). THE TYPE OF STEEL FOR ALL STRUCTURAL STEEL SHAPES, PLATES, BARS ETC., SHALL BE INDICATED IN THE SHOP DWGS.

2. COMPLY WITH AISC STEEL MANUAL. A.I.S.C. SPECIFICATIONS FOR DESIGN, FABRICATION, AND ERECTION OF STRUCTURAL STEEL FOR BUILDINGS SHALL APPLY, OR ANY MORE RESTRICTIVE REQUIREMENTS OF THE NEW YORK CITY BUILDING CODE.

3. ALL HSS RECTANGULAR AND ROUND STEEL SHALL BE A500 GRADE B.

4. ALL PLATES, ANGLES ETC., USED AS CONJUNCTION MATERIAL MAY BE ASTM–A36 STEEL U.O.N.

5. ALL BOLTS SHALL BE ASTM F–1852 A325 TC 3/4"ø, UNLESS OTHERWISE NOTED.

6. ALL BOLTED CONNECTIONS PROVIDE A MINIMUM OF TWO (2) BOLTS.

7. All STEEL SHALL BE SHOP PRIMED AND PAINTED PER OWNERS SPECIFICATIONS.

8. EXISTING STRUCTURE SHALL BE PROTECTED DURING THE INSTALLATION PROCESS.

SECTION A-A

SECTION B-B

CEILING

A

7/8"
1/2"

HSS1X1X⅛ RAIL,
SEE PLAN FOR LOCATION
#10 COUNTERSUNK SELF
TAPPING SCREWS
L2"X2"X⅛"-1" LONG
HSS1X1X⅛ POST,
SEE PLAN FOR LOCATION

③ TYP. DETAIL @ CEILING
SCALE: 6" = 1'-0"

CEILING

7/8"
1/2"

HSS1X1X⅛ RAIL,
SEE PLAN FOR LOCATION
#10 COUNTERSUNK SELF
TAPPING SCREWS
L2"X2"X⅛"-1" LONG
HSS1X1X⅛ POST,
SEE PLAN FOR LOCATION

④ TYP. DETAIL @ CEILING
SCALE: 6" = 1'-0"

3/4"

ART WORK ART WORK

2"
7/8"
1/2"

1"X⅛" BENT PLATE
(4) FOUR #8 EQUALLY SPACED
SCREWS
#10 COUNTERSUNK SELF
TAPPING SCREWS
L2"X2"X⅛"-1" LONG
HSS1X1X⅛ POST,
SEE PLAN FOR LOCATION

⑤ TYP. DETAIL @ ART WORK
SCALE: 6" = 1'-0"

EXIST. WALL

HSS1X1X⅛ POST,
SEE PLAN FOR LOCATION

#12-3" LONG COUNTERSUNK
SCREW. TOTAL OF 3 PER
VERTICAL LEG. OFFSET 6"
FROM FLOOR/CEILING AND
AT MID POINT.

⑥ TYP. DETAIL @ VERTICAL WALLS
SCALE: 6" = 1'-0"

SECTION C-C

7/8" 1/2"

C

HSS1X1X⅛ POST,
SEE PLAN FOR LOCATION
L2"X2"X⅛"-1" LONG
#10 COUNTERSUNK SELF
TAPPING SCREWS
1"X⅛" CON. PL.
PROTECTION

7/8"
1/2"

FLOOR

#10 COUNTERSUNK BOLTS

⑦ TYP. FLOOR DETAIL
SCALE: 6" = 1'-0"

SECTION D-D

D

HSS1X1X⅛ POST,
SEE PLAN FOR LOCATION
L2"X2"X⅛"-1" LONG
#10 COUNTERSUNK SELF
TAPPING SCREWS
1"X⅛" CON. PL.
PROTECTION

7/8"
1/2"

FLOOR

#10 COUNTERSUNK
BOLTS

⑧ TYP. FLOOR DETAIL
SCALE: 6" = 1'-0"

S for Split(ting) = S (BN/ONM1), S (BN/SOC8)
/splɪt/

To split means to divide into two or more parts. Dividing and sharing something (especially resources or responsibilities) is a matter of issuing new shares (of stock) to existing shareholders in proportion to their current holdings.

Subjectivity—which, for Michel Foucault, is a culturally and historically constructed form—should not exhaust our capacity to conceive of new understandings of the self. Foucault refuses notions of the subject as a condition of experience (as in Existentialism and Phenomenology) or as a Transcendental Consciousness.

Foucault's injunction to "get rid of the subject itself"[7] may open new paths for modes of being.

In *The Psychic Life of Power: Theories in Subjection*, Judith Butler writes:

> For Foucault ... the body is produced *as* an object of regulation, and for regulation to augment itself, the body is *proliferated* as an object of regulation.

This proliferation both marks off Foucault's theory [of subjectivity] from Hegel's and constitutes the site of potential resistance to regulation. The possibility of this resistance is derived from what is *unforeseeable* in proliferation. But to understand how a regulatory regime could produce effects which are not only unforeseeable but constitute resistance, it seems that we must return to the question of stubborn attachments and, more precisely, to the place of that attachment in the subversion of the law.[8]

Splitting refers to Barnett Newman's zip paintings (ZP). S (BN/SOC8) corresponds to his *Stations of the Cross* (1958–66). Lawrence Alloway writes of the *Stations*: "Although Newman's *Stations* have no obligatory arrangement ... they need to be adjacent, so that repetitions and cross-references can perform identifying and expressive roles. Flexible as the paintings are, their spatial unity, as a group, is essential to their meaning." He continues, "The fact that he used oil paint and three different synthetic media reveals his awareness of the function of color in the series, not only in its relational aspects but as a physical property. Different blacks occur from one painting to another and, sometimes, within one painting."[9]

7. Michel Foucault, *Power/Knowledge: Selected Interviews and Other Writings, 1972–1977*, ed. Colin Gordon, trans. Gordon, Leo Marshall, John Mepham, and Kate Soper, (New York: Pantheon, 1980), 117.

8. Judith Butler, *The Psychic Life of Power: Theories in Subjection* (Stanford: Stanford University Press, 1997), 59–60.

9. Lawrence Alloway, *Barnett Newman: The Stations of the Cross, lema sabachthani* (New York: Solomon R. Guggenheim Museum), 15.

Butler's remarks on gender and subjectivity introduce a split into the supposedly unified subject of historical Feminism: the Woman. For her, sex and gender are cultural constructs. Gender, then, becomes performative. In Butler's work, the object/subject dichotomy (and the ideology that comes with it), as well as the traditional gender binary (man/woman), are exposed as artificial and hegemonic. The practice of troubling solidified categories can be seen as a performative exercise.

Splitting is an ongoing conversation with Newman's work. In his paintings, each zip is treated differently. Each work is singular. Splits do not exist as One unit after they are exhibited. They can only be partially acquired and experienced (a single buyer can only acquire one Split of a pair). They can form pairs, but only of two paintings from different Splits. They don't exist as a series, either. They occur in different moments in time, and in different materials. Each time a new Split is produced, new configurations can be created.

V for Void = MR (RC#1473/BP)
/void/

Void relates to the Latin word *vacāre* (to be empty, vacant, or unoccupied). It can be used as an adjective, noun, or verb. *Voidable* is the adjectival form, and *voidness* is the derivative as a noun. As an adjective, it means not valid or legally binding, or useless. As a noun, it means completely empty, or emptiness caused by the loss of something. As a verb, it can be used to mean to discharge, or something that is not valid.

Robert Smithson's 1966 article on Ad Reinhardt, published in *Arts Magazine* Vol. II, compares Reinhardt's "Twelve Rules for a New Academy" (1952) with George Kubler's seminal book, *The Shape of Time: Remarks on The History of Things* (1962). For Smithson, "The workings of biology and technology belong not in the domain of art, but to the 'useful' time of organic (active) duration, which is unconscious and mortal. Art mirrors the 'actuality' that Kubler and Reinhardt are exploring. What is actual is apart from the continuous 'actions' between birth and death. Action is not the motive of a Reinhardt painting. Whenever 'action' does persist, it is unavailable or useless. In art, action is always becoming inertia, but this inertia has no ground to settle on except the mind, which is as empty as actual time."[10]

In 1946, lifelong anarchist Barnett Newman titled a painting *Pagan Void*. Two years later, he started working in a signature style that he would use until the end of his life: the so-called zips. Says Newman, "[The] zip does not divide my paintings. I feel it does the exact opposite. It does not cut the format in half or in whatever parts [...] It creates a totality."[11]

Between 1964 and 1967, Mark Rothko painted fourteen paintings for a non-denominational Chapel in Houston, TX. After several conversations with Philip Johnson, Rothko decided that the Chapel would be octagonal. VOID = MR (RC#1473/PB) takes its structure from the single painting installed on the south wall of the Chapel's rear entrance, which measures 180 × 105 inches. The interior rectangle of this single panel is painted black. In a 1959 interview, Rothko said, "Sometime in the twenties I guess, I lost faith in the idea of progress and reform. So did all my friends. Perhaps we were disillusioned because everything seemed so frozen and hopeless during the Coolidge and Hoover era. But I am still an anarchist. What else?"[12]

10. Robert Smithson, "Quasi-Infinities and the Waning of Space," *Arts Magazine* Vol. II, November 1966.

11. Barnett Newman, *Barnett Newman: Selected Writings and Interviews* (Berkeley: University of California Press, 1992), 306.

12. Mark Rothko, *Writings on Art: Mark Rothko*, ed. Miguel Lopez-Remiro, (New Haven: Yale University Press, 2006), 132.

For Kubler, "Style is like a rainbow. It is a phenomenon of perception governed by the coincidence of certain physical conditions ... Whenever we think we can grasp it, as in the work of an individual painter, it dissolves into the farther perspectives of the work of that painter's predecessors or his followers, and it multiplies even in the painter's single works ... "[13]

The consumption of art relies on the existence of signature styles. Style has the function of transforming single "useless" repetitive actions into objects of common desire. The artist's voice becomes recognizable if certain recurring tropes can be identified in their work, or if one idea becomes a series, or if some structure and or system justifies her/his/their/its production. What if there were no system but situations and formal dialogues demarcating diagrammatic motivations? This is the logic of voiding: invalidating unity, negating existential and mystical experiences of unification, and moving toward situations that connect different realities to reveal the silent atomic guilt of a monochromatic generation encapsulated in coal and petroleum.

13. George Kubler, *The Shape of Time: Remarks on the History of Things* (New Haven: Yale University Press, 1962), 129.

Index 2

COAL PETROLEUM

INDEX 18 × 18" NAMING 24 × 24" OBSTRUCTION(AL) PAINTINGS 30 × 30" CANCELLATION 33 × 29" MONOCHROMING 60 × 60" VOID 105 × 180" WD#SD (@DL/NY, 2016)

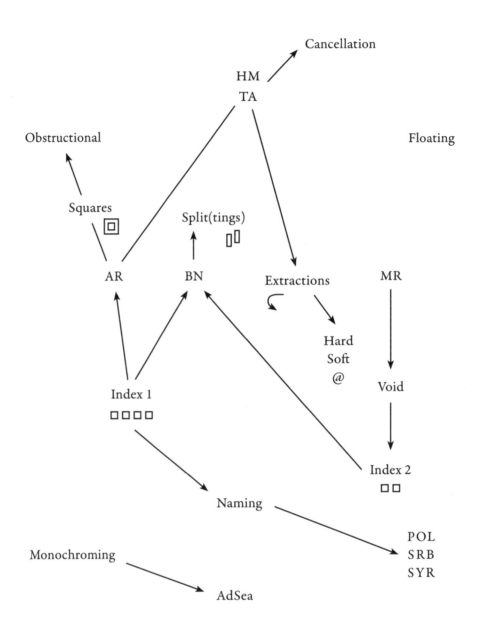

How to bring the hegemony
of the signifier into doubt?

And ... And ... And ...

Explosion of perception

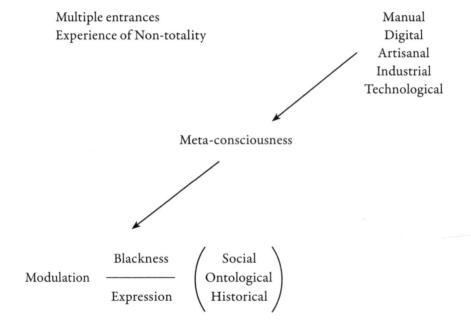

Multiple entrances
Experience of Non-totality

Manual
Digital
Artisanal
Industrial
Technological

Meta-consciousness

Modulation $\dfrac{\text{Blackness}}{\text{Expression}}$ $\left(\begin{array}{c}\text{Social}\\\text{Ontological}\\\text{Historical}\end{array}\right)$

Atomic

Silent

Karin Schneider, *F (FN/WTP)*, unnumbered edition, 2016

Situational Diagram

Karin Schneider

An art production that occupies neither the space of art, nor the space of philosophy, but is always emerging out of the movement between the production of sensations and that of thought. A reactive becoming that emerges when sensations come into being through the constant exercise of moving along unstable and multiple relations of non-programmed thought. Here, without the production of sensations, thought is always on the verge of losing its contours; conversely, sensations—affect and percept—can never be fully materialized without thought, their co-creator. This experimental becoming is, among other things, the result of combining two affective and conceptual universes that co-exist(ed) with each other: those delineated in Félix Guattari's *Cartographies schizoanalytiques* (*CS*), and his *What is Philosophy?* (*WiP?*), co-authored with Gilles Deleuze.

Conceptual becoming (concept) is then intrinsically interconnected with Sensory becoming (affect and percept). It intervenes in the order of the body and in the order of thought, whereby corporeal (books, magazines, conversations, artworks, etc.) and incorporeal objects (mathematical equations, political ideologies, etc.) inform each other in various ways. Thinking, rooted in and resulting in concepts, forms an active relationship with material production in a constant interplay of corporeal and incorporeal objects. Meanwhile, the corporeality of thought demarcates a specific relation with its place and its time; the Incorporeal has another

form of inscription that disrupts the demarcations of chronological and historical events. It is an act of perpetual experimentation with the actual and the virtual (neither in the technological sense, nor as an image, but rather in the sense of potentiality, as a force)—that is, with the real and the possible. Its situational dynamics suspend the habits, disciplines, historical readings, and given logics of artistic production, opening it up to processes of extracting and grasping situations, a practice of constant and fluid diagrammatization, in which thought is formed not by fixed structures of representation and language, but instead by a meta-modeling (that is, the affective diagrammatization that arises from deterritorialization, as I will discuss in reference to *CS* in what follows) approach to the historical, the social, the aesthetic, the formal, the economic, the cultural, the psychological, the technological, the digital order, and so on. This form of production generates a meta-semiotic lexicon.

In *Prolegomena to a Theory of Language*, Louis Hjelmslev states that a linguistic system has to be considered in its schema and its usage, in its totality and in its individuality, but also with respect to the human society underlying language. Language must be grounded in its historical, social, economic, cultural, aesthetic orders, among others. It is not an abstract system disconnected from the reality of material cultures. He differentiates language as existing as a pure form (schema), as a material form (norm), and as a set of habits (usage). Roland Barthes sees in these subdivisions a radical redistribution in the concept of language, relocating it as a social concept: usage. For Barthes, language is at once a social institution and a system of values. It is the product and the instrument of speech. Speech, then, is a combinative activity. Modes of talking, speaking, writing, and listening are attached to social fabrics and value systems from which these actions emerge.

The idea of a diagram, for Guattari, comes from Charles Pierce. For Pierce, a concept is the living influence of a diagram, or icon, whose parts are connected in thought to an equal number of feelings and ideas. In Pierce's theory of a sign system, language leaves its historical and predetermined site of representation to become a material in flux. It becomes the contact *within* reality. It

becomes a figure of political technology[1] regardless of any specific usage. It is a dynamic force, and it does not signify. He includes in this category technology and, more specifically, data storage, algorithms, and other computer processes. A diagram is a site for production. Instead of representing thought, it generates thought. For Guattari, diagrammatic thought uses signs, not language. Signs belong to the order of the incorporeal objects, to the plane of expression (the technological world, the animal world, the linguistic and non-linguistic signs, etc.). In a structure, objects are reduced to how they are signified. In a diagram, the plane of expression (incorporeal bodies) functions autonomously with respect to the plane of content (corporeal bodies), producing a complex form of interaction with unfixed forms of signification. Events such as wars, revolutions, and natural disasters transform social systems by creating virtual maps of possible new configurations.[2] Diagrams belong to the field of sensitivity and the logic of sensation.[3] It is the motor of life that makes one search outside of the states of certitude. A process of diagrammatization already exists in many modes of artistic production, in an embryonic form, producing movements in our ways of perceiving and/or creating situations. A process of diagrammatization detaches signs from language in relation to systems and processes of social interconnections.

What is the meaning of the term *situational* in this context? If the diagram is abstract, then the situation must always be concrete given its contingent nature. The historical, cultural, and aesthetic uses of figures of analysis, techniques, and critiques utilized by the Situationist International determined the parameters of our history, our perceptions, and our actions. Their critique of

1. Michel Foucault, *Discipline and Punish: The Birth of the Prison*, trans. Alan Sheridan (New York: Random House, 1977), 26.

2. Regarding these post-disaster configurations, see Jean-Luc Nancy, "Selections from *After Fukushima: The Equivalence of Catastrophes*," p. 121 in this book.

3. According to Guattari, "Collective ... is a description which subsumes on one hand elements of human intersubjectivity, and on the other pre-personal, sensitive and cognitive modules, micro-social processes and elements of the social imaginary. It operates in the same way on non-human subjective formations (machinic, technical and economic). It is therefore a term which is equivalent to heterogeneous multiplicity." *Chaosmosis: An Ethico-Aesthetic Paradigm*, trans. Paul Bains and Julian Pefanis (Bloomington: Indiana University Press, 1995), 70.

advanced capitalism is still haunting contemporary art production. How to remap affects/effects and reshuffle the (un)fixed cards of the value system of late capitalism, which is inextricably connected to spectacle, is still a question to be answered. It is not a question to be answered in the literal sense, but it is a question that must be inserted into the work as part of the dialectics traversing the space between its production and its consumption. This question must become part of the material of the work itself as much as of its concepts.

A situation, then, in this context, should be understood in its expressivity, but also in its morphology—as a function of its production in terms of its place in space and time, its economic, social, and historical conditions. Diagrammatic logic conceives of history as a machine that is constantly producing movement; it is a process that can be linked to Leon Trotsky's idea of permanent revolution. It is not about creating an ideal situation; rather it is a process of creating conditions that will enable moving the *collective imaginary* away from structures of power and hierarchical pyramids that are constantly being reproduced in groups, toward other cartographies that can vary in size, kind, duration, and nature. As such, it is concerned more with building concrete platforms that can experiment with relations of production than with forces of production themselves—production understood as inseparable from consumption.

The Unconscious in a diagrammatic situation is not only located in the order of the analogical form, as stated by Claude Lévi-Straus. The Unconscious is also located in the order of the connections the individual is affected by, and the effect their work/thinking is capable of producing in relation to the self, to the social milieu, and within the world. The Unconscious, in the diagrammatic sense, is social and political, nomadic and dynamic in its constant creation of relations in a fluid reality with no totality. Each situation is a form of mapping internal and external interdependence, by perceived and unperceived ripple effects that exist between multiple constellations. Mapping creates an existential territory that combats alienation and reproduction. Thought exists, then, by virtue of the *encounter* of multiple intersections and lines of flight (*lignes de fuite*) with many virtual and real situations creating a rhythm,

which perhaps can be constituted as a refrain, but always on the level of a contingent experiment.

This experiment is constructed under the concept I am referring to as Situational Diagram (SD). It has the intention of freeing thinking from disciplinary and institutionalized methods. The process of thought here is realized along with the construction of the object moving its dynamics away from the production of partial objects, toward the creation of *partialized* objects. According to Brian Massumi, partial objects refer to a libidinally invested objective perspective of one part of a body on another, or one body on another. It is the site he calls a "repetition-impulse" where power-language encounters an individual body.[4] Partialized objects instead are objects that are extracted from their historical totality to become something else, a practice of zigzag between the actual and the virtual, something that is constituted always by many people and situations.

SD does not have a closed form, but exists always as many possibilities. Each situation creates its own diagram. It is a concrete machine that opens production to the creation of partialized objects. Repetition within difference. Once activated, it provokes bifurcations on the level of interaction. Its morphogenesis carries choice and lines of possibilities. It is a process of production that has the potency of being disruptive, provoking another way of living and conceiving of the relations among the social, the political, the historical, the unconscious, and the subject. It also permits objects to exist differently in relation to subjects and vice versa.

SD is thus a tentative practice of diagrammatization of thought and de-individualization of the body. It is a *dispositif*—always

4. According to Massumi, "Meaning is only secondarily what words say literally and logically. At bottom, it is what the circumstances say, in other words—and outside words. The head of house says "Who has the salt?" (read: Don't just sit there, for Christ's sake, hand it to him). ... Every meaning encounter conveys an implicit presupposition, which more or less directly takes the form of a parenthetical imperative ... Deleuze and Guattari call the repetition-impulse of this imperative function immanent to language the 'order-word.' 'Order' should be taken in both senses: the statement gives an order (commands) and establishes an order (positions bodies in a force field)." *A User's Guide to Capitalism and Schizophrenia: Deviations from Deleuze and Guattari* (Cambridge: MIT Press, 1992), 31.

created collectively by multiple participants in different capacities and via different techniques (affect, conversations, encounters, writings, etc.), mapping its movements and situations (historical, political, economic, technological, etc.). It is constructed with respect to its own capacity for generating a *transitional fantasy*[5] among participants in the moment of the constitution of the work/situation. The roles played and the positions occupied by its participants are not fixed. An SD aims to provoke the dislocation of a participant into a real, active relationship with language, thinking, choice, and creation. It is a moment of exposing difference and repetition in all their singularities and variations as integral to the production of the work/situation. The work/situation's location, production, economy, circulation, and the dynamics among its participants and the group are intrinsically connected.

CS and *WiP?* map living systems, not individual beings. Social and living machines are inseparable, just as the unconscious is inseparable from rationality, both forms of apprehension being subject to the intervention of various other vectors. The materiality of concrete processes is inseparable from the production of processual, ethico-aesthetic singularities.

Meta-modeling is a process of auto-modeling that appropriates all or part of existing models in order to construct its own cartographies, its own reference points, and thus its own analytic approach, its own analytic methodology. It creates new paths. SD is a propositional meta-modeling activity that works with the potential to detach subjectivities from their normalizing models of interaction with thought/action. An SD occupies and activates an existential territory as a collective force that generates resistance, disobedience, and *affect*—the capacity for acting and being acted upon. Affect is the deterritorialized matter of enunciations that can be worked on. Affect is man's nonhuman becoming and a productive force that connects man with open systems of diagrammatization. In *CS*, Guattari differentiates between three different kinds of affect: sensible, problematic, and existential. The first uses memory and

5. *Transitional Fantasy* is a term originally coined by Félix Guattari in *Molecular Revolution: Psychiatry and Politics* (New York: Penguin, 1984), 39.

238

cognition as its referent (language and semiotic systems). The second is the basis of sensory affects. The existential affect allows for diagrammatic relations of signification to produce a meta-modeling system (meta-representation). When the object is deterritorialized, affect is diagrammatized, allowing one to become a creator rather than a participant. The unity of the object becomes a movement of subjectivation rather than a focal point. It dislocates being to experience diagrams of multiple machinic assemblages (*agencements*) that are always connected, producing a permanent work in progress.

An SD is a *dispositif* that dismantles certain codes of the social/body/perception. Its existence depends on its participants and their capacity to interact with the proposed situation. It can produce interactions with the city, liberating the body from its fixed form that is necessarily subject to normativity and control. In this sense, SD is a process of schizoanalysis, an unconscious in action, where the subject is a relative construction, a singular point inside particular collective assemblages (*agencements*). SD interacts with living/social machines creating experiential terrains that transform matter from sets of fixed significations into diagrammatical ones. Language in this situational trajectory is one of a multiplicity of apparatuses that the social/body needs in order to become diagrammatized. Its biopolitical form creates filters that shield bodies, enabling them to produce orifices for grasping existential affects. Each SD can be configured in multiple and/or hybrid forms—for example, a black block/music block that interrupts traffic by means of a collective dance and march during rush hour.

Affect in an SD activates the passive relationship between the producer and the participant, transforming the latter into the very creator of the diagram. It incorporates diagrammatic relations of signification, producing a meta-modeling system with no fixed identities. When production and consumption have a decentralized orientation, affect is diagrammatized and de-individualized. Historical, artistic, political, technological, economic, social, libidinal, etc. machines are sometimes reconstructed, appropriated, dislocated, deconstructed, revisited as part of the creation of this de-individualized sensibility. There are no subject-object relations, only forms

of collectivization producing a territory with multiple entrances. Each SD produces its own form and economy, in particular, individual/group universes of creation, interactions, and disseminations. Sometimes, SDs are connected with formal economies; sometimes they produce parallel, informal ones. An art exhibition, a black block, a call to action, a sabotage, a performance, any type of group-subject dynamic can be referred to as a Situational Diagram if its configurations present real transversal relations that provoke changes in the form in which it is constituted, and in the form in which it interacts with its surroundings. Each SD creates its own tactics and strategies in order to produce situations in which affect is collectively and individually generated and diagrammatized. SD is a process, not an image. It is a process of production that de-individualizes the body, and which, at the same time, constantly re-creates, throughout its production, new processes of individuation.

Maurizio Lazzarato traces the concept of power from Michel Foucault. Power for Foucault should be thought not only as a theory of obedience but also as the capacity for transformation that every exercise of power implies. For Foucault, "resistance was conceptualized only in terms of negation. Nevertheless, as you see it, resistance is not solely a negation but a creative process. To create and re-create, to transform the situation, to participate actively in the process, that is to resist."[6] For Lazzarato, Foucault's work ought to be continued upon this fractured line between resistance and creation. Resistance is always an act of risk-taking. It is located in the processes of micro-deinstitutionalization of subjectivities, where normativity can sometimes be invisibly erased, silenced, reverted, inverted, suspended, etc.

SD could be a public-square occupation, in which the group-person configuration can be slowly and horizontally organized by different kinds of people with no previous hierarchy, with an open microphone, creating singular voices that are constantly empowered and collectivized at the same time. Indignados (Spain), Occupy Wall

6. Maurizio Lazzarato, "From Biopower to Biopolitics," *Pli: The Warwick Journal of Philosophy*, 13 (2002): 99–110.

Street (USA), Black Lives Matter (USA), Nuit Debout (France), Ocupa Escola (Brazil), Those Who Go West (Japan), and Free Palestine are movements that have taken place locally, but resonated globally. Among the outcomes of Occupy in NY was the creation of a police force better equipped to control and disperse any form of aggregation in the city. During the crucial moments of the movement, the private sector donated about $4 million to the NYPD. Within one week, the police were intensively militarized. Laboratories to register the DNA data of suspects were installed around the city; cameras for recording faces became the most common tool used by the police (in addition to guns and pepper spray); iris scans were implemented; war tactics of repression by the police and the FBI were used to dismantle the occupation in the Park; new vehicles of incarceration were acquired, etc. The neoliberal strategy was to donate enough money to the apparatus of the state to make sure the movement would exist only in people's collective memory. The state also resorted heavily to the politics of technological control. An FBI list of artists, writers, filmmakers, activists, etc., was created. Phones were tapped; intellectuals were interrogated; text messages were delayed; email accounts were violated. Sharing actions on social media led to incrimination and fear, and these platforms became liberating traps: collecting data on individuals' thoughts and interactions, mapping their social networks, political and cultural alliances, and tendencies under (in)visible new protocols that are now constantly mediating social interactions.

Franco "Bifo" Berardi recounts Occupy and many other occupations around the world in 2011–12 and beyond as being part of a global movement that was ultimately unable to affect financial power. Occupy, for him, however, was an extraordinary movement that was much more connected to the body than to putting an end to the financial suicide. It was a process of reactivating the erotic force of society. In Berardi's view, the body and language have been increasingly disconnected from one another as humans have moved further and further into techno-capitalism. Power, for Berardi, is a special automation, an extractor, which is imposed on the present, and limits possibilities and potencies. Potency in this context is the subjective ability to disentangle an alternative possibility from the

existing structure of power. How to keep reactivating the erotic body of society is as crucial a question to pose as that of material production. The potential for finding a new meaning—the question of how to incorporate an alternative attitude into our system—reactivates the potency of the social body.[7]

The collective and horizontal form of production of SD resonates with the *grille*, an organizational methodology invented and implemented by Guattari at the Clinique La Borde, the revolutionary psychiatric clinic established in 1951 in France by Jean Oury and directed by Guattari from 1953–89. Induced by a lack of funds with which to pay workers, Guattari instituted a weekly rotation of duties (cleaning, cooking, etc.) shared by the *pensionnaires* (patients) and staff members in the Institution. Later, the *grille* was fully implemented and integrated as one of the daily operational mechanisms, functioning as part of the strategy for preventing institutional inertia.[8]

Institutions generally reinforce repetitive and fixed functions and actions by their participants. Institutional inertia is the result of these entrenched forms of interaction that cause sedimentation. With the *grille*, Guattari and Oury created new possibilities for interaction among the *pensionnaires*, doctors, nurses, and visitors. My visit to La Borde in 2012 was revelatory as I experienced firsthand how perception becomes blurred when codes are unfixed, effecting a physical reaction on the level of the body (and on the level of the heart—perhaps the state of potency described by Berardi), thereby opening the mind and the body to a different

7. For Berardi, "Only the conscious mobilization of the erotic body of the general intellect, only the poetic revitalization of language, will open the way to the emergence of a new form of social autonomy." *The Uprising: On Poetry and Finance* (Los Angeles: Semiotext(e), 2012), 8.

8. The *grille* was structured as a double-entry chart that tracked the daily chores of staff and patients as well as their feelings about the particular tasks. According to Guattari, the *grille* sought to "deregulate the 'normal' order of things" by "reshuffling" work distribution: doctors, nurses, service personnel, and patients were all responsible for cleaning, administration, and caregiving; tasks were shared on a rotation basis. This organizational principle allowed for flexibility in staff-patient relations, working against the tendency toward rigid institutional segmentarity and hierarchy. See Guattari's lecture at La Borde, "La grille" (*Exposé fait au stage de formation de la Clinique de La Borde*). January 29, 1987, IMEC Archives: ET04-13.

understanding of the world. As a visitor at La Borde, I was exposed to three distinct situations that caused a collapse of my understanding of the environment and the institution: a long walking-conversation around the clinic with a doctor who, I later found out, was in fact a *pensionnaire*; a group activity with a very intense *pensionnaire* who was, in reality, one of the chief doctors at the clinic; and a series of drawings I made together with a *pensionnaire,* who, Oury told me at the end of the visit, never interacted with visitors until the moment of our interaction. The non-immediate codification and subsequent collapse of fixed signs repositioned my body. My perception became more fluid. Processes of grasping and extracting situations began to occur on multiple levels of affects.

SD can exist inside art galleries and museums. It can be activated, for example, as a formal economy in an art gallery in order to create debt instead of profit. SD can also be a form of artistic production that deals with the history of abstraction and perception, for instance, SD (@DL/NY, 2016). It can use certain historical tropes as an exercise to provoke movement in thought, turning the exhibition into a process by making visible the ways in which the work that is on view resists being alienated from the labor force that produced its symbolic and capital value. It can not be detached from its sale and circulation. These are not abstract but concrete relations, which can produce a rupture in order to conceive of this collective situation as a singular moment to slowly provoke an ontological sliding.

In this sense, Guy Debord's prohibition of art making in the traditional sense ceases to be operative in certain diagrams. The Situationist struggle (which departed from a contradictory paradigm of radical individuation combined with liberation) has been coopted by the exact forces it fought against: the Society of the Spectacle. What if psychogeography were now to be dislocated from the city plan toward a broader relation to a historical *dérive* among various artistic and social tropes, which led to the unfixing of signifiers? What if, instead of the figure of the artist created by the social body becoming fossilized by fixed values, artistic value became a perpetual *dérive* in various forms?

An exhibition can depart from certain art-historical objects to reflect on how art production responded to these historical moments—

for instance, SD (@DL/NY, 2016)'s revisiting of the aesthetic device of the black monochrome in the aftermath of the Second World War, as well as of specific strategies of figuration in Western and non-Western modernist painting. From this exercise, what will emerge is a form of thinking as to why/how/what historical objects have been embraced by Art History, and how this history produced affects and effects in our thinking about the past, and about our contemporary condition. The situational quality of this proposition then connects phantasmatically and materially with historical objects, proposing to unfix the given forms of understanding them. It is a way of diagrammatically reshuffling certain fixed forms of perception, of thinking alongside objects, which are being actively re-coded and re-inserted into the system and the discourse in various ways.

This paradigm of diagrammatization recognizes that the body is a hybrid of corpuses in which matter is formed by biological, chemical, technological, etc. structures that carry thought into a different dimension beyond human grasping. Humanity must be understood as part of everything else that forms the cosmos, not as a separate and privileged entity. To think about the production of art under this condition is to think about what kind of subjectivities are being formed nowadays after this assemblage (*agencement*) has been constituted, and to think about what kind of energies/forms/works can be created that can reflect this condition.

In *A Thousand Plateaus*, Deleuze and Guattari (D&G) observe that "The expressive is primary in relation to the possessive; expressive qualities, or matters of expression, are necessarily appropriative and constitute a having more profound than being. Not in the sense that these qualities belong to a subject, but in the sense that they delineate a territory that will belong to the subject that carries or produces them. These qualities are signatures, but the signature, the proper name, is not the constituted mark of a subject, but the constituting mark of a domain, an abode. The signature is not the indication of a person; it is the chancy formation of a domain."[9]

9. Gilles Deleuze and Félix Guattari, *A Thousand Plateaus*, trans. Brian Massumi (Minneapolis: University of Minnesota Press, 1987), 316.

If we think within these parameters, the figure of the artist is nothing more than a social *dispositif* that is constantly interacting with individual/group processes of subjectivation/semiotization on molar and molecular levels. How to think/trace angles that can allow this social construction to be exposed, in order to produce more movements of fluctuation—as a point of fugue in this turbulent landscape—is one of the multiple motivations of this piece of writing.

Following this line of thought, Situational Diagrams originate from subjective assemblages (*agencements*), not from "subjects," whereas molar productions in contemporary art still operate under the logic of the "subject," producing marks/monuments of an object-subject relation. Examples of these productions can vary from sophisticated demarcations of how the body visualizes abstractions in imperceptible flows, to more systemic productions that emphasize structural configurations in order to allow variation and repetition ad infinitum. Molar production/circulation reinforces stratified planes of composition. The figure of the artist—a collective fantasy perpetuated by multiple systems—seems to still be the main character of this form of theatrical production/circulation. The signature of the artist is always attached to multiple social signifiers (gallery, institution, studio, assistant, curator, critic, collector, viewer, publisher, the Internet, etc.). And, conversely, the more people who participate in this chain of symbolic and financial value production, the more expensive the work gets. Meanwhile, fewer and fewer people receive the benefits of this collective enterprise. In this molar machinic production, affect becomes limited to a certain functionality. It becomes stratified and highly integrated into the logic of capitalist production. It generates a double bind (or defeat), a topology without an outside.

Given the heterogeneous movement that art/thought always generates, artistic production should never be limited only to the re/distribution of the symbolic/capital. Molecular art productions are complex and difficult to visualize because their configurations are not fixed. In a molecular setting, an assistant who produces an artwork can be considered a collaborator. An editor becomes part and parcel of the writer's voice. The choice of translator transforms a text and gives it a new life in a different language. When art production

and exhibition become diagrammatic, the molar and the molecular coexist. An understanding of the kind of body (molar/molecular) that belongs to such a production is what demarcates its line of flight (*ligne de fuite*) and relation to its historical time.

While in *WiP?*, D&G outline the creation of a concept as specifically belonging to the terrain of philosophical thought, *CS* inscribes the creation of a concept within the social, the technological, the economic, the sexual, the political, etc. effects. If one considers these two universes, one can think about artistic/social struggles/practices within molar/molecular processes as eternal experiments in the order of matter/substance/form in content/expression.

If nowadays one senses a certain impossibility of following Contemporary Art in its abusive and violent state of manic production and reproduction, one should also be able to think about how to react against this state of affairs without being subsumed by the rigid readings/writings of Art History that designate Situationism (or post-Situationism) its last possible form. The Situationist International sought to deregulate personal time and space, which have always been acutely controlled by the State. In this way, Situationism sought to destroy normativity and brought situations to *dérive*—an experiment of living an open system of situations, outside the regulation of the State apparatus, as opposed to normative situations.

With the insertion of digital technologies into the Culture Industry, and their rapid expansion combined with high levels of cognitive labor, molar productions exacerbate consumerist reproduction. In contrast, molecular productions seem to exist at a different speed given their lines of flight (*lignes de fuite*) and fugue. They throw a problem into the air, while the possible ways of bringing about a built-in fracture mechanism propel them with further momentum in their own arrangements. This movement is in search of the next assemblage of answers, whereby one world disappears in favor of another that is yet to be understood, deciphered, and presented again to the world, ad infinitum. Situational Diagrams effect dislocation of fixed economic, social, artistic, libidinal, political, etc., values, addressing micropolitics on the level of

group/personal dynamics. SD is a model of machinic production. It is aesthetically, economically, politically, ethically, and geographically oriented, and sometimes it can produce heretofore unthinkable resonances.

It is within this created collective/individual domain that the figure of the artist/thinker must unfix affects from normative values, and try experimenting instead with an open system of diagrammatization. However, machinic processes can never be disassociated from structures of territorialization. A process of subjectivation is constituted by social assemblages (*agencements*) and collective equipment. Market and desire machines operate between the social, the unconscious, and the political fields as well as on a subjective level that is never isolated from these fields. SD is a social and a productive *dispositif*. Detached from any fixed forms of representation, it activates affect/percept/concept and brings about a transitional fantasy capable of generating another existential territory for art production.

Sabu Kohso, b. Okayama, is an activist, writer, and translator based in New York. His work is focused on anarchist thought, the formation of urban space, and the postwar politics of nuclear disaster in Japan. He has published three books in Japanese on these topics. Kohso has translated books by Kojin Karatani and Arata Isozaki into English from Japanese, and by David Graeber and John Holloway into Japanese. He is the cofounder of the platform Japan—Fissures in the Planetary Apparatus, which promotes global exchange between thinkers, artists, and activists to address issues arising in the aftermath of Fukushima. Kohso is a frequent contributor to various journals and platforms, including *through europe, e-flux, borderlands*, and *boundary 2*. He is currently working on a book, *Radiation and Revolution,* for the series Thought in the Act, edited by Brian Massumi and Erin Manning.

Jaleh Mansoor, b. 1975, Tehran, is an assistant professor of art history at the University of British Columbia. She has previously taught at SUNY Purchase, Barnard College, Columbia University, and Ohio University. Mansoor's work addresses modernism, postwar art, Marxist theory, historiography, and feminism. Mansoor is the author of *Marshall Plan Modernism: Italian Postwar Abstraction and the Beginnings of Autonomia* (Duke University Press, 2016). She is co-editor of *Communities of Sense: Rethinking Aesthetics and Politics* (Duke University Press, 2009), an anthology of essays exploring Jacques Rancière's articulations of politics and aesthetics. She is currently working on two projects—one that addresses formal and procedural violence in the work of Alberto Burri, Lucio Fontana, and Piero Manzoni; and another on the problem of labor, value, and "bare life" in the work of Santiago Sierra and Claire Fontaine, among other contemporary artists whose practices examine the limits of the human. Mansoor is a critic for *Artforum* and a frequent contributor to *October, Texte zur Kunst*, and the *Journal of Aesthetics and Protest.*

Jean-Luc Nancy, b. 1940, is Distinguished Professor of Philosophy at the Université Marc Bloch, Strasbourg. He published his first book, *Le Titre de la lettre: une lecture de Lacan* [The Title of the Letter: A Reading of Lacan], co-written with Philippe Lacoue-Labarthe, in 1973. In 1980, he and Lacoue-Labarthe organized the conference *Les Fins de l'homme* [The Ends of Man],

on Jacques Derrida's political thought, at the Centre Culturel International de Cerisy. Nancy's works of political philosophy include *La Communauté désoeuvrée* [The Inoperative Community] (1982), *L'Expérience de la liberté* [The Experience of Freedom] (1988), *Être singulier pluriel* [Being Singular Plural] (1996), *La Création du monde ou la mondialisation* [The Creation of the World or Globalization] (2002), and *Vérité de la démocratie* [The Truth of Democracy] (2008), among many others. His works in aesthetics include *Les Muses* [The Muses] (1994), *L'Évidence du film: Abbas Kiarostami* [The Evidence of Film] (2001), *Au fond des images* [The Ground of the Image] (2003), and *Le Plaisir au dessin* [The Pleasure in Drawing] (2009).

Simon O'Sullivan, b. 1967, Norwich, UK, is a professor in art theory and practice in the Department of Visual Cultures at Goldsmiths College, University of London. He has published two monographs with Palgrave Macmillan, *Art Encounters Deleuze and Guattari: Thought Beyond Representation* (2005) and *On the Production of Subjectivity: Five Diagrams of the Finite-Infinite Relation* (2012). He is the editor, with Stephen Zepke, of *Deleuze, Guattari and the Production of the New* (Continuum, 2008) and *Deleuze and Contemporary Art* (Edinburgh University Press, 2010). His collaborative art practice Plastique Fantastique is represented by IMT Gallery in London.

Anne Querrien, b. 1945, is a sociologist, political scientist, and philosopher. She was a major figure in student and feminist protests in France in the late 1960s and '70s. Querrien studied with Gilles Deleuze and worked with Félix Guattari at the Center for Institutional Study, Research, and Training (CERFI). She was editor of the journal *Les Annales de la Recherche Urbaine*, and has been on the editorial boards of the journals *Chimères*, founded by Guattari and Deleuze, and *Multitudes*, since 2000. She has contributed essays to *Zone 1/2: The [Contemporary] City* (Zone Books, 1987), *Altering Practices: Feminist Politics and Poetics of Space* (Routledge, 2007), *Deleuze and Architecture* (Edinburgh University Press, 2013), and *La Libération des femmes: une plus-value mondiale* [The Liberation of Women: A Global Surplus Value] (l'Harmattan, 2015). Querrien is a professor at the Université Paris 8 Saint-Denis and Université Paris 1, Panthéon-Sorbonne.

Abrahão de Oliveira Santos is a professor of psychology at the Universidade Federal Fluminense (UFF), Niterói, Brazil, and director of Kitembo, a laboratory for studies in Afro-Brazilian subjectivity and culture. Santos works in the field of mental health using the thought of Félix Guattari and Gilles Deleuze.

He is the author of the book *Psicose: questões de vida ou morte* [Psychosis: Matters of Life and Death] (Vetor, 2006). Recent articles include "Culture Africaine au Brésil: rêve, résistance et singularisation" [African Culture in Brazil: Dream, Resistance, and Singularization] in the journal *Chimères* (no. 86, 2015) and "Gestion collective des rêves: extractions déterritorialisées" [Collective management of dreams: deterritorialized extractions] in *Revue L'Unebévue* (no. 31, 2014).

Valentin Schaepelynck, b. 1978, is associate professor in education sciences at the Université Paris 8 Saint-Denis. His work concentrates on the critique of institutions, different forms of institutional analysis, and pedagogical practices. Schaepelynck is a frequent contributor to the journal *Chimères*, founded by Félix Guattari and Gilles Deleuze, as well as to *Le Télémaque*, a journal of the philosophy of education. He is part of the laboratory Experice, co-headed by the Université Paris 8 and the Université Paris 13, where he teaches in a master's program in education sciences.

Karin Schneider, b. 1970, is a Brazil-born and New York-based artist and filmmaker. In 1997, Schneider founded Union Gaucha Productions (UGP) with Nicolás Guagnini, an artist-run, experimental film company that carries out interdisciplinary collaborations with practitioners from different fields. From 2005 to 2008, she was a founding member of Orchard, a cooperatively organized exhibition and social space in New York's Lower East Side. In 2010, Schneider co-founded CAGE, a space that facilitates new kinds of social interactions. Her most recent body of work is Situational Diagram, which she first presented as a text at the Centre Culturel International de Cerisy, France, in 2015, and as an exhibition at Dominique Lévy, New York, in September 2016.

Aliza Shvarts, b. 1986, Los Angeles, is an artist and scholar based in New York City. Her work deals with queer and feminist understandings of reproduction and time. Her artwork has been shown at Abrons Art Center and MoMA PS1 in New York, The Slought Foundation in Philadelphia, and the Tate Modern in London. Her writing has appeared in *The Journal of Feminist Scholarship, Women & Performance: a journal of feminist theory*, and *TDR: The Drama Review*. She was a 2014 recipient of the Creative Capital | Warhol Foundation Arts Writers Grant, a 2014–15 Helena Rubinstein Fellow at the Whitney Independent Study Program, and is currently a Joan Tisch Teaching Fellow at the Whitney Museum of American Art as well as a PhD candidate in Performance Studies at New York University.

Begum Yasar, b. 1983, Istanbul, is director at Dominique Lévy, where she organized the critically acclaimed exhibition "Hypothesis for an Exhibition" and edited the accompanying publication in 2014, in collaboration with artists such as Giulio Paolini, Kerstin Brätsch, and Seth Price. Yasar launched and is responsible for the exhibition programming of The Back Room, the gallery's project space, where she has presented exhibitions of Senga Nengudi, Hans-Christian Lotz, and Antek Walczak. She holds a Bachelor's degree in Philosophy and Economics, and a Master's degree in Political Theory from the London School of Economics, as well as a Master's degree in Modern Art: Critical and Curatorial Studies from Columbia University. Yasar's research interests lie in ethics, political theory, aesthetics, phenomenology, and the philosophy of science.

Tirdad Zolghadr, b. 1973, Tehran, is a curator and writer. He teaches at the Dutch Art Institute in Arnhem and the Center for Curatorial Studies at Bard College, among other institutions. He writes for *frieze* and other publications, and is an editor at large for *Cabinet* magazine. Zolghadr most recently organized the national pavilion of the United Arab Emirates, in the 53rd Venice Biennale in 2009, and the long-term project Lapdogs of the Bourgeoisie (with Nav Haq). *Traction*, a curatorial polemic, will be published by Sternberg Press in August 2016. He is at work on his third novel, with the working title *Headbanger*.

Figure Captions

15, top: Lacan's concept of the Four Discourses (those of the Master, the University, the Hysteric, and the Analyst) was first presented in his 1969 seminars *The Other Side of Psychoanalysis* and *Radiophonie*. Lacan here articulates discourse as a fundamentally social bond founded in intersubjectivity: Speech always implies another subject. The four positions occupied in each discourse are: (1) Agent, upper left: the speaker of the discourse; (2) Other, upper right: what or whom the discourse is addressed to; (3) Product, lower right: what or who the discourse creates; and (4) Truth, lower left: what the discourse attempts to express.

15, bottom: Levi-Strauss's culinary triangle was first formulated in his article of the same title in *The Partisan Review* 33, Autumn 1966: 586–96.

18, top: *A Thousand Plateaus: Capitalism and Schizophrenia*, trans. Brian Massumi (Minneapolis: University of Minnesota Press, 1987), 183.

18, bottom: Ibid., 185.

19, top: Lacan's completed graph of desire, the compendium of multiple individual graphs of desire, was first presented in his 1960 essay "The Subversion of the Subject and the Dialectic of Desire in the Freudian Unconscious," in *Écrits*, trans. Bruce Fink (New York: W.W. Norton & Company, 2006), 692.

19, bottom: *A Thousand Plateaus: Capitalism and Schizophrenia*, trans. Brian Massumi (Minneapolis: University of Minnesota Press, 1987), 135.

22, left: First published in *Poésie Nouvelle* 10, 1960.

22, top right: The sigil of the gateway is a falsified sigil found on the cover of an edition of the *Necronomicon*, a fictional magic textbook which figures in stories by horror fiction writer H. P. Lovecraft.

25, top: This diagram combines a vevé for the Haitian Vodou Loa (spirit) Carrefour/Papa Legba (the spirit of the crossroads) with a Hasse diagram—a type of mathematical diagram used to represent a finite partially ordered set—for the $P(S)$ (power set) three.

Published on the occasion of the exhibition
Situational Diagram
September 7–October 20, 2016

Dominique Lévy
909 Madison Avenue
New York, NY 10021
+1 212 772 2004
dominique-levy.com

Editors: Karin Schneider and Begum Yasar
Associate Editors: Sylvia Gorelick, Andrew Kachel, and Valerie Werder
Copy Editors: Abraham Adams and Sam Frank

© 2016 Dominique Lévy Gallery
Design: Franklin Vandiver
Printing: Tallinna Raamatutrükikoja, Estonia

ISBN: 978-1-944379-09-4